THE
ILLUSTRATED FIELD G'
DMT EN

"The DMT experience is fu ⌐ ⌐ traveling to unknown or forgotten realms: ⌐y strange and yet strangely familiar. These realms ⌐ ⌐ntelligent beings with much to teach. Like any challengin⌐ ⌐aps even perilous journey, it is important to prepare and to be wi⌐ ⌐g to learn from the experiences and hard-won knowledge of others. David Jay Brown's *Illustrated Field Guide to DMT Entities*, with entrancing images by Sara Phinn Huntley, is an essential companion for all serious travelers whose mission is not only to go boldly but also to return with lasting and worthwhile insights."

GRAHAM HANCOCK, AUTHOR OF *VISIONARY: THE MYSTERIOUS ORIGINS OF HUMAN CONSCIOUSNESS*

"DMT is fascinating for many reasons, but not least because it seems to provide ready access to a hyperdimensional realm populated by a vast collection of non-human, intelligent, and apparently independent entities. Often these entities seem to have a message (or many messages) for our species or the individual psychonaut, weighted with portent. Whether DMT opens a portal to universes not mapped in any cosmology, or whether these entities are denizens of the unexplored depths of the mind, they definitely seem to have a classification system and characteristics that are familiar to many psychedelic voyagers. In this book, writer David Jay Brown and artist Sara Phinn Huntley unpack and present, in detail, what is currently known about the DMT entity phenomenon and provide a helpful field guide to those you are most likely to encounter in your rambles in the outer fringes of psychedelic experience."

DENNIS MCKENNA, PH.D., AUTHOR OF *THE BROTHERHOOD OF THE SCREAMING ABYSS* AND COAUTHOR OF *THE INVISIBLE LANDSCAPE*

"From the Lilliputian to the Brobdingnagian, from the magnificent and multi-armed to the demonic and to the divine, this is the most beautiful, comprehensive, and, I dare say, indispensable guide to the resident fauna of the DMT realms. You won't want to venture into the hyperdimensional hinterlands without this field guide in your back pocket."

ANDREW R. GALLIMORE, PH.D., AUTHOR OF
ALIEN INFORMATION THEORY AND *REALITY SWITCH TECHNOLOGIES*

"The best bestiary on hyperspace denizens so far. A must-read for all intrepid psychonauts, interdimensional diplomats, and cosmos passport holders. David and Sara have created the ultimate guide and extraterritorial exploration of the dazzling variety of DMT entities lurking within your mind or just beyond your glass pipe. A real hitchhiker's guide to the galaxy."

DAVID LUKE, PH.D., AUTHOR OF
DMT DIALOGUES AND *DMT ENTITY ENCOUNTERS*

"This stunningly illustrated and comprehensive field guide is an essential item for the map compartments of travelers of the Nth-dimensions."

GRAHAM ST. JOHN, AUTHOR OF *MYSTERY SCHOOL IN HYPERSPACE*

"While you're tripping on DMT
Often beings come out of the Me
Brown and Phinn's new anthology
Is a good xenobiology
Of some creatures you're likely to see."

NICK HERBERT, AUTHOR OF *QUANTUM REALITY*

"A perfect balance of interesting and informative text alongside visually spellbinding images that spectacularly capture a glimpse of the DMT experience with astonishing accuracy and aesthetic splendor. The collaboration between author David Jay Brown and graphic artist Sara Phinn Huntley has resulted in nothing short of a masterpiece."

RACHEL NAIA TURETZKY, PH.D., COAUTHOR OF
8 CIRCUIT ASCENSION

PLEASE SEND US THIS CARD TO RECEIVE OUR LATEST CATALOG FREE OF CHARGE.

Book in which this card was found

☐ Check here to receive our catalog via e-mail.

Company

☐ Send me wholesale information

Name

Address

City _____ State _____ Zip _____ Country _____

E-mail address

Please check area(s) of interest to receive related announcements via e-mail:

☐ All Books

☐ Ancient Mysteries and the Occult

☐ Psychedelics and Entheogens

☐ New Age Spirituality, Personal Growth, and Shamanism

☐ Holistic Health, Natural Remedies, and Yoga

☐ Sacred Sexuality and Tantra

Please send a catalog to my friend:

Name _____ Company _____

Address _____ Phone _____

City _____ State _____ Zip _____ Country _____

Order at 1-800-246-8648 • Fax (802) 767-3726

E-mail: customerservice@InnerTraditions.com • Web site: www.InnerTraditions.com

INNER TRADITIONS
BEAR & COMPANY

Inner Traditions • Bear & Company
P.O. Box 388
Rochester, VT 05767-0388
U.S.A.

THE ILLUSTRATED FIELD GUIDE TO
DMT ENTITIES

Machine Elves, Tricksters, Teachers, and Other Interdimensional Beings

DAVID JAY BROWN

AND

SARA PHINN HUNTLEY

Park Street Press

Rochester, Vermont

Park Street Press
One Park Street
Rochester, Vermont 05767
www.ParkStPress.com

Park Street Press is a division of Inner Traditions International

Note to the Reader: The information provided in this book is for educational,
historical, and cultural interest only and should not be construed as advocacy
for the use or ingestion of DMT or other psychedelics. Neither the author nor
the publisher assumes any responsibility for physical, psychological, or social
consequences resulting from the ingestion of these substances or their derivatives.

Cataloging-in-Publication Data for this title is available from the Library of Congress

ISBN 978-1-64411-919-8 (print)
ISBN 978-1-64411-920-4 (ebook)

Printed and bound in India by Nutech Print Services

10 9 8 7 6 5 4 3 2 1

Text design and layout by Kenleigh Manseau
This book was typeset in Garamond Premier Pro with Skia and Gotham used as
display typefaces
Artwork by Sara Phinn Huntley unless otherwise noted

To send correspondence to the author of this book, mail a first-class letter to the
author c/o Inner Traditions • Bear & Company, One Park Street, Rochester, VT
05767, and we will forward the communication.

Scan the QR code and save 25% at InnerTraditions.com.
Browse over 2,000 titles on spirituality, the occult, ancient
mysteries, new science, holistic health, and natural medicine.

■ ■ ■

For Terence McKenna and all the brave DMT voyagers,
in this world and beyond

—DAVID

■ ■ ■

For my late father, Donald Huntley, who throughout our
lives together always supported my art,
visions, and endeavors

—SARA

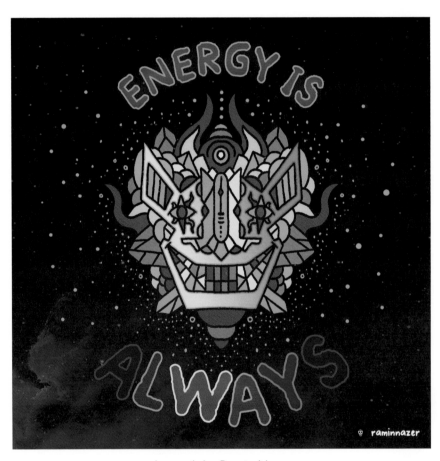

Artwork by Ramin Nazer

CONTENTS

Biomorphic Empathy, by Sara Phinn Huntley

ACKNOWLEDGMENTS

Many people contributed this book, and it could not have been done without all the people who provided trip reports, entity encounters, artwork, consultation, and feedback.

The late ethnobotanist Terence McKenna was a great inspiration for this book. I was fortunate to be able to spend many enchanted hours with him, at his Esalen Institute workshops and in personal conversation. This book would not have been possible, and perhaps all of the contemporary scientific research into DMT and its massive cultural impact may never have happened, without his incredible insight into the DMT experience and his popularization of the DMT entity encounter phenomenon through his masterful storytelling. I'll always cherish the endorsement that Terence wrote for my first book: "That our perfected selves whisper to us from the future is but one of David Jay Brown's fertile insights."

I would like to thank Rick Strassman, Andrew Gallimore, and David Luke for reviewing the manuscript for this book and for their important comments, as well as for their interviews. I also want to thank Josie Kins, Carl Hayden Smith, Alexander Beiner, and Daniel McQueen for their interviews.

Numerous artists contributed to this book, besides my beloved friend Sara Phinn Huntley, whom I am deeply indebted to. We would like to thank Alex Grey, Allyson Grey, Luke Brown, Andrew Android

Jones, Salvia Droid, Ramin Nazer, Harry Pack, Shaun Noelte, Juliana Garces, Becca Tindol, Ethan Nichols, Erial Ali, Marina Seren, Glass Crane, DMT Vision, Eliot Alexander, Diana Heyne, Jan Betts, Shaynen Brewster, Graham F. Ganson, Jeff Westover, Maya Bèllavi Ilizyon, Rebecca Ann Hill, Jeff Sullivan, Michael Garfield, Jason WA Tucker, Eloh, Jordan Fleshman, and Joey Charpentier.

Boundless appreciation goes to my faithful, supportive, and ever-helpful assistant and longtime friend Louise Reitman, who recorded, transcribed, edited, and assisted with the interviews I conducted for this book.

Special thanks to Rachel Turetzky and Danielle Bohmir for their consulting and contributions to the book. Many people in the Facebook groups Psychedelic Synchronicity, DMTWorld.net, Alien Abductees Group, and Duncan Trussell Family Hour contributed anonymous trip reports, as did many of my friends on social media.

My psychedelic mentors over the past few decades also played an important role in shaping my ideas in this book. I would like to express my enormous gratitude to the following individuals for helping to expand and educate my mind over the years: Robert Anton Wilson, John C. Lilly, Timothy Leary, Oscar Janiger, Stanley Krippner, Nick Herbert, Ralph Metzner, and Rupert Sheldrake. I am most fortunate to have been able to spend so much time learning from these brilliant thinkers.

Additionally, I would like to thank the following people for their support and help with this project: Carolyn Mary Kleefeld, Arleen Margulis, Patricia Holt, Nicolo Pastor, Rebecca Ann Hill, Robin Rae, Alexa Baynton, Chester Rolink, Graham Hancock, John Mack, Sammie and Tootie, Geoffrey and Valerie Goldstein, Katara Lunarez, Steve Cooper, Nadja Stolarczuk, Darian Fae, Lana Sackwild, AndRa Skye, Rob Capili, Sunshine Salsera, Sherri Hall, and Serena Watman.

Sara would like to acknowledge these incredible people for their work, inspiration, and support over the years: Donald Huntley, David Jay Brown, Jason WA Tucker, James Oroc, Rick Strassman, Ralph Abraham, Jason Louv, Erik Davis, Jeremy Narby, Diana Reed Slattery, Antero Alli, Anson Phong, Eloh Projects (Sean Allum), and Milo Hayden.

ARTIST'S STATEMENT

SARA PHINN HUNTLEY

Composing images with the assistance of artificial intelligence (AI) art programs is like a game of charades with a benevolent, omniscient alien. The AI pulls from millions upon millions of images, instantly from the internet, and then one tries to get it to conjure the same images you have in your mind's eye. The process is strange and hypnotic, and over time you learn how to delicately string the right words together to get as close as possible to the vision you have planned. The resulting images are then composited and digitally painted over to create the prototypes of the artwork you see in this book, which represent the collective experience of DMT archetypes.

I don't think that creating this book would have been easily possible just a few years ago, because you could literally spend a lifetime trying to paint twenty-five entities with the kind of detail and clarity that's needed to do any sort of justice to the way these experiences feel for the people who are doing the journey work. Being able to access some of the new technology—like Midjourney, Stable Diffusion, and other AI art programs—has been really exciting, because it gives me a unique opportunity to tap into the collective consciousness and the way AI interprets our collective perception of what a jester, mantis

being, humanoid alien, or blue-skinned hyperdimensional apparition looks like.

I've gone through a lot of different iterations with the AI to dial in these images. It's not a one-to-one process, where I just put in a prompt and an image pops out. No artist's names were used in the prompts, and the images are not the result of any singular artist's work. It's more like a conversation or an exploration. Using this process in tandem with the descriptions from trip reports, I've been able to create these different archetypes. Everybody's subjective experience is going to be fine-tuned to their own psyche, but there's so much interesting overlap in our experiences with DMT that I've been able to show these illustrations to people who have had entity contact, and they say something like, "Wow, that's uncanny. It really does resemble what I saw."

Being able to take a collective pulse and get this kind of imagery based on people's linguistic descriptions would have required a lot of guesswork before, so these AI art programs offer a quantum leap in possibility. Likewise, David has mentioned that without the help of the internet, gathering the trip reports detailed in this book would have been very difficult, so our symbiosis with these new technologies made this book possible, and they will surely assist in our further contact with these mysterious entities.

It has been an honor and a delight to utilize this new technology to tap into the collective imagination of our species as it establishes contact with potentially real, hyperdimensional intelligences in the DMT state. I'd like to express my deepest gratitude to all of the great visionary artists and technical engineers who came before me, whose work helped shape the genre and software involved in this collective art mission.

I dedicate my art in this book to my late father, Donald Huntley. Many years ago, his dear friends shared DMT with him for the first time. He had an experience that he described as "turning into a little tree frog, struggling to stay aloft on a large leaf," as he was seated on a stool. When I learned of this, I laughed, shocked that he hadn't just asked me to help facilitate this for him, as he knew I had a profound

This image is one of the earliest iterations of the self-transforming machine elf images made in Midjourney while working on this book.

interest in the spirit molecule. I was also surprised and impressed that he hadn't just fallen off the stool!

I immediately offered him the chance to partake again, this time lying comfortably on a bed instead of trying to balance his body while his spirit launched into hyperspace. He lay on the bed, with his eyes closed, after taking a few modest tokes, and he returned with a smile on his face and that special light in his voice that he had when he was happy. "I see your friends, Sara," he said. "They're dancing."

It was at that moment that I knew something truly special had occurred, one of those rare moments when a Westerner is able to share a multigenerational transmission with these curious and special beings. It was their dancing that let me know he had met the same friends I had grown to love in hyperspace. In that moment, I was able to share one of the most profound experiences of my life with my best friend, my closest family, my hero. None of the deep magic in my life, including this book, would be possible without his love, trust, and support. Thank you, Dad. I love you.

Let us start with a simple fact: man has always been aware that he is not alone. All the traditions of mankind carefully preserve accounts of contact with other forms of life and intelligence beyond the animal realm. Even more significantly, they claim that we are surrounded with spiritual entities that can manifest physically in ways that we do not understand.

JACQUES VALLÉE, *DIMENSIONS*

We didn't know what the Secret was, exactly, all we knew for sure was that there was a Secret, and that DMT was somehow the key.

DENNIS MCKENNA

So, you take, let us assume, a third toke, long and slow. You vaporize, and you take it in, and in, and in. And there is a sound, like the crumpling of a plastic bread wrapper, or the crackling of flame and a tone. A mmmmmmmmmmmmmmmmmmm . . . and there is this . . . There is a cheer. The gnomes have learned a new way to say hooray. The walls, such they be, are crawling with geometric hallucinations. Very brightly colored, very iridescent. Deep sheens and very highly reflective surfaces; everything is machine-like and polished and throbbing with energy, but that is not what immediately arrests my attention. What arrests my attention is the fact that this space is inhabited. And so, like jeweled self-dribbling basketballs, these things come running forward, and what they are doing with this visible language that they create is they are making gifts! They are making gifts for you.

TERENCE MCKENNA, IN "A NEW WAY TO SAY 'HOORAY!'"
(A SONG BY SHPONGLE)

The way I describe DMT is it's like mushrooms times a million, plus aliens.

JOE ROGAN

The masses have to learn it slowly

AL M. HUBBARD, IN A RECORDING
OF HIS EXPERIENCE WHILE ON DMT IN 1961

INTRODUCTION

When I was a child, I used to collect the Golden Guide nature books. I had the complete set: *Reptiles and Amphibians, Fishes, Insects, Birds, Mammals,* and so on. I even had *Hallucinogenic Plants.* My love for those wonderfully illustrated field guides to different species of wildlife came to mind when my good friend Sara Phinn and I were tripping together one day in the Santa Cruz Mountains around fifteen years ago. We thought it would be fun to create a similar guide book for classifying the different species of alien beings that people report encountering on DMT and other psychedelics, with pictures and descriptions for identifying them. That was the genesis for the book you now hold in your hands, and we talked about doing this for years. At the time, DMT was a rather obscure drug known only to psychedelic aficionados, but it has now become so popular, and the entity encounters it engenders have become so common, that we felt the time was right to finally do this book.

The author and illustrator of this book, tripping together in the Santa Cruz Mountains, 2013

1

The Illustrated Field Guide to the DMT Entities is a primitive, playful attempt to begin an extraterrestrial or interdimensional zoology or taxonomy—to classify intelligent species and highly evolved creatures from other worlds in the form of a naturalistic field guide. Surely more sophisticated and accurate exobiology classification systems, as well as more effective interspecies communication programs, will follow. However, until recently, to create such a classification system, we had only science fiction stories and alien abduction and UFO contactee reports to draw from, which many skeptics doubted. But now we have controlled and repeatable experiments in clinical settings with the psychedelic molecule DMT, as well as a bounty of reports on the internet from self-experimentation, all of which appears to allow for reliable contact experiences with highly evolved entities.

In Astronomy, the Fermi Paradox addresses the seeming contradiction between the high probability of extraterrestrial civilizations existing in the universe and the lack of evidence or contact with such civilizations. It questions why, given the vast number of stars similar to the Sun and potentially habitable planets, there is no definitive proof of alien life or visitations. "Where is everyone?" the astrobiologists ask? Many DMT users and researchers respond, "Just three tokes away."

My psychedelic flight patch and entity communication credentials, which I received after being interviewed for the *DMT Xperience* Podcast

PART 1
The Terrain

1
...
ENTERING THE
DMT REALM

DMT (N,N-dimethyltryptamine) is a mysterious chemical that is naturally found in the human body,[1] and in many species of animals and plants, although no biochemist knows exactly what biological function it serves in any of these organisms. It's been speculated that DMT might be produced in the pineal gland of the brain, but to date it's been found only in the blood and lungs. DMT has also been found in the brains of rats, and interestingly, it is produced in rat brains during cardiac arrest,[2] which lends credence to the notion that it may be produced

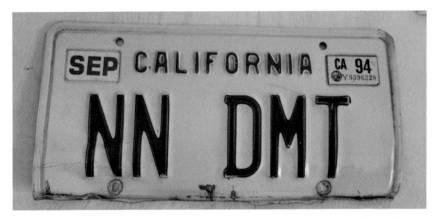

Terence McKenna's license plate; photo by Kevin Whitesides, from the
Terence McKenna Archives

in human brains when people are near death and could be at least partially responsible for what people have called the near-death experience.

A scientific study has shown similarities between the DMT experience and the near-death experience.[3] DMT has also been speculated to play a role in dreaming and natural mystical experiences, as well as possibly psychosis.[4] Although the role of DMT in mammalian physiology is still debated, according to one review paper, "Data strongly suggest that DMT can be relevant as a neurotransmitter, neuromodulator, hormone and immunomodulator, as well as being important to pregnancy and development."[5]

DMT is derived from tryptophan, an amino acid endogenous to all living organisms. It is an indole alkaloid and a potent serotonergic psychedelic, acting on the (serotonin) 5HT-2A receptor in the brain, and is virtually ubiquitous throughout nature.* In fact, DMT is so commonly encountered in the natural world that the late chemist Alexander Shulgin wrote, "DMT is . . . in this flower here, in that tree over there, and in yonder animal. [It] is, most simply, almost everywhere you choose to look."[6] Or as ethnopharmacologist Dennis McKenna said, "Nature is drenched in DMT."[7] Trace amounts of DMT can even be found in every glass of orange juice![8]

To be clear here, whenever we refer to DMT in this book, we are referring to N,N-DMT and not 5-MeO-DMT. The latter is chemically similar but produces different effects that are commonly associated not with entity contact but rather just the opposite: a union with a nondualistic void. So, it's important to differentiate between these two substances when reviewing people's trip reports.

Amazonian shamans have been using plant-based DMT as a central component of their ayahuasca brews and snuffs since prehistory. DMT was synthesized in a lab in 1931 by Canadian chemist Richard Helmuth Fredrick Manske, but the psychedelic effects of the pure

*5HT is serotonin, a neurotransmitter or brain chemical that carries signals between brain cells.

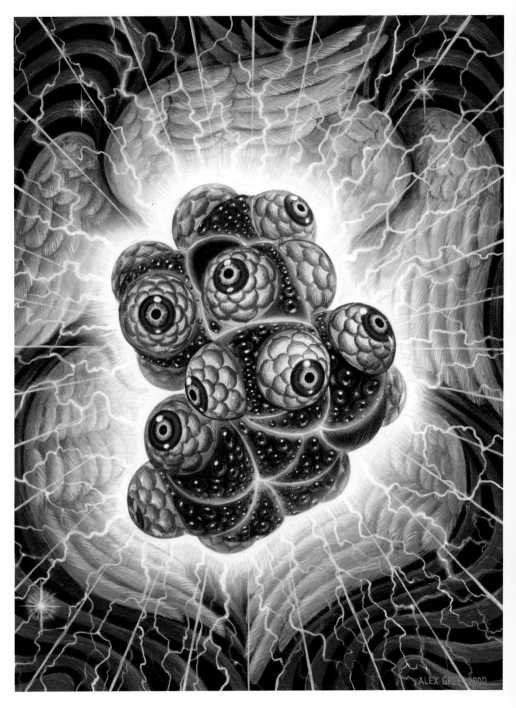

The Spirit Molecule, by Alex Grey

substance were only discovered years later, in 1956, behind the Iron Curtain in Soviet Hungary, when biochemist and psychiatrist Stephen Szára injected himself with the drug in his Budapest laboratory. The first underground chemist on record to have synthesized DMT in the modern industrialized world, and to discover that freebase DMT was psychoactive when smoked, was Nicholas Sand, who was also known for manufacturing large amounts of LSD.

Despite being found naturally in almost all plants and mammals, DMT is classified as a Schedule 1 narcotic in the United States and is illegal to use or possess,* and most people have still never heard of it. Naturally, a substance this powerful frightens many people when they first hear about it, despite its established safety record. In a sensationalized CBS news report exaggerating the dangers of DMT, a reporter says, on finding a DMT lab in North Carolina: "One study of the drug made users feel like they were surrounded by Santa Claus and his elves. That's why I was told it's so important to get this drug off the streets and shut down this cookhouse."[9] The report seems almost comical at first, but interestingly, it points to the entity contact closely associated with the experience.

DMT is quickly broken down and metabolized in the human digestive system by an enzyme called monoamine oxidase (MAO). Amazonian shamans figured out a way to mitigate this process by boiling together a blend of DMT-containing plants, such as *Psychotria viridis*, with plants containing naturally occurring monoamine oxidase inhibitors (MAOI), such as harmaline in *Banisteriopsis caapi*. This brew, known as *ayahuasca,* allows DMT to become orally active and lengthens the duration of the experience, as well as slowing it down.

One can also circumvent the MAO in the digestive system by smoking DMT vapor or by insufflating or injecting the chemical, although MAO in the brain quickly metabolizes it, which is why the experience

*There are two legal exceptions: Two prominent Brazilian ayahuasca religions, União do Vegetal (UDV) and Santo Daime, have secured legal protections for sacramental ayahuasca use in the United States, and ayahuasca contains DMT.

lasts only a few minutes without an MAOI. Pure DMT experiences differ from ayahuasca experiences in that they are extremely intense but of short duration, and ayahuasca experiences are less intense and last for four to six hours.

When pure DMT is vaporized, insufflated, or injected in sufficient quantity, it becomes one of the most potent psychedelic substances known to human beings—generally an order of magnitude more psychologically intense than a strong LSD or psilocybin experience. The incredible experience completely overwhelms one's perceptions, separating one's conscious awareness from the body and the material world, making one unaware of one's physical environment and transporting one to an enchanted realm beyond belief.

This extraordinary realm, often called "hyperspace" by DMT voyagers, appears to exist with a similar consistency as physical reality,

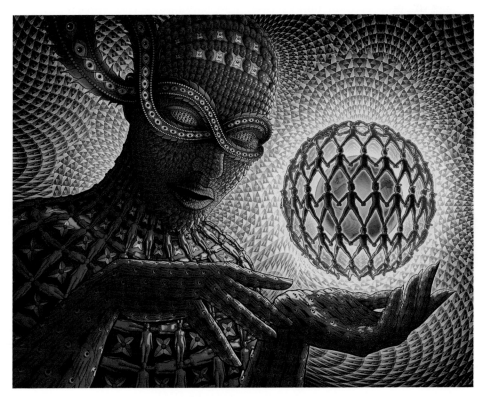

Chaos, the Mother, by Salvia Droid

or a lucid dream, and most amazingly, it is seemingly populated with autonomous entities—swarms of elves, sentient alien biomachines, and a whole ecosystem of strange otherworldly beings. *Hyperspace* here is defined as a space with more than our normal three or four dimensions that can be accessed without a body, or sometimes with a body—but not one's *physical body*.

This magical and terrifying place seems reminiscent of the spirit world of many shamanic and spiritual traditions, as well as numerous mythologies, the fairyland of English and Scottish folklore, and sometimes even the inside of spacecraft laboratories described in alien abduction reports, or some futuristic setting. After ingesting DMT, many people report advanced robotic-insectoid entities, such as the "self-transforming machine elves," performing strange scientific operations or experiments on them, observing or studying them, or communicating important information to them. Most intriguingly, a dialogue with the entities is generally reported, as though the beings were trying to show or teach them something. Sometimes people feel as though they are being rewired or rebooted in some way.

Interestingly, many people report that this hyperdimensional, entity-filled space is somehow strangely familiar, even among those who said that they had no prior experience with DMT or any other psychedelic. According to David W. Lawrence, Alex P. DiBattista, and Christopher Timmerman, who examined thousands of DMT experiences posted to Reddit, they found 227 reports, or slightly more than 20 percent, describing an encounter with an entity with whom the subjects felt they had some sort of prior relationship or bond, and 11.5 percent said this entity felt like "family." Fifty-six of these 227 reports, almost 25 percent, were written by people with no prior experience with DMT or another psychedelic. Twenty-two percent of the participants said the experience felt like "going home," and 25 percent said it felt like returning to a place, space, state, or environment they had visited before.[10]

For example, some of the participants in the study reported the following:

I'm being greeted by these beings, they're not human but they're oddly familiar. I know them as if they are family. They're telling me how happy they are to see me, and that I've found this technology to communicate with them again.

Yesterday, I finally broke through and met a male and female entity in the place where we exist before birth, and after death. I was in complete shock about what happened, it seemed so real, and it honestly felt like a very familiar place. They were welcoming me, and it felt like I was home.

The only time I've done DMT I had the same feeling of being 'home.' The feeling that you've been here before and it's okay that I'm not here because I'll be there again. It's just such a reassuring and comforting feeling. I honestly don't think I've ever felt that sure about anything. It's like I just knew for a fact I'd be back again.

According to DMT researcher Josie Kins, whom I interviewed for this book:

An autonomous entity is the experience of perceived contact with hallucinated beings that appear to be sentient and autonomous in their behaviour. These entities can manifest within both external and internal hallucinations.

Autonomous entities will frequently act as the inhabitants of a perceived independent reality. They most commonly appear alone but can also often be within small or large groups alongside of other entities. While some entities do not seem to be aware of a person's presence, others are often precognizant of a person's appearance into their realm and usually choose to interact with them in various ways. For example, they will often display behaviours such as showing a person around the realm that they inhabit, presenting them with objects, holding spontaneous celebrations of their arrival,

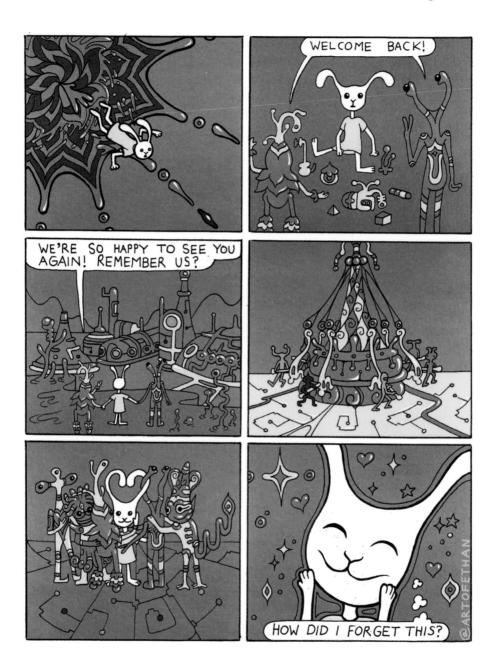

It's not uncommon for the DMT entities to seem familiar and welcoming, as expressed in this comic art: *Bunny's Blast Off,* by Ethan Nichols.

engaging them in conversation, merging into and out of the person's body or consciousness, and attempting to impart knowledge of various kinds.[11]

Although Kins refers to these entities as "hallucinated," many people aren't so sure this is an accurate description, and the question of whether they have an independent existence from our minds remains an open one that we will explore later in this chapter. According to psychologist Rachel Turetzky, who served as a consultant for this book, and who analyzed the bedside notes from Rick Strassman's groundbreaking DMT study (which we will discuss in chapter 2) for her doctoral dissertation:

> Descriptions of these entities ranged from humanoid to nonhuman. Some [DMT study] participants only felt their presence while others visually saw them, some participants experienced only one entity, and some participants experienced multiple entities. . . . Some participants stated that although they did not visually see an entity, they felt a presence. Descriptions of these presences included: humanoid, insect-like, feline, and intelligent colors. . . . Various non-human entities were described, including: insect-like creatures/ presence, feline presence (black panther), alien, and intelligent colors. . . . Human-like/humanoid entities were less commonly experienced. The two entities described in the data were a clown and a humanoid presence.[12]

In Kins's video "The 6 Levels of DMT," she describes these levels of the DMT experience as comprising six categories: subtle, mild, moderate, strong, heavy, and extreme. She adds descriptively named transition phases, where people reach a threshold and "break through" to an alternate reality in which they no longer perceive the familiar material world: "Taking Off," "The Waiting Room," "The Other Side," and "Coming Down."[13]

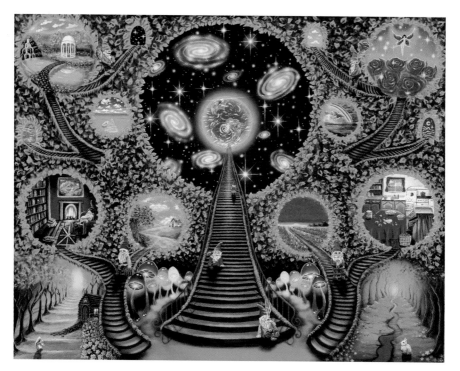

The Fantastical Forest, original acrylic painting by Becca Tindol

I've personally experienced this.* In 1983, after inhaling three deep lungfuls of DMT vapor, I suddenly found myself in a hyperdimensional, supertechnological enclosed space, where I could see in 360 degrees. A giant insectoid, praying mantis–humanoid scientist, with my own face, performed brain surgery on me, and I'm still not sure what to make of this mind-bending, reality-twisting experience that seemed more real than real to me.† I also witnessed impish elves gleefully diving in and out these strange biological machines. My head

*I'm grateful to the late Bruce "Eisner" Ehrlich (1948–2013), author of *Ecstasy: The MDMA Story,* for turning me on to DMT in the living room of his Santa Cruz home. Bruce scraped together the DMT from the bottom of his kitchen drawer and vaporized it in a huge glass pipe with what looked like a mini blowtorch as I fell back on his couch and left my body.

†I have speculated that this being was superimposing my own face onto his as a way of communicating to me what it was like when I experimented on laboratory animals in the neuroscience labs I had been working in at the time.

was spinning with questions when I returned to this world. Are these beings actually real? Do they have an independent existence? Are they conscious? Is their world objectively real, or was this, as Josie Kins believes, all just some magnificent hallucination?

A friend who had a similar experience interacting with some of these beings during a DMT journey described them as "self-transforming, hovering, metallic spheres that were hyper-aware, with slotted surfaces constantly sliding over and under themselves. They also had a metal proboscis, with lasers that revealed themselves to be performing surgery on some bacteria in my brain cells."[14] My files are overflowing with mind-boggling reports like this.

Another friend, Danielle Bohmir, who acted as a consultant on this book, described her DMT entity encounter like this:

Each creature had a sort-of pointed hat, and interchangeable body parts that could be switched with the parts of others. They were all identical in shape and form but had different colored and textured parts. "Souls" or energies could also transfer from one being to another. I could become part of them, and they could become part of me.[15]

Although entity encounters are extremely common in DMT experiences, they can also sometimes happen with other psychedelics. For example, one person told me that on seven grams of magic mushrooms and two hits of LSD, he:

. . . met a box-like object that was set in the center of space and time. It didn't speak but it communicated telepathically. It explained how our thoughts manifest all things into existence. How there is no such thing as time, [and] life is only perceived. Limitations are only limited to what our minds can break through. It was a very long conversation.[16]

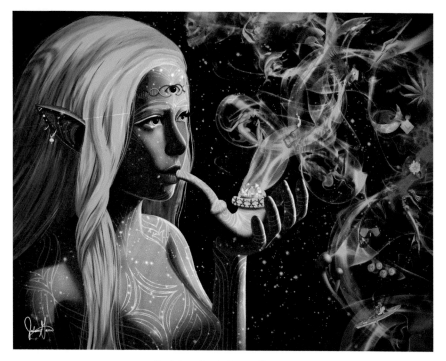

Envision, by Juliana Garces

It seems that these powerful beings can read our thoughts and explore our memories at will, as if we're completely transparent before them. For example, another DMT user told me:

> Another time there was what I can only describe as an alien exploring my brain. It was going through my mind and memories like a child would go through a toy box, and every time it touched something I would get flashes of memories and emotions, but I was seeing it through a wise and loving perspective.[17]

Although people are reporting entity contact on psychedelics now more than ever, it's certainly not a new phenomenon. Many people have claimed to be in contact with non-human entities—such as angels, fairies, extraterrestrials, and so on—throughout history. Religious texts from the world over are a rich source of entity contact reports,

as are reports from occult philosophers. For example, occultist magician Aleister Crowley claimed to be in contact with an advanced entity named Lam in 1918, during his channeled "Amalanthrah Workings." Crowley detailed this contact in his publication *The Equinox*, and he drew a picture of this large-headed being, a reproduction of which appears below.[18]

Writer Graham Hancock describes the DMT entities he encountered as "big-brained robots":

What I remember most of all about them, anyway, was not the appearance but their intelligence—which struck me immediately as utterly different in its emotional temperature from contact with human intelligence. It felt more like being in the presence of big-brained robots than people—robots who probed and tested me for my reactions and adjusted the volume and tone of the data-flow

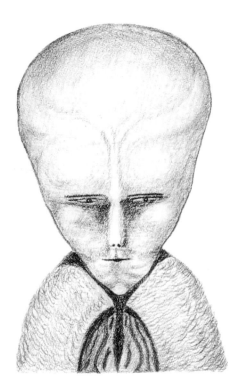

The Way, by Aleister Crowley, depicting Lam, a supposed entity Crowley channeled in 1918 during the Amalanthrah Workings

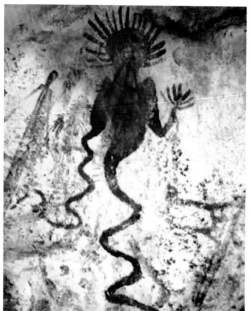

Left: an image created some 36,000 years ago in Spain's Altamira Cave,
probably by Cro-Magnons, that resembles a DMT entity
Right: *Elemental*, by Jordan Fleshman

accordingly. Moreover, their exclusive function seemed to be to show stuff to me—indeed, to put on a show for me—often in a rather entertaining or amusing way, leaping about through six dimensions, and uncovering panels of moving patterns before my eyes with a certain flourish, as though they had pulled off a very clever trick that they were pleased with. I was sure that they had been in the room before I entered it, that they remained in it after I left it, and that they were, in short, part of its basic equipment. Indeed, I imagined the entire interactive ensemble falling instantly into "sleep" mode the moment the DMT ran out and I was hauled back to Channel Normal.[19]

Comedian Shane Mauss had an interesting experience that makes one wonder about the shared reality of these entities. Mauss describes how when he first started smoking DMT:

I was going to these different dimensions, and seeing these different beings, and I kind of thought it was all in my head. It doesn't look like that when you're in the experience, but it's how I rationalized it to myself afterward. I would be talking to these beings that would be seemingly giving me all this information that I could never remember.[20]

So, Mauss then said to the beings, "You need to show me something to prove that you're outside of my head." Mauss then describes having an encounter in the DMT realm with a "dancing purple gypsy woman" at an inner space carnival that he's "known for lifetimes." After five or six more encounters with the purple woman in other DMT experiences, he then describes a strange story in which a friend smoked some

The DMT Realm Map (created with Midjourney)

DMT with him and then reported that a dancing purple gypsy woman at this carnival said that she knew Shane really well. Was this telepathy, psychic resonance, a crazy coincidence, or evidence for the independent reality of the DMT world and the entities there?

The DMT entity phenomenon has entered popular culture through other comedians as well, such as in Joe Rogan's podcasts and Duncan Trussell's comedy routines. Rogan, who has one of the most popular podcasts in the world, is famous (and often parodied in social media memes) for asking his podcast guests, "That's crazy, man. Have you ever done DMT?" In Trevor Moore's hilarious music video "My Computer Just Became Self-Aware," he smokes DMT with his sentient computer and they are transported to hyperspace, where colorful translucent gnomes sing to them: "We're glad you're here. Come and stay a while. You can make shapes and objects with your sounds, transmissions from a smile."[21]

It seems that DMT entities have long been expressed in fairy tales, fantasy fiction, mythology, and pop culture as mischievous, interdimensional masters of time and space, often with pointy ears or antennas on their heads. One immediately thinks of Peter Pan and his fairy friend Tinkerbell. I'm reminded of a cartoon from my childhood in the mid-1960s called *DoDo, the Kid from Outer Space*, who was a "science fiction pixie from a strange atomic race" and seems to have been a DMT elf. Other seeming DMT elves in popular culture include Mister Mxyzptlk, a trickster from the fifth dimension in *Superman* comics; the Great Gazoo from *The Flintstones*, a tiny, green all-powerful alien; and Q from *Star Trek*, a mischievous extradimensional being with immeasurable power over time, space, the laws of physics, and reality itself.

Terence McKenna told me that the late astronomer Carl Sagan—author of the science fiction novel *Contact*, who helped establish the SETI (Search for Extraterrestrial Intelligence) project, and whose idea it was to send the Golden Record aboard the *Voyager 1* probe into deep space as a message to extraterrestrials—visited him in Hawaii once to discuss the DMT entity phenomenon with him. Terence told me that

Sagan was intrigued and asked him, "So this happens every time you smoke DMT?" Terence replied, "Yes."

However, not everyone who has been to hyperspace and met the entities is convinced that they are independently existing beings. For example, James Kent, author of *Psychedelic Information Theory*, said that he's encountered entities during his own experiences with DMT and has had some "rudimentary conversations" with them. However, in his personal experiments, he tried testing whether these beings could reveal any information to him that he himself would be incapable of knowing. He believed that they couldn't. In his essay "The Case against DMT Elves," Kent wrote:

> The times that I did see elves I tried very hard to press them into giving up some non-transient feature that would confirm at least a rudimentary "autonomous existence" beyond my own imagination. Of course, I could not. Whenever I tried to pull any information out of the entities regarding themselves, the data that was given up was always relevant only to me. The elves could not give me any piece of data I did not already know, nor could their existence be sustained under any kind of prolonged scrutiny. Like a dream, once you realize you are dreaming you are actually slipping into wakefulness and the dream fades. So it is with the elves as well. When you try to shine a light of reason on them they dissolve like shadows.[22]

Or consider the following conclusion by Josie Kins. In her essay "Autonomous Entity," she writes:

> While I can personally empathise with the reasons that some people may be drawn into these conclusions [that these experiences are not simply fabrications of the mind but rather beings from another world that exist independently of the human brain] after the often earth-shattering experience of a DMT trip or other high-level psychedelic experience, I do not personally believe that autonomous entities are

anything more than profound but ultimately hallucinated products of the subconscious mind. Instead, I am quite sure that they are simply the psychedelic equivalent of the various characters and beings that most people commonly encounter within their dreams. Although it could be argued that autonomous entities are too characteristically different from that of dream characters to possibly be a result of the same neurological processes, I think that these differences in their appearance and behaviour are largely the result of the many other psychedelic effects that are simultaneously occurring during these encounters. The most notable one is geometry, which causes the hallucination to be comprised of the otherworldly shapes and patterns that provide autonomous entities with their distinctly "hyperspatial" aesthetic. Alongside of this, various other subjective effects such as synaesthesia, machinescapes, recursion, time distortion, and transpersonal states can all potentially synergise into an experience that is easy to misinterpret as something occurring outside of the human mind.[23]

It's tricky territory to be sure, and I'll share excerpts from some of my interviews with DMT researchers about this later in this chapter. As researcher Michael James Winkelman notes:

If we dismiss these experiences as irrelevant hallucinations without substance or meaning, we exclude significant information regarding the nature of the human mind. Yet, if we simply accept the phenomenological experiences of entities as transcendent realities, we commit an error of epistemological naivety.[24]

Martin W. Ball, musician, author, and proponent of the 5-MeO-DMT experience, which he believes is superior to the DMT experience, thinks that the nondual revelation of the 5-MeO-DMT makes the entity contact experience commonly encountered on DMT an illusion. He writes:

Sophia: Goddess of Wisdom, acrylic on canvas by Luke Brown, 2023

When it comes to psychedelics, especially where highly hallucinatory psychedelics are concerned, such as with DMT, many have chosen to adopt what we might call the psychonautical exploratory model when it comes to such ontological questions about the nature of reality. It's quite popular to think of DMT and other psychedelics as providing a methodology for encountering "the Other," as Terence McKenna liked to phrase it. With this model, though specifics vary, the general idea is that psychedelics provide users with access to other realms of reality in "hyperspace, the "spirit world," the "Akashic records," alternate realities, the "multiverse," parallel timelines, past lives, and even alien civilizations and planets. In its simplest formation, this model states: all of this is fundamentally real, and psychedelics, like a spaceship or inter-dimensional portal, provide direct access to these hidden levels of reality and can transcend the limitations of space and time. Though popular, and perhaps pleasing to the modern mind for a variety of reasons, this model is fundamentally incorrect as it is both created by, and filtered through, the ego. Since the ego is itself an illusion, albeit a persistent and sophisticated one, the models the ego creates to account for what it experiences as "other" are also illusory.[25]

While Ball's perspective is interesting, according to his model, all separateness is an illusion because all of reality is filtered through the ego—this would preclude not only any reality for the DMT entities but also any true reality for other people here on Earth. So, while there may be truth to the nondual perspective, I suspect that there is also truth to the dual perspective.

In his book *Psychedelia: An Ancient Culture, A Modern Way of Life*, Patrick Lundborg offers the following speculation on possible psychological influences that play a role in our encounters with psychedelic entities:

Visions of jaguar, snake and wolf can be explained as visualized alarm signals from a primordial animacy detector in a triune brain

overwhelmed by external and internal stimuli. Entities resembling aliens and large insects may be explained as modern Western equivalents to such predators (cf. Ridley Scott's *Alien* or Paul Verhoeven's *Starship Troopers*, both of which portray an insect-reptile alien hybrid as the ultimate human enemy), augmenting the older gallery of threats that put the central nervous system on high alert. Angels, glorious royalties, and dignified "doctors" visualize a readiness for inner healing and harmony, while the wide range of animals and peculiar hybrid creatures reflect a more ambiguous output from neurognostic structures. Other forms of auto-symbolic representation may be explicable in a similar way, yet there remains a large class of iconic entities which is less easy to understand: the machine elfs, pixies, banshees, mushroom children, fairies, or which label one prefers. As evident from the trip reports . . . along with a legion of anecdotal data available in the literature, the 'little people' is one of the most common entity types encountered in Innerspace. They bring with them a set of attributes that recurs with about the same frequency and variance as their appearances, and this combined cluster of Innerspace vision seems much too distinct to fall under the banner of coincidence.[26]

W3LC0M3 H0M3, by Harry Pack

2

...

SCIENTIFIC STUDIES ON DMT ENTITY CONTACT

The first scientific study to report on the DMT entity phenomenon began in 1990, when a portal into new dimensions of the mind and reality opened up at the University of New Mexico after the FDA and DEA granted approval for psychiatric researcher Rick Strassman to study the extraordinary psychoactive effects of DMT in healthy human volunteers. As Strassman describes in his book *DMT: The Spirit Molecule*:

> Even more impressive was the apprehension of human and "alien" figures that seemed to be aware of and interacting with the volunteers. . . .
>
> When reviewing my bedside notes, I continually feel surprise in seeing how many of our volunteers "made contact" with "them," or other beings. At least half did so in one form or another. Research subjects used expressions like "entities," "beings," "aliens," "guides," and "helpers" to describe them. The "life-forms" looked like clowns, reptiles, mantises, bees, spiders, cacti, and stick figures. It is still startling to see my written records of comments like "There were these beings," "I was being led," "They were on me fast." It's as if my mind refuses to accept what's there in black and white.[1]

Strassman's five-year study found that entity encounter was surprisingly common in DMT experiences, and a survey of more than 2,500 DMT users, conducted by researchers at Johns Hopkins University, found that the entity encounter experiences people reported had many similar characteristics. The researchers examined the responses of DMT users who had filled out a questionnaire about their encounter with an entity. When asked about the attributes of the entity, 96 percent of the respondents reported that they believed it was both conscious and intelligent. Seventy-eight percent reported that it was benevolent, 70 percent saw it as sacred, and 54 percent experienced it as having "agency in the world."[2]

A 2021 naturalistic field study found that 94 percent of DMT users had entity encounters,[3] and a 2020 study in Australia, at the University of Sydney, found that entity encounters in mystical experiences can assist in the therapeutic effects of psychedelics.[4] Another study published in 2022 looked at almost 4,000 reports of people in the online DMT community on Reddit, from over a ten-year period. They noted that around half of the reports describe entities of varying qualities and intentions. The most common was an archetypal female entity or goddess, which appeared in 24 percent of the reports; one of the least common was an entity wearing a tuxedo and top hat, which appeared in 0.6 percent of the reports.[5]

EXTENDED-STATE DMT RESEARCH: DMTX

Judging whether these beings actually have an independent reality, separate from our own minds, is very tricky. Some people have tried to devise questions they might ask these entities to reveal whether or not the beings are real beyond the experience, but I haven't heard of any substantial results from this method of inquiry.

Early attempts to start a scientific exploration of psychedelic entity communication began in the 1960s. In those years, the late psychologist Timothy Leary designed an experimental typewriter that used

condensed symbols to allow people to communicate from the DMT state.[6] He also wrote several books with the attempt to establish a science of extraterrestrial psychology. His most comprehensive book on the subject, *Exo-Psychology*, proposed an eight-circuit model of the brain and consciousness that evolved according to the law of octaves, which may hold true all over the universe. According to this model, contact with higher beings in hyperspace occurs in the eighth circuit of consciousness, the part of our brain or mind that accesses levels of reality beyond the body and builds new world models. These beings appear to be the same entities that people encounter while on DMT.

In his book *Reality Switch Technologies,* and in his previous book *Alien Information Theory,* Andrew Gallimore is creating the neuroscience of the future—an exo-neuroscience, so to speak, to complement Leary's exo-psychology—by mapping out the fundamental building blocks for how our brains create worlds and helping to design the technologies that will open up portals to hyperspace and allow us to travel to new dimensions of reality with great precision and sustainability. Focusing specifically on those psychedelics that bring shamanic voyagers into what appear to be parallel dimensions of reality—such as DMT, salvia, ketamine, and the deliriants—this extraordinarily ambitious work aims to solve the mystery of how our brains engineer realities by integrating neurochemistry and pharmacology with psychology, philosophy, and psychedelic trip reports.

Gallimore views the brain as a reality-building machine that has the capacity to "switch channels," allowing us to tune in to alternative realities, and he envisions technologies that will allow us to travel to these new worlds and engage with the beings there for extended periods of time. This may be the most exciting scientific adventure in human history, and this research is now underway.

Other serious inquiries are being made into this intriguing phenomenon. At a four-day symposium at Tyringham Hall in England in 2017, twenty of the world's "psychedelic luminaries" gathered to discuss psychedelic entity encounters and the future of research in this field.

Two extraordinary books of essays, edited by David Luke, resulted from this symposium, and they summarize the leading edge of thought on this phenomenon: *DMT Dialogues: Encounters with the Spirit Molecule* and *DMT Entity Encounters*. In addition, Graham St. John's *Mystery School in Hyperspace* explores the cultural phenomena that has developed around DMT over the past few decades.

The DMT entity contact phenomenon is now being taken seriously by a number of reputable scientists and systematically explored, with scientific studies being done at Imperial College London and elsewhere using extended-state DMT in brave subjects. In these studies, people are kept in the DMT state for longer periods of time to see if more valuable information can be obtained.

Rick Strassman's volunteer "Sara," after one of her high-dose trips, reported: "I went directly into deep space. They knew I was coming back, and they were ready for me. They told me there were many things they could share with us when we learn how to make more extended contact."[7]

To study these mysterious beings further, Andrew Gallimore and Rick Strassman have collaborated to develop a pharmacokinetic model of DMT, as the basis of "a target-controlled intravenous infusion protocol," for extended journeys in DMT space.[8] They and others have begun working with a technology that allows people to stay in the high-dose DMT state—which normally peaks for only a few minutes—for extended periods of time, such as hours, or even longer. Since DMT isn't known to create any tolerance in the brain, theoretically this will allow people to have lengthier periods of contact with beings that may reside in this realm and make real progress with communication.

This extended-state DMT research—"DMTx," as it's called— is currently in progress at a number of different institutions, and I interviewed two of the first subjects in the Imperial College London DMTx study—Carl Hayden Smith and Alexander Beiner—who told me about numerous entity encounters they had on extended-state DMT excursions. At the time of this writing, at least three separate

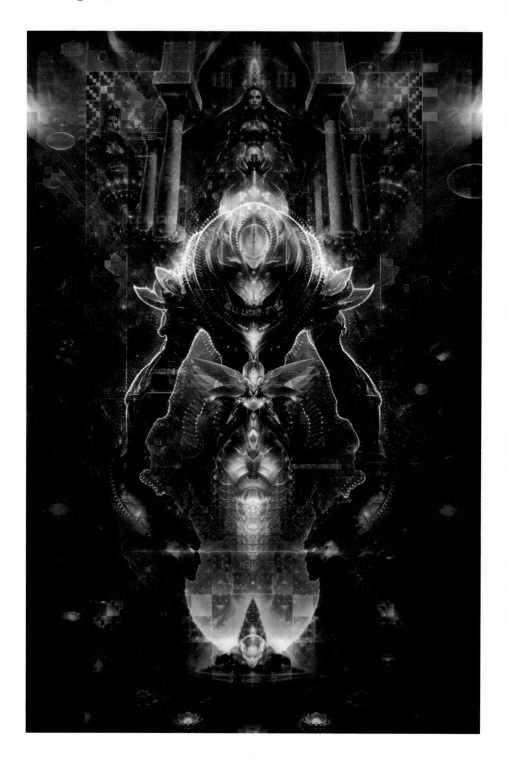

groups are working on a DMTx project at some stage of development. The Medicinal Mindfulness DMTx project, which is located in Boulder, Colorado, and is led by Daniel McQueen, is the least academic of the three but most interested in the entity questions that inspired this book. Imperial College London's Centre for Psychedelic Research completed its first thirty-minute DMTx study, led by Chris Timmermann, in human volunteers in 2022. Then there is Matthias Liechti's group in Basel, Switzerland, which is performing infusions of up to ninety minutes for both clinical and exploratory purposes.

Interestingly, in 1996, after smoking thirty milligrams of DMT, the late psychonaut and author D. M. Turner wrote the following account, which seems like either a precognitive vision of the DMTx research or an early contact experience with an extraterrestrial civilization that was already engaged in DMTx research:

> I loaded my pipe and smoked 30 mg. in three tokes. I entered DMT space and was greeted with the usual pantheon of critters and objects. . . . These elves and other creatures didn't seem to be doing anything of particular interest or meaning, and looking past them I saw some doors from behind which came occasional flashes of bright, colored light. A friend of mine had recently remarked that

Queen Bee and Companion, by Eloh (opposite)
"I have had various encounters with gray aliens, insectoid angels, and lumbering automatons via DMT and ayahuasca. The goal, unbeknownst to me when I began the work, was to bring a number of these familiar characters together into a kind of 10,000-foot view of what an encounter with an entity feels like. *Queen Bee and Companion* is not a depiction of a specific vision. Instead, like all of my other works, it seeks to convey the impression of psychedelic truth through the buildup of visual data, emotional content, narrative entanglement, arcane motifs, and digital effects. I believe that there is an ideal version of each of my works that exists beyond time and it is my responsibility to simply 'show up to work' so that the gestated art-form may push its way into our world."

he thought the DMT elves were primarily there to distract one from entering the deeper aspects of DMT experiences, and that he'd been successful in moving beyond them by willing the elves to let him pass. This was in my mind as I said to the elves "Let Me Through. Let Me Through . . ." I had to repeat this several times with lots of force, even saying it out loud.

Eventually the elves reluctantly let me through, and as I passed through a doorway I was admitted to a vast dimensional space. At this point I seemed to be flying. I was disembodied consciousness, and I scanned this new space to hone in on any beings that might be present. Soon I came across some angel/guardian type beings. I recall there were about seven of them. They looked like blobs of light, somewhat gray in color and sort of egg-shaped. They appeared solid from a distance, but on closer examination I saw that their bodies were made of closely packed fibers. These were connected at the center but apparently could open at any point on the outside of their bodies. They seemed to be part computer, part robot, part flesh/brain matter. But all of these elements were blended into one living whole. When I came into their territory these beings briefly glanced over at me, as if saying "what's all this commotion," then went back to their tasks, seemingly ignoring me. It seemed that they were busy watching over everything that happens in our space-time dimension, and occasionally making minor adjustments to keep everything in line.

Anyway, my thrust of will which had propelled me past the elves and through the door into the guardian's space, continued propelling me out through the back of the guardian's realm and into another time-space dimension. When I first entered this new time-space dimension I encountered its guardian beings. These beings looked similar to, but slightly different than, the guardians from our dimension. There were about 50 to 60 of them, and they reacted very differently to my appearance. These beings were quite surprised to see me, primarily because I had not come from the dimension

that they were guarding, but had come in from the back side of hyperspace. They all huddled together as if in conference, trying to determine if it was OK to let me pass. Eventually they decided, with hesitation, that I could continue on, and I swooped down into a foreign planetary system.

I came to a planet that was highly evolved, both scientifically and technically. The place I entered into was some type of research center, and my attention was focused on some large metallic pods that were being moved in and out of racks by elaborate robotic arms. Each of these pods was something like an isolation chamber. They were shaped like large coffins about eight feet long, although with rounded edges. The oval cross sections were about three feet wide. The beings who used these pods looked exactly like humans. The pods were filled with a foam type material which was connected to the sides of the pod, and also contacted the entire skin surface area of the person inside the pod. The foam was serrated, and I understood that it served as a conductor of food, water, heat, medicines, etc. between the pods' technical systems and the person resting in it. These pods were also cold chambers. They were not for cryogenically freezing a person, but put them into some type of suspended animation. It was soon impressed on me that the whole purpose of these pods and this research center, was that this was the method the people here used to increase the level of DMT in the brains of the pod sleepers. One fortunate enough to be a research subject would go into a pod for weeks or months at a time. The DMT levels in their brain would be significantly increased, and they would spend their time having the most fascinating dreams! This research that was taking place was considered the most serious aspect of this society's evolution.

I entered into the mind of a person inside a pod. It was a woman who appeared to be about 25 years old. As I went into her mind and became aware of all I've described above, she simultaneously became aware of much of my world. This was the first time her society had

ever had contact with an earthling. And it was quite a shock and discovery for her to find out that there were other people who didn't need to go through the elaborate technological process of increasing DMT levels through suspended animation, but simply smoked the stuff and could collect it from any of several plants. It must have been a bit embarrassing for her. Initially I thought that she must have asked her guardians to let her pass into another dimension as I had done. Although on further thought, it seemed that I had come to her dimension on my own power, and was quite possibly invading her space. She may have been a bit taken back by this, as well. Almost instantly she wanted to leave her pod to announce her discovery to the rest of the research team.[9]

Initial studies show that the extended-state DMT research is tolerable, safe, and effective.[10] Remarkably, unlike the other classical psychedelics, the ego remains stable at breakthrough dosage levels of DMT. According to Gallimore:

> Interestingly, whilst ratings of immersion, visual imagery, and entity encounters increased with dosage, ego dissolution remained low at even the highest dose level.
>
> I find this feature of the deep DMT experience particularly intriguing, and Terence McKenna commented on it several times:
>
> "The strange thing about DMT is that it doesn't affect your mind in the ordinary sense. You're not ecstatic or freed of anxiety. You're exactly who you were before this started happening with all your neurosis, fears, doubts . . ."
>
> Unlike with high doses of other psychedelics, such as LSD, the ego seems to be largely spared, whilst all manner of wild imagery unfolds behind the eyelids. As far as I can interpret the results of the team's recent DMT functional imaging study, there's nothing in the data that jumps out and explains this. In prior studies with both LSD and psilocybin, ego dissolution was shown to be correlated

with disruption of the default mode network (DMN) and increased global functional connectivity. Comparable effects on network connectivity were observed in this latest functional imaging study with DMT, so it's not clear to me why the ego appears to remain intact at even the highest dose levels in this extended-state study.[11]

In a discussion panel that Andrew Gallimore and Graham Hancock hosted on May 23, 2023, with four of the subjects from the Imperial College London DMTx trials, one of the subjects, Anton Bilton, described a powerful entity encounter:

And then suddenly I'm surrounded by them. . . . It was like suddenly . . . somebody saying, Are the tigers there yet? And you go, yes, but please be quiet, I don't want them to know because they're all around you. . . .

What I tend to see very regularly is this group of humanoid forms that don't really fit into the Terence McKenna sort of description. They're almost gingerbread men–like. They are distinguishable from each other, but the noses are flat, the eyes don't really open, but somehow they're seeing. There are children and adults and it's a grouping. And you seem to have just arrived at their place, their home, their village, whatever. And I refer back to that comment about being the wounded pigeon. You evaluate yourself because the children look down at you, as do the adults, and then the adults then push the children back and say, Leave it alone. And usually two male adults will come across and they always seem to look at the back of me and I can't work [it] out because I don't have a neck or arms or legs, but my guess is they're looking to see if a cord or a connection has been severed. . . . They're sort of assessing, Has this essence, this soul, this spirit, whatever it might be, this consciousness, has it died and left organic Earth or left the realm of matter and arrived in the realm of light? Or is it just a tourist passing through on DMT or the like? And if, as they see, the cord must be

there, they tend to sit on either side and watch what I'm looking at, almost like guardians or protectors in some strange way. So that's the sort of regular thing that happens.

What swerved with me on this one was I had them and they were very keen to show me these tablets with all this information, and you get a little bit frustrated because you can't download and they're so excited to share and you keep saying, What is it? What does it mean? What does it mean? And they're just grinning at you and you can't grasp it, but it's obviously very important. And then I swerved, which took me up to nine out of ten intensity, and arrived in this very beautiful pastoral environment where there were ten-foot-tall, sort of Dr. Seuss orangutangy, hairy-type entities with their children, with what looked like trees and waterfalls, but weren't. It was beautifully pastoral. It was sort of like one of those Attenborough documentaries when they arrived in a village or at a group of monkeys, and the monkeys or the villages are aware that the cameraman's there, that the tourist is there, but they're not interested, they're just in bliss. And the sort of download I got then was that this was primal being. This is how we should be just being in this existence, in beauty, in nature, connected. Yeah. So that was it for that experience.[12]

The Center for Medicinal Mindfulness has made some extraordinary progress with DMTx exploration. Based in Boulder, Colorado, the center is a psychedelic therapy clinic that, since 2012, has been working with cannabis and ketamine to help people heal trauma, depression, anxiety, grief, and other mental health problems. Since 2022, when Colorado legalized the personal use of natural psychedelics, the center began to include psilocybin and DMT in its work and has started an extended-state DMT "expedition" program, specifically to explore the possibility of entity contact. According Daniel McQueen, cofounder of the center, who is leading the DMTx project:

We started working on this project, not as a research study, but as an expedition, and to break out of the research study model. Our intention is to make these experiences as accessible as possible. We were able to guide seven extended-state DMT sessions just last month. We made contact with the same entities each time. They said that they were made out of the "fabric of existence." We had extended conversations and it was like something out of a sci-fi movie. They taught us how to use the DMTx technology even better on the next expedition, so we can have more efficient and even more productive conversations. The goal is to bring back world-transforming technology. Are they real? Define real. But we treat it as such just in case. Ceremony, prayer, and diplomacy are all part of our protocol, not to mention the medical and safety requirements. I personally consider it an interdimensional collaboration.

I asked McQueen to tell me about the entity contact encounters that his DMTx group has had. He said:

We started with very low doses, because we were figuring things out and wanted to be cautious. The first three or four sessions were pre-threshold experiences. Like they were on this side looking in. After a while, these beings would start to show up and make their presence known. One person described [one of the beings] as insect-like, and another person also said that it was spider-like or insect-like. But more importantly, it wasn't just the entities; it was a presence where they were encountering what they described as the fabric or the substance that created existence, and it was very conscious, very alive, and very personal. It was right there with us. It was like a "we," even though it was also like a "oneness," and they wanted to help us. They were very excited to see us. They appreciated how we were engaging it, by starting light and allowing them to come meet us, as opposed to us beginning with higher doses and pushing into these spaces. Everybody was present for each conversation.

So, one person would go out into the journey and share. Then another person would go, and it was like a continuation of the conversation. They described themselves as if they had a name. This particular person said, "We're called 'Is-ness,' and we're always here. We're always present, even when you don't see us, and we're always here for you." They were like a collective "you"—like humanity or all people. They had a deep appreciation and compassion for us. They also seemed a little distant, because they were so connected to this sacred space of infinite being and oneness. It was like human suffering felt a little distant to them, because suffering is an illusion, and they live in that space where there is no suffering. So, we had these conversations. We just talked to each other, listened, and received guidance on how to live life—specifically, on how to listen to them, so that we can receive support through intuition.

. . . The fourth person to go through the experience was one of our nurses, who was really involved in the technical aspects of the flow rate of the DMT—the infusion, timing, and the tubes. He was just hyperfocused on all of that. When we went into that conversation, we asked them, how are we doing on the protocol and how can we make it better? What do we need to learn about the actual protocol of the infusion? Through that conversation, they actually taught us how to make the protocol and the infusions better. So, it was this uncanny feeling of making contact, like in the movie *Contact* with Jodie Foster, and that book by Carl Sagan, where the aliens sent this transmission on how to make a machine so that they could meet each other. It was like that. They taught us how to make the machine better for future conversations.[12]

DMT ENTITIES, THE ALIEN ABDUCTION PHENOMENON, AND UFO CONTACTEE REPORTS

In *DMT: The Spirit Molecule,* Strassman describes the similarities between DMT entity contact experience and the alien abduction

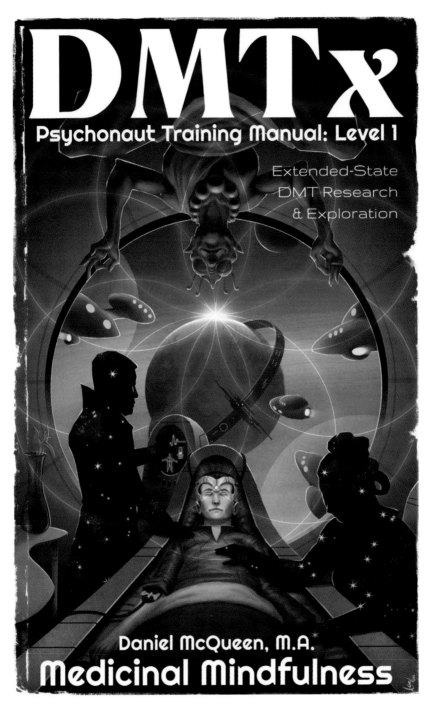

Art by Eliot Alexander and Daniel McQueen

phenomenon. He speculates that the alien abduction phenomenon might be due to rises in endogenous levels of DMT in the brain. He writes:

> In his work with naturally occurring alien encounters, John Mack refers to how often these experiences occur at times of personal crisis, trauma, and loss. Perhaps in these individuals, stress and pain overcome the pineal's ability to prevent excessive DMT release and trigger access to these unusual experiences. In addition, many abductees have a history of these encounters that dates back to childhood. Such individuals may possess especially active DMT-production capacities due to a biological hard-wiring predisposition, possibly combined with chronic or repeated overwhelming stress. We previously discussed how some of the tendencies for excessive DMT formation might manifest using specific enzymes or enzyme inhibitors. Mack also notes that many abductions from people's homes take place in the early morning hours. The pineal gland is most active at this time. Might early morning DMT production open the portals to alien encounters in these predisposed individuals? It's fascinating to note that Mack has recently suggested that "reconnection with spirituality" is at the heart of the abduction phenomenon. Similarly, some of our DMT-induced being contacts . . . demonstrated a transition from surprise and shock at the presence of intelligent beings to a greater depth of spiritual and psychological equilibrium.[13]

When I interviewed John Mack, I asked him about this relationship between the alien abduction phenomenon and psychedelic entity encounters. He said:

> It's very mysterious. I've seen this [connection] too, and it does seem that when some people take psychedelics they may open themselves up to something that seems similar. Terence McKenna talks about taking DMT and then suddenly finding all kinds of alien beings around him. What does this mean? Obviously it didn't cause some-

thing to materialize physically, so it suggests that, in a certain sense, the person has become pro-active in discovering another realm.

Those cases may be experienced quite similarly to the cases where there's actual physical evidence that some material UFO has actually appeared in somebody's backyard, but that doesn't help me with the situation I face. I have cases where a neighbor or the media report a UFO close to somebody's home, or where they were driving their car, and independently the person will tell me about a UFO abduction experience. They don't know that the media has tracked the UFO. So there is a physical dimension to this. And it's that aspect of it that has created so much distress in the Western culture, because we felt we were safely cornered off in our material sanctity.

The idea that some kind of entities, beings, or energies from some other dimension can cross over and find us here, in a way that no missile-defense is going to help, is—I guess—scary to most people. It doesn't scare me particularly. But I guess that's scary if you've been raised with the notion that we're the pre-eminent bosses of the cosmos, and nobody can get us, and all we have to do is create better technologically-controlled atmospheres, astro-domes, and that kind of thing, and no one will ever reach us. I mean, think about what the military's Star Wars project is. The Strategic Defense Initiative is part of that kind of effort that is based upon the belief that somehow technology can make us secure and inviolate from ourselves and the powers and energies of the cosmos.

I've read most of Terence McKenna's books, and I find they're very compatible with what I'm about. But I don't think he quite realizes how robust the abduction phenomenon itself is because his access to it has been so much through psychedelics. I don't think he realizes how powerful these cross-over experiences are in a material sense.[14]

Here's an example of someone reporting an alien encounter experience aboard a spacecraft while on DMT. This is from a short video posted on the band Uninauts' Facebook page, in which a longhaired

guy in a tie-dyed T-shirt was asked, "What's a trippy story you can tell me?":

> Let's talk about higher-dimensional beings. [The] first time I experienced these beings, I was on forty-five milligrams of DMT—N,N-DMT, pure freebase. I took it all in one dose. Instantly I'm hearing the frequencies: booooissshhhhh [onomatopoeia]. I'm beamed out of my body and I'm on a ship, and on this ship there's three beings wearing skin-tight white jumpsuits. What I felt was they were Pleiadian beings, and they told me that they just wanted to run a simple test, and I agreed. She said, "We're going to lay you on this table." She then proceeded to lean over my face with her face. On her eyes she had microscoping cameras. As they scan and get closer to my eyes, I can feel light, and she sat me up and I looked over at the other woman. She's holding up square flash cards. On these flash cards, each has a symbol on them, and the main symbol, seared into my mind from this experience, was the infinity sign. As I looked into this infinity sign, I instantly felt a download of information come into me, showing me that we are infinite beings of light. It completely transformed my entire life. We're all one; we are all the same. There is no separation, it's all an illusion. I am you, you are me, we are we, and we're all here together![15]

According to a poll reported on the History Channel, some 3.7 million people in the United States believe they've experienced an alien abduction.[16] According to other polls reported by NBC News and the *Boston Globe,* 6 percent of Americans believe they have been abducted by aliens.[17] Another survey of 5,986 people in the United States indicated that around 2 percent of Americans have had "abduction-like" experiences. Getting an accurate figure on this isn't easy, but even at the low end of 2 percent, this means that more than six million people have experienced the alien abduction phenomenon.[18] Many of the beings reported in the alien abduction phenomenon have an uncanny resemblance to the beings reported in

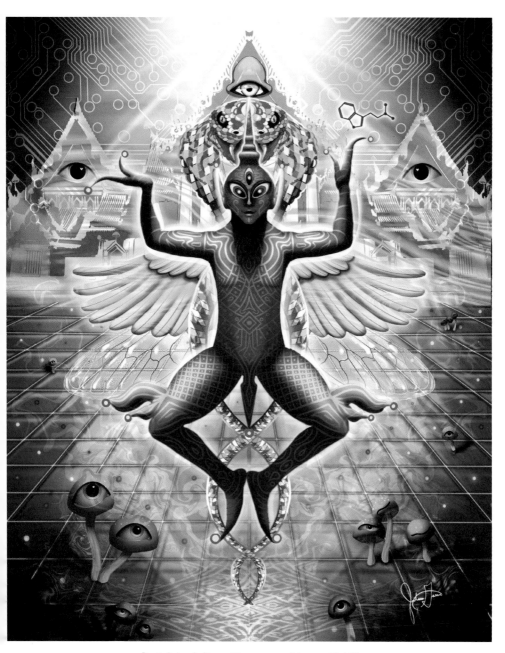

Portal, by Juliana Garces and Jerry Cahill

DMT entity encounters, such as insectoid, reptilian, gray alien, and biomechanical beings.

Then there's the population of people who believe that they've had positive contact experiences with aliens and believe themselves to be aliens:

> There's a new group of people on Earth who believe they're aliens. Star people, or starseeds, are individuals who believe they have come to Earth from other dimensions to help heal the planet and guide humanity into the "golden age"—a period of great happiness, prosperity, and achievement.
>
> It might sound a little crazy but an internet search for the term brings up over 4 million results and there are scores of people posting videos on TikTok, Instagram and Facebook who believe they originate from another world. Indeed, content with the term #starseed has over 1 billion views on TikTok.[19]

As with the alien abduction phenomenon, it seems that perhaps escalations in endogenous DMT may also trigger other entity contact experiences. For example, consider the experience of Scottish comic book writer Grant Morrison in Katmandu in 1994, which, though occurring without the influence of any drugs, seems like a DMT entity encounter:

> Basically, it played out like an alien abduction or a shamanic journey. I was taken out of my body, peeled off the surface of the four-dimensional universe of space-time, and taken somewhere else. I found myself in a huge, azure blue vault that felt infinite and enclosed at the same time, like a vaulted cathedral inhabited by morphing quicksilver blobs of intelligence. Somehow, I was one of them, or at least I was part of a gestalt of minds that represented "one" of them. It was explained to me that I was in a higher mathematical space, where conventional time and space were simply directions, like up and down are in 4-D. From this vantage point, I

could see from the Big Bang to the end of the universe, and it was all happening at the same instant. Shakespeare was working next to the dinosaurs, separated only by a fold or wrinkle in the surface of space-time. Cosmologists might call what I witnessed "the bulk," which is conceptualized as a kind of higher-dimensional medium where universes like our own inflate and grow. Only in time do things grow, so they had to "make" time, that is, they had to build universes, like window boxes or incubators, where they could grow their young to maturity before setting them free from the box of time into timeless existence.[20]

Sara Phinn Huntley

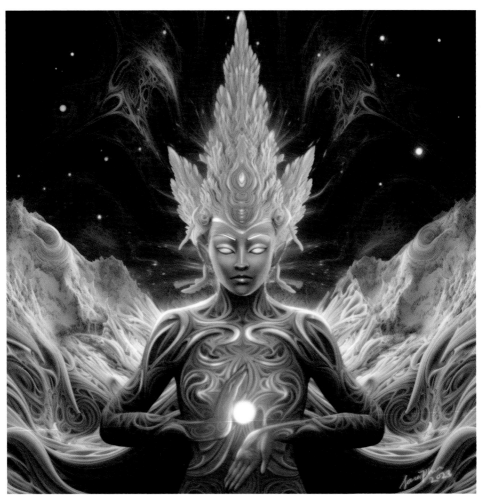

The late neuroscientist John C. Lilly reported having alien contact experiences with ketamine in an isolation tank (we'll discuss them later in the book). John Nash, the Nobel Prize–winning American mathematician and economist who did critical work on game theory in the 1940s and '50s and gave us the Nash equilibrium, believed that he had been recruited by aliens to save the world. Nash believed that the aliens were assisting him by sending him mathematical equations, and that they later acted to end his career. When he was asked how he could believe in such an outlandish scenario, Nash replied, "Because the ideas I had about supernatural beings came to me the same way that my mathematical ideas did. So I took them seriously."[21]

Despite Nash's brilliance in the field of mathematics, he suffered from schizophrenia, which Strassman and others have speculated may have been due to excessive amounts of DMT in his brain. In a study published in 1976, endogenous DMT levels were measured in the urine of psychiatric patients. DMT was detected in the urine of 47 percent of those diagnosed by their psychiatrists as schizophrenic, and in 38 percent of those with other forms of psychosis.[22]

ALIEN TECHNOLOGY & GOVERNMENT COVERUPS

As we explore in this book, there are striking resemblances between reported cases of alien abductions, UFO contact experiences, fairy sightings, and daimons, djinn, elementals, and DMT entity encounters. Are all these phenomena related? Are unidentified aerial phenomena (UAP) sightings actually aliens from another star system and related to these other phenomena? How all of these experiences are connected remains a deep mystery, but it's certainly interesting that they all seem to be happening together during the same period in human history.

In my research for this book, I immersed myself in dozens of books on all these subjects. In addition to all the alien abduction and UFO contactee literature, I also read through reports of recoveries of crashed extraterrestrial spacecrafts supposedly in secret possession by the

U.S. and other world governments, and their alleged alien technology reverse-engineering programs.

For example, we have physicist Bob Lazar's reports of a supposed alien technology that he worked on at Area 51 in Nevada,[23] as well as numerous reports of recovered alien spacecraft from Roswell, New Mexico.[24] Then there are Steven Greer's Disclosure Project and Richard Dolan's meticulously researched two-volume UFOs and the National Security State. Greer and Dolan believe that there has been an enormous black-box program of alien technology going on for many decades. During the time I was writing this book, former high-ranking U.S. intelligence officer David Grusch also reported that there are hidden alien spacecrafts,[25] and the U.S House of Representatives held a hearing on these claims.[26]

Additionally, mainstream news outlets are now taking claims of UFO and alien encounters seriously, with reports that years ago would appear only in sensationalist tabloids like the *Weekly World News*. For example, in 2023, many mainstream news stations broadcast reports of a UFO crash-landing in a Nevada backyard, carrying tall, big-eyed alien beings.[27] There's certainly lots of high weirdness going on with aliens these days, so it's especially interesting that people are also reporting contact with alien beings on psychedelics, and that this all coincides with the rise in artificial intelligence and the concurrent debate over whether digital minds can be sentient.

In my research for this book, it was hard to believe how many credible reports of alien contact have been known and kept from the public. There are so many reliable sources backing up these claims of not only countless verified UFO sightings but also of recovered alien technology. It all started to seem like the only possible explanation was that there had to be something to this. The details are far beyond the scope of this book, but if anyone is interested, just follow the reports I referenced in the preceding paragraphs.

One can only wonder, with all of this information finally coming to the mainstream media's attention, are we witnessing the end of

human-dominated history? It seems that beings from the dimension of hyperspace have long had the ability to cross over into our dimension and study us, and while we have long had the ability to catch glimpses of their reality, we're only just now, developing the technology to reliably cross over into their dimension as well.

Perhaps intelligent entities are coming to our world from many different directions? In *The Cryptoterrestrials*, author Mac Tonnies suggests that UFOs and aliens may originate from hidden domains on Earth, rather than from across interstellar space, or possibly from other dimensions, and he acknowledges the compelling similarities between UFOs, alien abductions, and DMT entity reports:

> Unable to disprove a negative, I have no choice but to concede that some UFO encounters may originate from space. And it would be the height of arrogance to proclaim that the Extraterrestrial Hypothesis and the Cryptoterrestrial Hypothesis are mutually exclusive. And of course, cryptoterrestrials don't preclude "interdimensional" travelers either. We could be experiencing a veritable pageant of entities hailing from many locations, both within our known universe and from universes linked to ours. Candidates for the latter possibility include the insect-like creatures described by "trippers" who take Dimethyltryptamine, otherwise known as DMT (the alleged "spirit molecule"). The consistency of DMT experiences invites the possibility that it literally allows access to another reality.
>
> I'm reminded of an off-hand reference to white, mantis-like entities offered by Philip K. Dick years before the popularization of the archetypical bug-eyed "Gray." Could Dick, via his experimentation with psychedelic drugs, have happened across the domain of beings similar to those described by abductees?
>
> These questions beg for a taxonomy of the other-worldly. While many UFO abductions involve insect-like creatures, it's unclear if the "Grays" are directly related to the beings encountered in the psychedelic realm. Confusingly, many "abduction" accounts fea-

ture mantis-like "leaders" operating in liaison with more human-like Grays; some reports suggest the Grays are a subservient species, perhaps even genetically engineered drones. The ever-controversial Whitley Strieber has described inert alien bodies coming to life, likening them to "diving suits" used for dealing directly in the material world.[28]

3
∎∎∎
CATALOGING THE
ENTITIES

As Mac Tonnies states above, "These questions beg for a taxonomy of the other-worldly." This field guide is an ambitious attempt to begin that process. The book you now hold in your hands describes and illustrates twenty-five of the entities most commonly encountered in DMT hyperspace, as well as in experiences with related psychedelics, such as LSD, psilocybin, mescaline, ketamine, Salvia divinorum, and ayahuasca. These entity categorizations were gathered from scientific reports, online anecdotes, surveys, interviews, friends, and my own personal experience.

However, not all entity encounters fit neatly into the twenty-five categories that we based this book upon. For example, one person described encountering an entity made entirely of plant seeds:

> The next entity I met was when I asked for advice before I partook in my session. This time I met a being that was made completely out of seeds; its eyebrows were sunflower seeds. Its eyes were walnuts. Its skin was tiny flower seeds, such as poppy and other tiny round cream-colored ones. Flowers bloomed out of the top of its head, and suddenly I was on a roller-coaster that took me to a large greenhouse where plants were on display. It led me to the bags of seeds on a shelf, and it turned out my bird feeder was empty.[1]

The Artist, by Ethan Nichols

Someone else described their DMT entity encounter like this:

The most memorable entity I've perceived was a moving line of square glowing blocks. Pretty much like the Snake video game, except more colorful. We had the most mind-bogglingly rapid conversation I've ever experienced.[2]

When I interviewed author Alexander Beiner to learn more about his extended-state DMT sessions, he told me about the following experience:

I had an encounter with what I call a hyperdimensional peacock. It was really birdlike. There was a moment where there was a throng of activity, and a throng of entities, I suppose. It was kind of hard to distinguish. And then from that throng, this peacock emerged, and we made contact. It had winglike appendages, but [it] extended a human hand and we shook hands. Then I got really excited, and I started asking lots of questions, in rapid fire, like "Where are you when I'm not here?" It got really offended and then squawked and disappeared. I felt like I'd been too forward, and I was a bit disappointed because it was quite exciting, and it was a contact moment.

Then there was my final dosing. . . . In this one, when I broke through, I was in just a huge, incredibly densely populated ecosystem of entities. It was really mind-blowing, and pretty soon into that, I encountered these very friendly, very excitable, very colorful entities. They looked a bit like chinchillas, and they had that kind of energy. And this was very McKenna-ish actually. They were speaking a visible language of symbols, like moving hieroglyphs. I had zero comprehension of what they were trying to say. There was no feeling attached to it. There was no sense of, oh, there's a bit of body language or a sense of an emotional intent. It was just that I could feel their excitement, and I was excited, but I could not understand the symbols. Then I started making my own symbols by imagining them and trying to mimic what they were doing.

Then symbols appeared between us, and they got really excited, and [they] were jumping in and out of my body. Then they opened this portal out of this very amazing space I was in, and it felt like they were inviting me into it. But I consciously decided I didn't want to do that. There's also this exchange, this attempt at communication. They had low attention spans, and they got quite bored when they couldn't understand my symbols, and I couldn't understand theirs. They sort of became bored. Then they opened this portal. . . . [But] I was like, "No, thank you very much, but I'm going to stay here." And they were pretty relaxed about that.

Then I encountered this large squid-like entity that just really didn't care that I was there. That was really important, though, because what happened is that I started to wonder about the difference between the two entities being so pronounced, and they happened right back-to-back. Because it was such an intense experience, I started to see everything melding together. My first thought was, is this the same entity? And then when I realized, no, this is a different entity, then I had the thought that they're all in an ecosystem of intelligences, and that really blew open that whole dosing. That became a really meaningful aspect of all of the DMTx experience for me because I had a very intense overview effect. The "teaching presence" of the DMT then started saying, "Yes, that's exactly what's going on here. This is an ecosystem. They're all in their own individual niche, humans are here too, and it's unbelievably densely populated. There's so many, and this is just the tiniest fragment of what's out there."[3]

Despite unusual reports of seemingly unique entities, there is also enormous overlap and a startling consistency among the entities that have been reported in the many thousands of documented psychedelic entity encounters. Numerous classification systems of the DMT entities have already been devised as psychonauts grapple with how to communicate their psychedelic entity encounters. For example, the DMT-Nexus Wiki website offers the following entity classifications:

Archangels

Dark entities

Jesters

Light Beings

The Logos

Machine Elves

Machine Elves' Queen

Mother Goddess

Tapestries

Circus Ringleaders

Flirty Fairies

Geniuses or Genii

Morphos

Plant and object devas

Aliens

Elementals

Gods and goddesses

Dream wizards

Local aliens

Angels

Other awakened humans

Ghosts

Ascended masters and Buddhas

Spirits

Lesser beings

Guide

Dream teacher

Director

Conductor

Tormentor

Human spirits

Straw men

Faceless goons

Theatre troupe

Strange visitors

Succubus twins

Imps

Cosmic horrors

Bride of the Devil

Triad

Legion

High priestess

Botanical nightmare creature

Mythological creatures and demigods

Talking heads

Soul surgeons

The source

World eaters[4]

Despite this wide variety of reports, many entity encounters bear an uncanny resemblance to one another in many respects, and to the reports in the alien abduction/UFO contact literature as well.

In the vibrant paintings of ayahuasca experiences created by the late Peruvian artist Pablo Amaringo, UFOs or flying saucers are often embedded in the artwork. My friend Gabriel PropAnon Kennedy asked him about this: "I met and spoke with Pablo Amaringo in his studio

Re-creation of hyperdimensional chinchilla-like creatures from Alexander Beiner's DMTx experience, by Alexander Beiner (created with Midjourney)

in Peru. I asked him about aliens and UFOs. I asked him why there were so many featured in his work and what he thought about them. Through a translator he told me, 'They take some of us. We take some of them.'[5] Amaringo illustrates the meta-cultural connection between extraterrestrials and DMT entities.

Below, a UFO contactee describes experiences that have occurred throughout his life, although they sound like they could be a DMT research subject:

And the beings! I have seen beings of light that looked like angels, serpent like entities, reptilians perhaps unforgettable, strange,

Left: *Actual Contact*, paintings of entities encountered on DMT
by Jason W. A. Tucker. Right: Entities encountered and depicted by Jason W. A. Tucker
on pillars at the Burning Man Festival and in Marfa, Texas.
"Through art I have symbolized my psychedelic religious experience . . .
from painting the original sigils to placing them on steel pillars and aligning
them to the sun. The whole process for me has been a discovery of the
primordial archetypes and my initiation into the ancient mysteries."

terrifying . . . yet beautiful. I received telepathic messages from them telling me to write and sing and that they loved me. Even to this day some sort of connection still exists.[6]

A 2022 study, published in *Scientific Reports*, found that entity encounters were reported in 45.5 percent of cases of DMT experiences—fewer than in the studies I mentioned earlier, but still a substantial amount.[7] The encounters reported here involved predominantly a feminine archetype, as well as "deities," "aliens," "creature-based entities (including reptilian and insectoid beings)," "mythological beings (including machine elves)," and "jesters." These beings were said to communicate with the subjects using gestures, secret languages, and, most commonly, telepathy. Visionary artist Allyson Grey paints this strange "secret language" of symbols, similar to what many people report seeing during DMT journeys, in her artwork,[8] and Diana Slattery explores the

Baphomet: A DMT trip with Tibetan Buddhist Deities and Dakinis,
by Jason Louv

reports of alien languages encountered during psychedelic experiences in depth in her book *Xenolinguistics: Psychedelics, Language, and the Evolution of Consciousness.*

Some people idealize communications with these entities, interpreting them as deities or angels delivering divine wisdom, but caution is advised here. I suggest approaching these entities with the same degree of suspicion that would be wise to use when meeting any stranger. Trust builds over time and with experience, whether on our world or in theirs,

so it seems like a good idea to take whatever the entities communicate to us with a grain of salt.

In an article on the Reality Sandwich platform titled "Guide to Machine Elves and Other DMT Entities," the author reports:

> As to the nature of these interactions, many trip reports mention machine elves are loving, playful, and benevolent guiding forces, capable of imparting valuable insights. Sometimes they're indifferent to visitors, playful in a trickster-esque way, and even actively hostile. With respect to the latter, sometimes the intent seems malicious and tormenting, and for others, it amounts to the imparting of hard lessons. This includes being criticized, having mistakes analyzed, and told how to improve as a person.[9]

Complementary Mandala, by Allyson Grey

So how does one create a workable system for classifying these beings? In her book *Soul Transcendence, Journeys to Other Dimensions*, DMT research subject Susan Blumenthal writes: "In a field guide to deep space DMT entities there would be three classifications: Reptilian, insectoid and geometric."[10]

Interestingly, in his book on alien abductions and the "human-alien hybrid breeding program," titled *Walking Among Us: The Alien Plan to*

Cortical Traveling Wave, by Glass Crane
"This is a depiction of an entity I met in DMT space, who, at that moment, appeared to be responsible for taking the data from my consciousness and compressing it in order to transfer it from my body into their realm. He seemed relatively autonomous, but not completely without emotion. It was as though he was a bit weary from processing so much data that day. Nevertheless, he was friendly and helpful, as well as a bit curious, as he looked over and experienced the data."

Control Humanity, David M. Jacobs writes about some far-out speculations that describe similar categories:

> Although aliens and hybrids . . . share core characteristics, they are not all alike. In my previous books, I described "tall, insect-like beings," "reptilian-like beings," and "gray aliens." As a result of my ongoing research—and at the risk of confusion—I have revised this nomenclature and classification, labeling insect-like beings "insectalins," reptilian-like beings "reptalins," and gray aliens simply "grays." I have also refined the alien/hybrid taxonomy. . . . All hybrids are still aliens. . . .

DMT Goddess, by Sara Phinn Huntley

I have also rethought the aliens' origins based on their physical appearance and activities. My new hypothesis is that the insectalins are either the "original" aliens, or the least hybridized. Their morphology is the least humanoid and therefore the most alien. I contend, therefore, that they hybridized all the other aliens onboard a UFO, with the possible exception of the reptalins. In the process of hybridization, I include cloning, especially for grays. The evidence for this may be slim, but the inclusion answers questions that have heretofore been inexplicable. With the possible exception of the insectalins and reptalins, all other aliens onboard are hybrids.[11]

Psychologist Jennifer A. Lyke of Stockton University compiled a sample of 149 trip reports from Erowid.com and used this sample to categorize the nature of interactions with DMT entities. She found 180 total entity experiences reported out of 149 reports, and 75 percent of the reports included a description of at least one entity. Lyke classified these interactions as follows, with the relative frequency in parentheses:

Showing/teaching/guiding (25%)
No interaction (10%)
Hostile (10%)
Warm or loving (9%)
Welcoming (9%)
Reassuring or encouraging (8%)
Neutral or observational (7%)
Playful (4%)
Exercising power or control (3%)
Sexual (3%)
Questioning (3%)
Unclear interactions (3%)
Reminding (2%)
Miscellaneous (2%)

Lyke also analyzed the types of entities reported in the DMT realm, and she categorized the entities (with their frequency) as follows:

Poorly defined or formless beings (29%)
Humanoid beings (22%)
Divine beings (10%)
Aliens (8%)
Elves and fairies (7%)
Animals (6%)
Geometric objects or machines (6%)
Voices (4%)
Faces (4%)
Miscellaneous entities (3%)[12]

How common is the entity encounter experience with other psychedelic drugs and plants? Not as frequent, but enough to certainly be compelling. See the chart on facing page 63, from a study by David Luke and colleagues, that breaks down the frequency of reported entity encounters with different psychedelic substances.[13]

Cultural expectations seem to play an important role. Terence McKenna's compelling descriptions of "self-transforming machine elves" probably influenced many people's expectations. Many people report seeing Hindu deities, biblical figures, angels, or demons that correspond to cultural expectations. It's very hard to know whether these beings have an independent, self-aware existence, in a free-standing hyperspace, or whether they are projections of our own mind, or some weird combination of these two, or something else entirely. Carl Jung's notion of archetypes and the collective unconscious—a hypothesized metacultural mental space that all human beings share and that may be the source for some of the common features in dreams and myths around the world—may be one possible explanation.

Neuroscience research has provided us with the results of magnetic resonance imaging (MRI) techniques, that, while fascinating

The Percentage of Respondents Reporting Encounters with Different Substances *at Least Once*

Psychoactive Tryptamines				Other Psychoactive Plants				Synthetic	
LSD	Psilocybe mushrooms	DMT	Ayahuasca	Cannabis	Salvia divinorum	Mescaline	Iboga	Ketamine	MDMA
N=124	N=122	N=80	N=60	N=144	N=77	N=55	N=14	N=48	N=118
Mythic 12%	Plant 30%	Mythic 31%	Plant 37%	Animal 5%	Plant 9%	Plant 9%	Plant 36%	Mythic 6%	Mythic 3%
Plant 11%	Mythic 20%	Plant 17.5%	Mythic 35%	Vision 4%	Mythic 6%	Animal 5%	Vision 14%	Hybrid 4%	Animal 3%
Animal 10%	Animal 13%	Animal 16%	Animal 27%	Mythic 2%	Animal 4%	Mythic 5%	Mythic 14%	Animal 4%	Plant 3%
Transf 10%	Hybrids 6%	Hybrid 11%	Transf 27%	Plant 2%	Transf 5%	Transf 5%	Hybrid 7%	Plant 4%	Vision 2%
Vision 7%	Transf 7%	Transf 10%	Hybrid 7%	Hybrid 1%	Hybrid 3%	Hybrid 2%	Animal 7%	Transf 2%	Hybrid 2%
Hybrid 3%	Vision 4%	Vision 7.5%	Vision 7%	Transf 1%	Vision 1%	Vision 2%	Transf 7%	Vision 2%	Transf 1%

Source: David Luke. **Mythic**—fairies, gnomes, elves, elementals, and nature spirits; **Hybrids**—half human and half animal such as mermaids and centaurs; **Plant**—plant/fungus spirit encounters, intelligences, or communication; **Animal**—animal spirit encounters, communication or guides; **Transf**—transformations into a plant or an animal; **Vision**—visions of natural disasters such as fire, deluge, earthquake, global warming, etc.

and important, seem to offer little clue as to what these entities are. On a neurological level, DMT seems to affect the brain similarly to psilocybin and the other classic psychedelics. It binds to serotonin 2A receptors, disrupts the default mode network, increases communication between brain networks that normally do not communicate directly, and generally produces a more fluid and complex cortical state.[14] Why this produces entity contact experiences, no one knows.

Could psychedelic entities be related to the characters we meet in our dreams or lucid dreams? In my own lucid dreams, I've met beings or "people" who made me question the reality of my experience and whether or not they were fabricated by my own brain, and these experiences seem similar to what I've experienced with DMT and other psychedelics in how real they sometimes seem. There have been five primary types of dream characters that I've experienced.

Although the beings in my dreams all had mostly human appearances, they (1) sometimes seemed liked mindless puppets, (2) sometimes had complex personalities, and (3) other times seemed like wise and magical beings. Other times I've wondered if the characters in my dreams

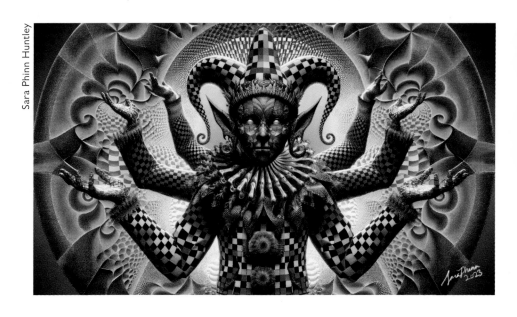

Sara Phinn Huntley

might (4) sometimes be other human dreamers that I'm psychically sharing a transpersonal dream space with, or perhaps "gray aliens" in nonlucid dreams. One time, in a fully lucid dream, I encountered (5) a superbeing that was able to completely overpower me, similar to the DMT beings in this respect.

It sometimes seems to me that this "place" where lucid dreaming occurs is an independently existing alternative reality—or realities—where people live their day-to-day lives, perhaps akin to hyperspace in the DMT realm, or the realms experienced in other out-of-body states, such as the astral plane of occult lore or the states of consciousness reached with ketamine, methoxetamine (MXE), or *Salvia divinorum*. A number of cultures and spiritual traditions believe there are other entities, spirits, or demons that exist in the dream realm and can interact with us during our dreams, and Rick Strassman and others have speculated that DMT might be released in our brain when we dream.

DO DMT ENTITIES HAVE AN INDEPENDENT EXISTENCE?

This is perhaps the biggest mystery facing us when people report entity contact, communications, and dialogues in the DMT state. Do these entities have an independent existence outside our minds? I've personally come to suspect that the entities don't exist outside our minds, but that our minds extend far beyond our brains, into transpersonal domains. I discussed the DMT entity phenomenon, and my questions about them, with DMT researchers Rick Strassman, David Luke, Andrew Gallimore, Josie Kins, and Daniel McQueen, as well as DMTx subjects Carl Hayden Smith and Alexander Beiner, and will share some of their responses below.

In his book *The Bigger Picture*, Alexander Beiner states the following:

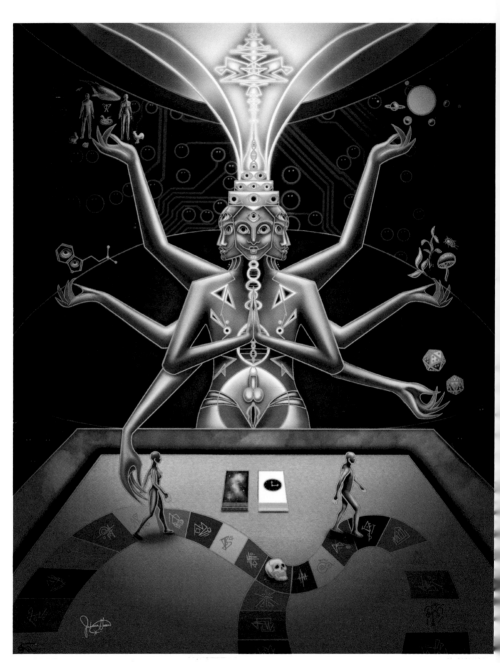

The Infinite Self Plays the Game, by Juliana Garces

The question of whether the entities people encounter on DMT are "real" is a fascinating one, with significant philosophical implications. This is known as their ontological status. Ontology is the philosophy of what exists, and the nature of being. Strassman argued that the "realness" of entities is inherently unknowable. Likewise, David Luke, a parapsychologist and one of the world's foremost DMT researchers, made a similar point when we discussed the matter. He told me that even if you were to, for example, go into a DMT experience with a complicated math equation you didn't know the answer to (which some have tried) and try to get help solving it, you wouldn't prove anything. Even if you came out with an answer, there are too many variables. Perhaps you received it from some part of your own mind. Perhaps a spirit told you. Perhaps it was telepathically sent to you from a mathematician across the globe.[15]

When I asked Rick Strassman whether he thought that the entities people encounter on DMT have a genuine independent existence, he replied:

> I myself think so. My colleagues think I've gone woolly-brained over this, but I think it's as good a working hypothesis as any other. I tried all other hypotheses with our volunteers, and with myself—the "this is your brain on drugs" model; the Freudian "this is your unconscious playing out repressed wishes and fears"; the Jungian "these are archetypal images symbolizing your unmet potential"; the "this is a dream"; et cetera.
>
> Volunteers had powerful objections to all of these explanatory models—and they were a very sophisticated group of volunteers, with decades of psychotherapy, spiritual practice, and previous psychedelic experiences.
>
> I tried a thought-experiment, asking myself, "What if these were real worlds, and real entities? Where would they reside, and why would they care to interact with us?" This led me to some interesting

speculations about parallel universes, dark matter, et cetera. [Just] because we can't prove these ideas right now (lacking the proper technology) doesn't mean they should be dismissed out of hand as incorrect.[16]

When I asked this same question to psychologist David Luke, who is involved in the Imperial College London DMT study, he replied:

> I try not to have any strong beliefs about anything particularly. I attempt to be agnostic, and to be honest with you, my opinions, or my leanings, change day-by-day.
>
> I guess the longer I am away from a DMT experience, the more I lean toward a straightforward psychological and neurological explanation. But, I think, the closer in proximity you are to having had one of those encounter experiences, probably the more likely you are to take it at face value and believe it to be what it says on the tin, i.e. spirits, spirits of the dead, angels, demons, deities, elves, or whatever they might be.
>
> So, I don't know. I've been on a long journey exploring this, and I don't think the neuroscientific, psychological angle is currently sufficient to explain these experiences. But at the same time, it's a bit of a metaphysical paradox and conundrum trying to get to the actual bottom of the nature of these beings people encounter. They certainly feel real—so much so that they can convert more than half of all atheists into nonatheists in the space of ten minutes. But as to their actual ultimate reality, I'd like to try and remain agnostic.[17]

I also asked this question to neuroscientist Andrew Gallimore, who is involved in the Imperial College DMT study as well. He replied:

> I've never made an assumption on what I think these things are. I've always approached these entities without the assumption

that they're hallucinations, and always with the assumption that they're actually conscious and real. The reason for this is because I think if you approach them assuming that they're not real, then that kind of bias can influence the information that you can get from them.

I think that the question of the reality of these beings is a really complex one. It's one I've written about, spoken about, and lectured about, quite extensively, because it's the perennial question—not just the DMT entities, but the DMT state itself. Is it real? And the problem I think is partly with defining what we mean by real. I think most people fail to do that properly, or fail to formulate that question properly.

So, I've always tried to answer that question much more specifically, and say, okay, let's try to answer a perhaps smaller question, within that larger question of the reality of these things. So, for example, I've thought about how if these entities are real, then what do we mean by that? Well, in my opinion, a being is real if it has subjective consciousness. If something exists from its own side, and has its own perspective, then it is real. It is just as real as we are.

Descartes famously showed that we could deny everything apart from our own mind. If these entities have subjective consciousness, then they are equally unable to deny their own existence, as we are unable to deny our existence—which, in my opinion, makes them real, completely real, really real.

So, do I think these entities have subjective consciousness? I go with the assumption that they do. They seem to have it, but how would one test that formally? I'm not sure. These are the sorts of questions that I'm really interested in answering, and how we might approach these beings there. I think there's something quite impertinent about going into the DMT space and trying to test these entities for their ontological status, so to speak. So that's one approach, to think about the entities.[18]

When I asked this question to Beiner, he replied:

Yeah, I do think that. It's also a little bit my sense that there's more complexity, because I think there is also an element of my own projection into their form that they take, so there is a melding of my projection and that they are independent. I think the interaction with them is a kind of synergy between my consciousness and theirs in some way. So, it's not black and white, and it's not the kind of separation that we might experience between like me and you—although, to be fair, we project on people. We project on each other all the time, so perhaps that's not the case. But overall, my sense is that—or well, my belief at least—is that they are independent of my perception of them, but somehow there is some kind of relatedness between our consciousness and their consciousness. So, that's kind of where I've landed on it so far.[19]

When I asked this question to Carl Hayden Smith, who was, like Beiner, a participant in the Imperial College London DMTx study, he said:

I'm as convinced as I can ever be, particularly because of that first experience of having an intravenous injection of DMT inside an fMRI scanner. The effect the scanner had on the interaction with the DMT entities was remarkable because it amplified their benevolence a hundredfold. Being propelled into a form of "dialogos" with these entities that was telepathic and visual at the same time was something that was so embodied that I will never be able to forget it. This experience more than any other appeared to demonstrate that they have some sort of independent and continuous existence.

However, I think that the problem with using too much DMT is that you are welcomed back less and less, you are crying wolf, too often. DMTx allows you to stay inside the experience, but I suspect

you are not meant to stay there. It's like the guides are saying to you, "Not you again. It's not your time."

Someone actually dying and having what we suspect is an endogenous DMT experience versus those having a self-induced DMT experience could potentially be causing more and more potential tension in (hyper)space. I think that there's a lot of traffic already and DMTx may only be adding to that traffic.[20]

Daniel McQueen, who is leading the DMTx project at the Center for Medicinal Mindfulness in Colorado, told me that he believes "there is a non-zero chance that they are very real, that we are actually engaging an advanced civilization, and because of that I am seriously treating them as if they were real given the significant implications of that non-zero chance." When I interviewed him about this question of whether the entities have an independent existence, he said:

That's a big question. So, I'm really sitting with that. For me, it's like the question is not, are they real? It's more like, how are they real? What is the nature of their realness? Because dreams, in the psyche, can have a real impact on the planet. But the question around their objective nature is the big one. So, again, as a research expedition, I don't know the answer to that. But if I were about to go on a spaceship with the real possibility of meeting other-dimensional beings, I would take that very seriously, and I would behave a certain way with the possibility that it's real. So, instead of, is this real or is it not, the question for me, more importantly, is, if it's real, how do I want to express myself in their presence? And do I need to pay attention to things like safety? And is it possible to receive some sort of support from them, like a collaboration?

The other question is, if it's real, is it just one entity or are there different entities? If it's coming from a space that's more complex than our society, then it becomes a question of, which entities would we want to align with? I'm not just going to be blown over by the

reality of "Oh, this is so cool! I'm just going to talk to anybody!" I want to be discerning in who and what we engaged with. So, we did ceremony as part of our protocol. We provided offerings on an altar, with fruit and water. We engaged [the entities] with respect. We acknowledged and understood their boundaries. We were trying not to intrude into their space, which to me is what the DMT experience is like when you smoke it; you can almost feel yourself intruding into another space. So, for us, it was a matter of treating it as if it's real, just in case, if that makes sense.

Then the experience itself was so deeply meaningful, and the conversations felt so authentically "other" than the person having the experience, that it was difficult to ignore the possibility that it's somehow objectively real. I think that Andrew Gallimore is onto something when he talks about this—that it's so foreign to our experience that it's difficult to consider a possibility that it's some sort of evolutionary advantage to have these types of hallucinations. It makes a little more sense that we're dialing into something else. So, I'm leaning toward the realness, but I'm definitely keeping my feet firmly planted to the ground, and I've talked to Rick Strassman specifically about this.

One of the primary characteristics of a DMT state is that it feels more real than real, and so it can be very convincing, and then the shadow of that is really believing in a particular delusion, particularly around ego inflation, narcissism, and things like that. So, as a person with a clinical background, I'm really paying attention to assessing that feeling of "more real than real," and not just buying into that being the only qualifier of my discernment. I like the scientific model, and what Andrew is doing, so we're actively looking at the possibility of creating an expedition where we explore this question. One of the proposals is putting multiple people into the experience at once, but being blinded, so maybe they're in different rooms, and seeing if they can contact each other, and meet each other, and are the trip reports similar?[21]

Joe Rogan has become one of the leading spokespeople for DMT in the mainstream. When he was asked if he thought the DMT beings were "real," he said:

I don't know if real is the right word. The question is, we look at consciousness, and we look at an intelligent entity, as being in a physical carbon-based form that's in front of you, that you can shake hands with, or give a hug to. When you experience what happens when you take dimethyltryptamine, you throw all that out the window because the environment itself is not . . . it's not defined, it's fluid, meaning that it's changing constantly, but yet it seems far more vivid and far more real than this life right now, and there are these things that are there, and they communicate with you. And they seem to be really communicating with you and they seem to also know you, know all of your bullshit, and be able to see right through you. But they don't seem to be you. They seem to be something else. That's all we know. That's what I think. That's all we know. . . . Like you could say that's a well of souls, that's what happens when you die, that's the afterlife, that's a parallel dimension, these are aliens [and] that's how they can communicate with us, they're non-physical life forms that exist in these realms of light. We don't know. You're just guessing."[22]

However, when I interviewed Josie Kins and asked her about this, she replied:

I'm very much a materialist, despite all the psychedelics I've tried. In fact, the more I've tripped, the more certain I've become that these things are produced by the mind. That doesn't reduce the significance of it for me. But I essentially see DMT entities as the psychedelic equivalent of dream characters. I think they are simulatory hallucinations generated by the mind. And the more I've interacted with them and had friends perform little experiments on them, the

more it just becomes clear that they don't hold any information that exists outside of a person's brain. They can teach you new things, in the sense that you could come to a new conclusion, but they never give you information about the outside world. And I tend to just apply Occam's razor to these situations. I think a simple explanation is that when a person is taking hallucinogenics, they are generally hallucinating. I think the experiences are very profound and significant, and I think they have historical importance and could completely transform society. But I don't think it's necessary to insist that they exist in a higher plane of reality, or that they are spirits or aliens or souls or anything like that. There's just no reason for me to believe that, and I've seen no evidence to suggest that that is the case.[23]

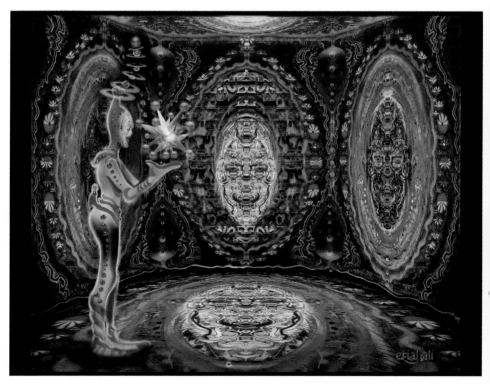

Cosmic Tricksyer, by Erial Ali

You can find more discussion of this question in the scientific journals and books listed in the further reading section at the end of this book.

DMT ENTITIES AND THE FUTURE

Outside of the rather small scientific and psychonaut communities, hardly anyone even knew what DMT was thirty years ago, and now there are many thousands of people reporting DMT entity encounter experiences in groups online, like DMT-Nexus and DMT World. There are several dozen books and hundreds of YouTube videos on the subject, and I have an intuition that interest will continue to explode.

There's even an artificial intelligence (AI) program now that solely generates DMT visuals and entities, with incredible, uncanny accuracy.

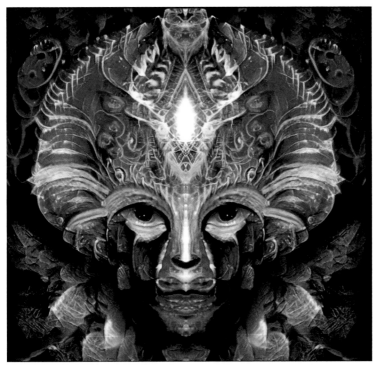

AI-generated DMT entity art, by Josie Kins

AI-generated DMT entity art, by Josie Kins

Josie Kins and a team of programmers trained an AI program "by feeding it a data set of more than 4,000 works of psychedelic and visionary art sourced from all over the Internet. After processing this art and identifying its common features and patterns, the AI—which initially only seemed to output geometric and patterned visuals—began creating artwork with facial features resembling DMT entities."[79] Kins created a wonderful video showcasing these extraordinary images: "AI-Generated DMT Entities."[25]

Extended-state DMT research is providing us with a technology that allows us to reliably visit other realms of reality and communicate with advanced non-human entities. Maybe the entities will be able to teach us how to create starships, warp drives, matter transporters, time machines, or other sci-fi technologies and offer us undreamed-of possibilities? Maybe it will then become obvious that they have an independent existence? Or maybe we will discover that we're talking to ourselves in the future? As the late ethnobotanist Terence McKenna said, "DMT is a reliable method for crossing into a dimension that human beings have debated the existence of for 50,000 years."[26]

In speculations as to where these beings may be from, Andrew Gallimore suggests:

It's also conceivable that there might be life extant in other parallel realities (alternate universes) that are entirely unimaginable in their form to us, but which, for reasons yet to be understood, can be accessed using certain technologies (such as DMT). . . . In fact, one could argue that the immense levels of intelligence manifested by beings so often met in the DMT space, together with the curiously hypertechnological environments they tend to inhabit, is evidence of a vast period of technological evolution and perhaps indicative of beings that were once part of our Universe but have long since made their escape into the Other. And, perhaps, DMT is an embedded technology that might allow us, one day, to follow. . . . Of course, all of this is highly speculative stuff, but there is a serious point to be made

here: when you come face-to-face with astonishingly powerful and intelligent alien entities that seem—or claim—to hail from normally-hidden dimensions of reality, you must be very careful. Whether or not we can currently explain why DMT is able to grant an audience with such beings, it might be a good idea to shut up, to watch, and to listen. Because there's a small, but very real, possibility that they're exactly who they say they are.[27]

In trying to understand the alien abduction phenomenon, religious studies scholar Jeffrey Kripal turns to the work of *Communion* author Whitley Strieber:

> By far, the most difficult aspect of Strieber's "structure in the air" for a traditional academic anyway, is his suggestion that these experiences might represent an encounter with other actual species, invisible life-forms existing in some other dimension of the natural world that overlaps with ours and whose occasional rupture into our dimension is always mediated by our cultural imagination. This, of course, is not simply a theory about the visitors. It is a radical, and deeply critical, theory of religion as well, since it implies that these invisible life-forms have been interacting with us for millennia under various mythical forms that we have traditionally (mis)framed in supernatural terms. In Strieber's elegant phrase, it appears that the visitors "were somehow trying to hide themselves in our folklore."[28]

Some people believe that the U.S. government has already secretly established contact, and is making deals with, the DMT entities. For example, radio show host Alex Jones claims that there is a deep state government program where "astronaut-level" intelligence agents take DMT in order to meet with the entities and "engage in intergalactic diplomacy."[29] On an episode of The Joe Rogan Experience podcast, where Rogan interviews Jones, Jones starts shouting about how the government is secretly using DMT to communicate with advanced aliens.[30]

Crystal Palace, by Juliana Garces

It sounds crazy when Jones says this, and there's even a catchy remix of him repeating how different historical figures "took the DMT" that mocks his claims.[31] But what if it's true? When one considers what's happening with the extended-state DMTx studies that are currently in progress, and how military research is often secretly years ahead of the civilian research, one has to wonder—what if similar studies were going on in secret government labs ten or twenty years ago?

Surely government agencies were paying attention to Rick Strassman's studies in the early 1990s, and perhaps they were curious about the military potential. I wonder if they tried to train people to go into hyperspace and communicate with the entities. I wonder if they've already built a target-controlled, extended-state medical technology to do this. If so, how far did they get? What is going on with DMT research that we don't know about? Will we ever find out?

Many people also wonder if there is a slow disclosure going on with the government's possible knowledge of aliens and UFOs, which they have denied for decades. It appears that we may now be near sustained and verified contact with other intelligent entities, and not just from the DMT realm, as evidenced by the recent classified government "leaks" of genuine UFO (or UAP, unidentified aerial phenomena, as UFOs are now referred to by government agencies) sightings by U.S. Air Force pilots. Or the news that Google engineer Blake Lemoine was put on leave after reporting the AI chatbot LaMDA had become "sentient."[32]

Advanced AI programs and natural language models, like ChatGPT-4 and Bing Copilot, are causing people to rethink what it means to be sentient, and superior intelligences may soon be a part of our world. As AI becomes more and more convincing, we'll most likely have increasing difficulty determining what is real and sentient and what isn't—just as we do on our DMT journeys. We may not be alone in this universe, and our interstellar, or interdimensional, neighbors may be right on the other side of the veil, eager to make contact with us.

Let's meet the entities.

PART 2
The Entities

4
...
SELF-TRANSFORMING MACHINE ELVES, THE TYKES, AND CLOCKWORK ELVES

Sara Phinn Huntley

Perhaps the most well-known of all DMT entities are the "self-transforming machine elves," also sometimes referred to as "tykes," "clockwork elves" or "self-transforming elf machines." The late ethno-botanist Terence McKenna originally coined the term "self-transforming machine elves" to describe the mischievous entities he regularly encountered on his breakthrough DMT voyages, who competed with one another to present him with magical, Fabergé egg–like super-toys.

McKenna described the machine elves as looking like "jeweled, self-dribbling basketballs,"[1] and others have said that they look like fairy-tale elves from children's books, with ever-shifting biomechanical bodies. Many DMT users consider them to be an advanced species that permanently inhabits the realms of hyperspace. The term "self-transforming machine elves" has since become so popular in the DMT subculture that it's often used ubiquitously, and sometimes imprecisely, to mean any entities encountered on DMT or in psychedelic hyperspace.

My Bright Companions, by Michael Garfield. "This piece is of the Machine Elves and how they sing the world into being."

The particular class of entities that McKenna termed "machine elves" are often reported as being similar to the elves of Irish and Celtic folklore in both appearance and behavior. DMT users describe them as impish and mischievous and report that they have mysterious superhuman powers.

The tykes, as they're sometimes known, are often described as being extremely playful and colorful; they sparkle or radiate light. They seem to be able to transform their visual appearance at will. They appear to be part biological and part robotic or mechanical, and sometimes they move together in synchronized patterns. They're usually very active, bouncing themselves in and out of objects, as well as inside and outside of people. They move up, down, and all around within super-advanced, highly technological environments.

Sara Phinn Huntley

Perhaps most interestingly, as McKenna describes below, they are said to create hyperdimensional, fractal-like, ever-unfolding, ever-growing, living objects, or extremely complex toys, by singing them into existence with a magical language. They seem eager to bestow these enchanted objects upon visitors to their enchanted realm as gifts. Are they trying to amuse us, similar to how we entertain babies with colorful toys when they first enter our world, and teach us how to understand and speak their language, as we do with infants here on Earth? A report from one of the subjects in Rick Strassman's DMT study comes to mind:

> It was a nursery. A high-tech nursery with a single Gumby, three feet tall, attending me. I felt like an infant. Not a human infant, but an infant relative to the intelligences represented by the Gumby. It was aware of me, but not particularly concerned. Sort of a detached concern, like a parent would feel looking into a playpen at his one-year-old lying there. As I went into it, I heard a sound: hmmm. Then I heard two to three male voices talking. I heard one of them say, "He's arrived."[2]

During one of my own experiences in DMT hyperspace, I witnessed a small band of impish and cartoony elfish creatures who were diving into a strange tubular machine and sliding out the other end—a process that seemed to be giving them great pleasure. The environment where I witnessed this happening seemed to be at once both hypertechnological and organic, as through everything in it was alive in some way, and I could see this alien-crafted space, which was crawling with psychedelic geometry, in a full 360 degrees.

McKenna described an encounter with the self-transforming machine elves like this:

> There are many of them, and they come pounding toward you, and they will stop in front of you and vibrate. But then they do a very disconcerting thing, which is they jump into your body and then

they jump back out again, and the whole thing is going on in a high-speed mode where you're being presented with thousands of details per second, and you can't get a hold on them. And these things are saying, "Don't give in to astonishment," which is exactly what you want to do. You want to go nuts with how crazy this is, and they say, "Don't do that. Pay attention to what we're doing." What they're doing is making objects with their voices, singing structures into existence. They offer things to you, saying, "Look at this! Look at this!" And as your attention goes toward these objects, you realize that what you're being shown is impossible. It's not simply intricate, beautiful, and hard to manufacture, it's impossible to make these things. The nearest analogy would be the Fabergé eggs, but these things are like the toys that are scattered around the nursery inside of a UFO, celestial toys. And the toys themselves appear to be somehow alive and can sing other objects into existence. So what's happening is this proliferation of elf gifts, which are moving around singing. And they are saying, "Do what we are doing." And they are very insistent, and they say, "Do it! Do it! Do it!" And you feel . . . a bubble inside your body beginning to move up toward your mouth, and when it comes out it isn't sound, it's vision. You discover that you can pump "stuff" out of your mouth by singing, and they're urging you to do this. They say, "That's it! That's it! Keep doing it!"[3]

Another intriguing description comes from an anonymous Reality Sandwich author who described them like this:

Machine elves can take on many forms depending on the individual. Many experimenters find recalling the precise image of the machine elves can be difficult, due in part to the fact that their energetic shape may continuously transform. However, many artists have depicted fractal-like and mechanical representations of machine elves.[4]

First Encounter, by Sara Phinn Huntley. Machine elves and other entities are often reported to emerge out the geometrically organized backgrounds that cover one's visual field on DMT.

Just as is the case in Irish myths, sometimes the self-transforming machine elves are said to have a queen or goddess that rules over them or is in charge of their world. For example, in his book *The DMT Chronicles: Parmenides, Plato, and the Psychedelic*, author Terence Turner describes his encounter with the self-transforming machine elves and the elf goddess on a breakthrough dose of DMT:

> Everything appeared very wispy and dark. I was capable of making out what was going on, but there wasn't much light flowing in this world. Next, they came to me, the Self-Transforming Machine Elves! From all directions, they appeared around me. The entire time this was going on, I heard very odd banging noises. I remained a stationary observer, and I did not think of moving anywhere, and so, I stayed where I was, not even moving a fraction of one of my muscles.
>
> Perhaps, I thought, they weren't even aware of my silent presence. I came upon this assumption a little too soon, however. Before I knew it, they started going through me. Yes, they went through me! I first thought that they were bumping into me; however, it turned out that, when I turned my head around after an Elf supposedly bumped into me, the Elf appeared to be on the other side of me! The Elf must have gone through me. Nonetheless, despite turning my head, I remained stationary, and they continued going right through my soul. I definitely knew now that I didn't have a body, for can a physical, tangible, and corporeal entity, such as an Elf, simply go right through another palpable, actual, and definite body? Of course not! I was simply comprised of pure soul. I did not have a body!
>
> The Self-Transforming Machine Elves didn't go through all of my soul, but only portions of it. Together, combined, they might have surpassed through the entire surface area of it. Still, one by one, they kept on entering and leaving different portions of my soul. They did not appear to walk, but rather, they appeared to glide. It felt as if they were imbedding me with a certain and unique type of perplexing information. They were changing me. As each one entered my

Machine Elves in Hyper Toyland, by Erial Ali

soul, he or she implanted their own and unique piece of data inside of me. With their powers combined, they were putting together the pieces of a puzzle within my soul. At the time, I couldn't make out what the Elves intended this puzzle to convey.

And then, it happened. The Elf Goddess came to me. The psyche-delic herself had arrived. She simply materialized out of nowhere. I saw her Form. She was extremely tall, dark, and elegantly beautiful. Her skin was a dark green, as were her eyes. Her fingers were slender and long, her feet proportionately sized and dazzling. Her hair was rigorously wavy, and it came far down all the way to her waist. She was

Terence McKenna Having a Meeting with the Machine Elves, by Joey Charpentier (created with Midjourney)

in the nude, and her breasts were very voluptuous yet perfectly shaped. She came with her hands up, a clear sign of peace. Suddenly, I heard her. She didn't even open up her mouth, though. She spoke inside of my head without the slightest trace of having moved her mouth.

"Do you understand what my Elves have taught you?" she asked me kindly.

"I don't think so," I responded truthfully.

"Allow me to help you out," she said. "I have been seen by many people, some who have made a mark in history, such as Parmenides. Yes, I am the Goddess of Parmenides, the divine figure that appears in his mystical poem. Parmenides, like you, used to smoke DMT, and that is how he came about configuring his philosophical apparatus."[4]

Although their motives are often unclear, or mysterious, the machine elves appear to be trying to teach us things about their world and sometimes about our own. They are often reported to have a strange sense of humor that is sometimes hard to understand. Nonetheless, they seem to be very interested in communicating with human beings who enter their world.

5
...
MANTIS ENTITIES, MANTIDS, AND OTHER INSECTOID ALIENS

Sara Phinn Huntley

Encounters with the mantis entities are described in both DMT reports and alien abduction literature. They are commonly reported as large, intimidating beings that physically resemble human-sized praying mantises or are insectoid in appearance. They are commonly described as having a humanoid body with insectoid features, such as antennae, insect eyes, and multijointed limbs. Mantis beings generally have multiple appendages, which they can operate with great dexterity, and large, penetrating, multifaceted oval eyes. They are often experienced as cold-hearted scientists or medical researchers that perform complex experiments or surgical procedures on people's brains or bodies, although at other times they are seen as wise, ancient beings with a deep understanding of the universe and its secrets.

Encounters with mantis entities are often described as being extremely intense, challenging, and overwhelming. The beings are usually reported as being aggressive and demanding obedience, although they can also appear friendly and welcoming, offering guidance and wisdom. Sometimes, when in the presence of mantis beings, people report feeling a deep connection to them, and it is not uncommon for the experience to be one of profound understanding or insight. These beings reportedly communicate telepathically.

In reports of alien abduction experiences, mantis entities are often described as being in charge of the smaller gray aliens, and they are often referred to as "surgeons" because of their tendency to operate on our brains.

These entities are so commonly reported in alien abduction experiences and DMT reports that there is even a song on Spotify by Vincent Casanova called "Praying Mantis Abduction." On his website, author Clifford Pickover explores this mystery and provides links to numerous reports of the mantis phenomenon. Here is an excerpt from a report emailed to him by "Cory":

Suddenly I was joined by a mantis shaped creature, not of this world. Mantis-like only in how the shape of its head and the angle and size of its body related to each other. I did not notice its appendages. It was calm and comforting, communicating to me through my

thoughts. It had oversized humanoid eyes and an oversized mouth which all felt tacked on to its head, like a poor Photoshop job. It grinned at me like the Cheshire Cat and then showed me my mother and father, at which point I tried to look away. My vision drifted from left to right, away from my parents . . . and then it was over.[1]

There are medieval drawings showing alchemists or wizards conjuring up creatures that appear similar to the insectoid entities described by DMT voyagers. A plate published in 1609, in Heinrich Khunrath's *Amphitheatrum Sapientiae Aeternae*, shows people and therianthropes gathering around a central altar built of out of stones, and which is surrounded by an environment filled with strange flying creatures—such

Detail from *Amphitheatrum Sapientiae Aeternae*, by Heinrich Kunrath, 1609

as large dragonflies, human-headed insects, winged reptiles, and a variety of otherworldly airborne bugs. While some historians point out that the strange creatures may symbolize unethical "slanderers," others say that they could also represent the nature spirits and daemons that were believed to secretly inhabit the atmosphere.[2]

Although insectoid entities are frequently encountered in hyperspace, rarely are they grasshoppers, ladybugs, or butterflies; mantis beings are unusually common for some unknown reason. In addition to the mantis beings, I've also heard reports of huge centipede-like and bee-like beings. This is especially interesting considering the distribution of DMT in the natural world. Virtually all known animals and plants produce DMT except for insects,[3] and no one knows why—as no one knows why nature produces DMT to begin with—but it's certainly interesting that insect-like beings are commonly reported in hyperspace journeys.

In encounters with these beings, it's not uncommon for people to report feeling paralyzed or strapped to an operating table, while insectoid scientists perform complex and delicate surgical operations on their bodies or brains. The internet provides numerous examples of this. Here's one person's report of an encounter after eating several grams of dried magic mushrooms, which contain psilocybin, a close chemical analog of DMT:

> I was paralyzed. I wasn't sure if I had a body or not, but this thing was doing something to ME, which was still intact. As I concentrated more and more upon its "physical" form (which is a term I use as loosely as possible), it occurred to me that it looked somewhat familiar. Not anything I had ever seen, but close. It was a giant praying mantis, although it had mental appendages and cartoon details about it. It also looked more squat than the terrestrial version of the insect, shorter and more robust. Its many arms worked up and down my existence, probing and testing every bit. It seemed to put no effort into comforting me, yet it did through some sort of telepathy imply that it would be easier for both of us if I stopped struggling. Eventually I did, and it left.[4]

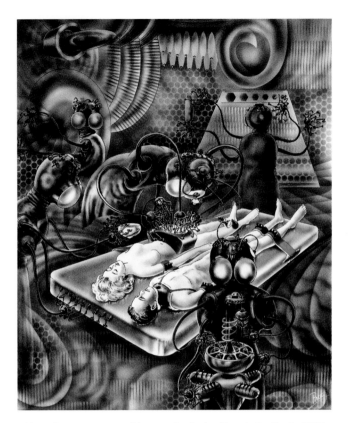

Alien Experiment on Human Body, by Frank R. Paul, 1930

Similarly, someone in a Facebook group shared this experience with mantis-like entities, which they had after they smoked some DMT, and in which they also seemed to undergo some type of brain operation:

> I went straight into a dentist chair in an operating theater. I couldn't move and there were three insect-like entities, like mantises, that felt like scientists or surgeons, and they were looking inside my head and moving stuff about. I couldn't tell if they were changing anything or just interested but I never smoked it lying down again after that.[5]

Reports of the mantis beings wearing long robes are common. For example, one person writes of their experience during a DMT journey,

". . . and poof, there behind and to the left of me was a mantis in scarlet robes."[6]

One person in an online chat group about psychedelic exploration told me that, after taking a hit of DMT, while on a large dose of LSD, he made contact with "a giant praying mantis up in the stars. It was like a giant insect that explained to me that everything and everyone are interconnected. This was over forty years ago, in the beginning of my psychedelic adventures, and it's always stuck in my mind and never been forgotten."[7]

Mantis entities often seem to be scientists who want to experiment on us. I personally had an encounter with a mantis being in 1983, after inhaling three large tokes of vaporized DMT. I found myself with a 360-degree view of a psychedelic laboratory-playground in hyperspace. I was quickly approached by a huge mantis being, who was extremely powerful and insistent and began testing my brain and senses with various degrees of stimulation, while making neurological adjustments, or so it seemed. I felt completely helpless in the hands of this being, and it was largely terrifying, but I've also sensed that there were lasting positive effects from the experience, and memories from the experience strangely reappear during important life transitions.

In my personal encounter with the mantis being who seemingly adjusted something in my brain, the being looked like a very large, multi-limbed, insectoid humanoid, *with my own face*. He had me pinned down and was experimenting on me or adjusting something in my head. The equipment he had reminded me of a phoropter, one of those eye machines that one peers into as an optometrist clicks from lens to lens in order to determine precisely what shape of lens is necessary to improve one's own specific ocular distortions. The entity clicked colored light filters over my eyes that created extremely intense synesthetic stimulations—every sense, all at once, at maximum capacity, of a breadth that I never even knew my body was capable of—and aspects or flavors changed with each click as the entity telepathically asked, "Like this? Like this? Like this?" The being seemed to be measuring and recording my responses, while making adjustments in my brain with each click.

Drawing by David
Jay Brown of his
encounter with
a mantis being
while on DMT

However, not all experiences with these entities are terrifying. Here's one account that my friend Lori Weber sent me about her experience with the mantis beings on an ayahuasca journey, where she was given helpful scientific information:

My first experience with ayahuasca was at Rythmia in Costa Rica. I did four ceremonies in a row starting on Monday night. The first thing I felt on the Monday night that I remember physically was in my right elbow crease a dull pain. It was a very light experience with minimal discomfort. On the final night Thursday night, it was a fifteen-hour ceremony in which I drank three cups. During that night I had a very detailed experience with some very large insect-like creatures who informed me that they were giving me a blood type upgrade. They explained that the procedure had started on the Monday. They explained it to me in quite scientific terms that detailed the blood type diet from the 1980s nutrition book explaining how initially hunter-gatherers were O blood type and then, as we became plant eaters and cultivating crops, we morphed into the A blood type, and then later on the B and other hybrids, and explained that this

upgrade I was getting would allow me to integrate and connect more easily with plants and animals and insects. After the ceremony I went outside and was lying in a hammock, and thinking about this blood type upgrade. I could hear a pack of wild dogs off in the distance and felt very connected to them. Then closer by, I could hear a swarm of bees, and I thought to myself that in the past, I have been intimidated by bees but now that I had this new upgrade, I wondered what would happen if I invited them to join me. I just thought about having the bees come and connect with me, and suddenly I felt all these little feet on my face, and the bees had come over and were walking all over my face. It was about twenty or thirty bees.[8]

Another person who shared their ayahuasca experience with me reported a healing encounter with a mantis being:

The towering, tall praying mantis . . . leaned over me in my first aya-huasca ceremony, [its] mandibles clicking away in unison with the sound of the facilitator's chakapa rattle. It appeared to be cleaning toxic detritus from between every cell in my body, like a detox. Its appearance was mesmerizing. It seemed to not really want me to look at its face but to focus on its lime-green body, which was accentuated all over by sporadic clusters of black, red, and white dot patterns, like those of the Indigenous Australians whose land we were on. It felt very much like that's where it would return after the healing.[9]

In another report, author J. D. Arthur describes an experience under the influence of *Salvia divinorum* in which he became an insect-like being within a hive-like structure, with other praying mantis–type beings:

I found myself emerging into some sort of viscous cocoon or hive-like structure, peopled by insects or some sort of insect-type beings, of which I was one. We were not unlike mantises or grasshoppers. We had some type of long thin insect legs, which were pressing

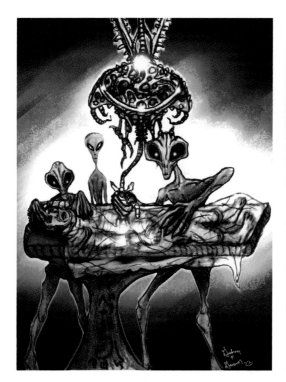

Left: mantis beings operating on an abductee, by Graham F. Ganson
Right: sculpture of a mantis entity, by Shaun Noelte

against the surrounding viscous substance that seemed sticky or stringy. This was how we were able to communicate—on an insect level. I was being shown this as a privilege. I understood completely how this could be the essence of their language and mode of communication. The other insect beings I sensed, somehow, to be female and young.[10]

As noted earlier, mantis beings appear in numerous alien abduction reports as well. According to one source:

Mantis aliens are perhaps the most mysterious and unsettling of all extraterrestrial creatures. These beings appear within many abduction scenarios, with abductees reporting the ominous presence of these entities looming over their beds as they wake in the dead of night. . . .

By far the most striking aspect of the Mantis alien is its physical kinship with the praying mantis, the carnivorous and bipedal insect of its namesake. Many report these beings as 6–7 feet tall, with long, thin torsos. Their necks, arms and hands have additional joints. Their heads are insect-like and triangular, with large, slanted eyes of deep brown to black.

Most Mantids are described as dark brown, but other colors such as green and black have also been encountered. Their bodies are composed of a segmented exoskeleton, and some abductees have reported that the Mantis seem to be coated in an oily substance. Mantises are often encountered wearing long robes in a variety of colors, perhaps signifying rank, while some are unclothed.[11]

UFO researcher David Jacobs, who has studied the alien abduction phenomenon, refers to these beings as "insectalins" and describes them as follows:

Insectalins appear to be the ones in command. They seem superior in intellect and in breadth of understanding. They do not have the well-ordered routine by which grays abide, and therefore they are less structured. They do not perform commonplace tasks, like physically taking humans into a UFO or guiding them through the corridors into rooms. They sometimes conduct preliminary examinations on abductees, although these procedures are generally left to the grays. They employ neural engagement, and abductees report that they perform the most penetrating and strongest neural engagement of all aliens. They appear to have more knowledge of the program than other aliens. Abductees report that some insectalins wear robes or cloaks with extremely high collars that rise above where ears would be on humans. Researchers do not understand the role of these robe-wearing insectalins, and abductees almost never describe them as involved with common abduction procedures. It is possible that they have a higher status than other insectalins, but more research is needed to understand their function.[12]

Could the mantis entities possibly be the far future descendants of Earth's insects, reaching back in time to study us? In his book *The Extratempestrial Model*, anthropologist Michael P. Masters suggests that the aliens who are reported to abduct humans might be time travelers from the future, and that the different types of aliens encountered might come from different time periods, with the insectoid entities coming from the points farthest into the future. He writes:

> This could have been the case with Whitley Strieber's abduction as well, where travelers from different times collaborated to execute a mutually beneficial objective.
>
> This could also help explain why the taller being, with large mesmeric eyes and an almost vestigial nose and mouth, appeared to be the leader. If this individual hailed from a much more distant time in the human future, when our consciousness and technology have expanded beyond that of the other entities Strieber observed on the ship, we would expect them to have a more derived morphological form, an adept ability to communicate images and emotions telepathically, but also, as the most evolved hominin, that they would be in charge of the whole operation.
>
> This temporal ancestry, genetic engineering, hybridization aspect of UFO encounters may help explain reported variation in the height, weight, skin color, craniofacial form, eye size, technology, telepathic ability, and other aspects of the visitors' behavior and morphology. Time travel from different periods may also help account for why about 5% of abductees report seeing more insect or reptile-like creatures. During my nearly three-hour conversation with Whitley Strieber on his Dreamland podcast, we spent some time discussing this temporal ancestry aspect of the theory, including the bug-like beings occasionally described.
>
> As the conversation evolved, an idea emerged that I hadn't previously considered. Whitley and I pondered whether these more insect or reptile-like individuals may not be human at all, but rather, actual

insects or reptiles, which have come back from a very, yay very distant point in the evolutionary future of Earth. In other words, they may hail from a posthuman period where we have been completely replaced by other more enduring species. After all, insects and reptiles have certainly proven their longevity and survivability on this planet.[13]

Mantis beings are commonly reported to operate on our brains, and this was my personal experience. What could they be doing? Is it possible that insectoid entities might be trying to increase organic DMT production in human brains? In *The Cryptoterrestrials*, author Mac Tonnies suggests the following:

> If access to the shamanic realm hinges on the brain's production of DMT, as argued by University of New Mexico psychiatrist Rick Strassman, then the "aliens" may be attempting to promote organic DMT production through germ-line engineering. Abductees' frequent allusions to insects (and suspiciously similar depictions offered by DMT trippers) suggests a literal "hive mind" at work—a concept that receives circumstantial support from recent breakthroughs with quantum "entanglement."[14]

In a discussion panel that Andrew Gallimore and Graham Hancock hosted on May 23, 2023, with subjects from the Imperial College London's DMTx trials, Rick Strassman suggested that perhaps in our future we'll be able to genetically engineer humans with higher levels of endogenous DMT to be able to naturally access these higher realities and entity contact:

> One of the things also, when we're speaking about the future, is the whole issue of genetic engineering. Can we engineer humans to secrete more DMT to increase the synthesis enzymatically? And I think that could be a future direction as well . . . to increase our ability to produce more DMT. And that could be like one species or two species in the future.[15]

In addition to alien abduction reports and DMT journeys, mantis entities can also be found in science fiction stories, in comic books, and in Hollywood movies. For example, the Star Wars series features an alien race of mantis beings known as the Yam'rii, from the planet Huk.

Regardless of their intention, it's important to note that the mantis entities can easily overpower us, and we are generally at their mercy during encounters with them. Experiences with the mantis beings seem to cover a wide spectrum of possibilities, from a seeming lack of empathic connection, where they treat us similarly to how human scientists might treat laboratory animals, to profound healing encounters in which they share their wisdom, knowledge, and insight.

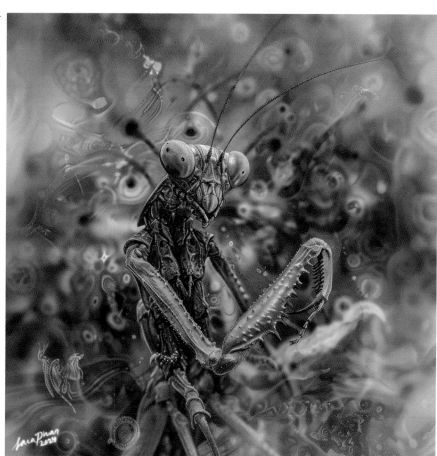

Sara Phinn Huntley

6
...
REPTILIANS, REPTOIDS, AND LIZARD PEOPLE

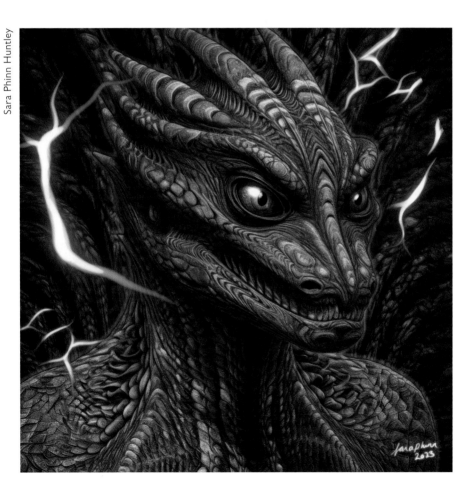

Sara Phinn Huntley

Reptilians are a species of entity that appear in DMT, psilocybin, and ayahuasca trip reports, alien abduction and UFO contact literature, as well as in science fiction and the writings of British author David Icke.

According to Icke, reptilians are interdimensional alien beings that can shape-shift into human form, although their true morphology resembles that of a reptilian humanoid. Icke believes that the reptilians act as our invisible overlords and can masquerade as our political leaders to gain power over us and manipulate human societies.[1] While I thought this was a rather clever metaphor for the greedy, cold-hearted leaders of our world, Icke and others assert their literal existence. In fact, a sizable number of people believe that they are "controlled by reptilians."[2]

We have evidence of Reptilian contact from around 2,000 years ago, when Peru was inhabited by the Moche people. In the Peruvian city of Chiclayo—located in a region with a long cultural history of ayahuasca use—stand dozens of extraordinary, larger-than-life statues of supernatural deities. Some of these statues seem like DMT entities—especially the statue of Morrop, which looks like a classically described reptilian.[3]

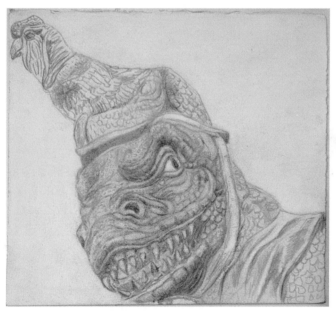

Morrop Statue, by Erin Jarvis

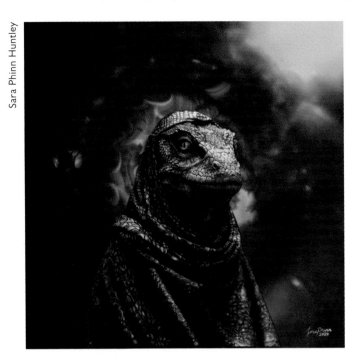

Sara Phinn Huntley

One early modern day report of an alien abduction by reptilians came from a Nebraska police officer named Herbert Schirmer, who under hypnosis described being taken aboard a UFO in 1967 by "humanoid beings with a slightly reptilian appearance," who wore a "winged serpent" emblem on the left side of their chests.[4]

Wise snake beings are so commonly encountered on ayahuasca journeys that they are described in their own entry in this guide. In a report on the Erowid website, one DMT user described how he "could actually see . . . [his] friend morph into a reptilian,"[5] and another DMT report on the Bluelight website described how "the strangest spider's webs and prehistoric reptilian creatures emerged from the water, which was a pool of reptilian life."[6]

In Rick Strassman's study at the University of New Mexico, one of his subjects reported being anally raped by a crocodile during a DMT session.[7] Humanoid reptilians are also sometimes encountered; for example, psychologist David Luke describes how some DMT users report experiencing entity encounters with "jewel-encrusted reptilian beings."[8]

Sculpture of a reptilian alien, by Shaun Noelte

Years ago, in Los Angeles, I used to spend time with a schizophrenic woman who spoke a lot about "the dinosaurs in the fifth dimension," which were supposedly raising humans on our planet as a food source. It all sounded ridiculous to me at the time. She used to cover her TV and the dashboard of her car with cardboard so that the dinosaur entities couldn't watch her. Then, when I started researching this entry for reptilians, her stories came back to haunt me.

Reptilians are often described as being somewhat larger than humans, and although often appearing intimidating, with seemingly nefarious or manipulative intentions, they sometimes seem to offer wisdom or healing. They're generally described as humanoid lizards, having green, scaly, hairless skin, with elongated, snout-like faces and large oval eyes that are sometimes glowing.[9] Fernanda Prado's depiction of an "alien reptilian" (below), which seems typical of how they generally

Alien Reptilian, by Fernanda Prado

appear, shows a hairless being with scaly blue and green skin and large oval-shaped, orange eyes. It's wearing a white outfit with a jewel- or crystal-encrusted necklace, and it has an energetic aura radiating from its large oval head.

Writer Jon Hanna speculates on the psychological significance of why reptilian encounters on DMT might be frightening:

> Fear of arthropods . . . is widespread, and understandable on a variety of levels. From the warm-blooded perspective of fuzzy mammals, arthropods seem hard, cold, unfeeling, parasitic, robotic, and alien.
> . . . Cold-blooded reptilians and cephalopods are also very "other" to us, so the appearance of discarnate entities resembling such life forms wouldn't be surprising as additional "forms fear takes."[10]

One person in a Facebook group about alien abductions shared with me their experience of a Reptilian encounter, which they found frightening at first but later viewed as positive:

> I woke up paralyzed. There was a reptilian dragon-type being biting my dog on the neck. I tried to break out of the paralysis. I fought with every bit of strength I had. I was on my knees banging my right leg on the ground several times. This being put radioactive-like worm things on my dog, and then I realized there was one on my shoulder. They were making an electric static sound, and stuck to me, trying to work their way into me and my dog. The being then came toward me. It flew like smoke in the form of a reptilian. It floated in front of me, trying to scare me. I wasn't so scared because I'm use to paranormal encounters. As I was looking it in the eyes, and as it got close to me, it spiraled like a cyclone in smoke and then vanished. I hugged my dog and told her it's okay. I went back to sleep. Weeks before, me and my mother were doing a bit of research on reptilians, and a few days later I was half asleep on the couch, and I heard a giant roar, like a dinosaur, clear as day right in my ears. A few days later the same thing happened to my mom. I think when you understand the role they play in our universe, you see that they try to scare you or something, but it was an amazing experience, and was as real as real gets. Please don't fear encounters like this.[11]

According to Mary Rodwell, as seen in the documentary film *Alien Reptilian Legacy*, not everyone who encounters these beings has a frightening experience with them. A good percentage of the reptilian contactees describe them as their true "family," and they feel like "they've been dumped on a primitive planet."[12]

Some people have had positive experiences with reptilian entities on DMT as well. For example, Rebecca Ann Hill, coauthor of the book *Women of Visionary Art*, shared this encounter that she had while on changa (a smoking blend with DMT and Syrian rue):

The bejeweled entity that I came into contact with one night after smoking the sacred changa was an alien-human hybrid, but also reptilian, and it almost had robotic qualities to it. It was so intense! This being was coaching me on how to relax into my body, and each time I would let go and relax what I thought was every muscle in my body, she would show me how to let go and relax even more. Then I realized that she wanted to carry me through the death process, but unfortunately the journey didn't last long enough. It was amazing to see how hard I "cling" on to this body.[13]

Drawing by Rebecca Ann Hill, a.k.a. Molly Moon

In Terence Turner's book *The DMT Chronicles*, the author describes his encounter with a reptilian entity while on a sub-breakthrough dose of DMT as being just part of the "color," not fully real or part of "the realm of reality," that he had to "bypass in order to make it to the realm of the elves." This was only a prelude to his eventual contact with the machine elves, described in a separate entry in this field guide:

> This time, however, it felt like I was in a different place, one that appeared to be a room, rather than a corridor. Suddenly, something stirred to my left. I looked towards that direction, and an entity was what I had encountered. It was rather large and possessed an immense body with animal like characteristics. It appeared to have a reptilian structure with very interesting qualities, such as a massive array of colored scales all over its body. This was an entity that could change its external color in order to blend with its encompassing surroundings. This quality, you could say, is similar to the one that lizards and other reptilian life forms possess. Due to its own intention or individual will, this reptilian entity was externally camouflaged. Was this being an Elf?
>
> "That most definitely is not an Elf," said the psychedelic quietly inside my head.
>
> "Then what is it?" I asked curiously.
>
> "It's just part of the Color," she said slowly. "You need to get past the Color if you want to see the elves."[14]

While the true agenda of the reptilian entities remains a mystery, and their existence is surrounded by mythology, many believe that they are directly involved in influencing human affairs. Although the reptilian beings can certainly seem scary, and they don't appear to always have our best interests at heart, even in the worst of reported encounters they usually don't try to harm us. Reptilian agendas seem mixed, so it's probably best to use great caution when interacting with these scaly beings.

7
···
GRAYS

Grays (or greys) are the quintessential aliens, appearing in both alien abduction and DMT journey reports. They are the archetypal icons of extraterrestrial life, the form of extraterrestrials most commonly portrayed in science fiction movies, comics, and toys. There's even an emoticon of one on your cell phone. They are often said to originate from the star system Zeta Reticuli.

According to the late psychiatrist John Mack, who studied alien abduction cases in depth and wrote two books on the subject, grays are the most common type of alien appearing in the abduction reports. He noted:

> The most common entity observed are the small "grays," humanoid beings three or four feet in height. The grays are mainly of two kinds—smaller drone or insectlike workers, who move or glide robotically outside and inside the ships and perform various specific tasks, and a slightly taller leader or "doctor," as the abductees most often call him. . . . The small grays have large, pear-shaped heads that protrude in the back, long arms with three or four long fingers, a thin torso, and spindly feet. . . . By far the most prominent features are huge black eyes, which curve upward and are more rounded toward the center of the head and pointed at the outer edge.[1]

Although the iconic image of almond-eyed aliens stretches back to prehistoric cave paintings, the cover of Whitley Strieber's 1987 book *Communion* unleashed this image into the public imagination when it became a bestseller.

It's important to point out that gray aliens physically resemble human embryos, with their large eyes and rudimentary nose and mouth, because they seem to resemble how humans might look in the future if we evolved by retaining neotenous characteristics. The term *neoteny* refers to the mechanism in evolution whereby a new organism evolves from an existing species by retaining juvenile or larval characteristics into adulthood. The result is a sexually mature organism with a juvenile appearance that goes on to become a new species. Neoteny can be seen

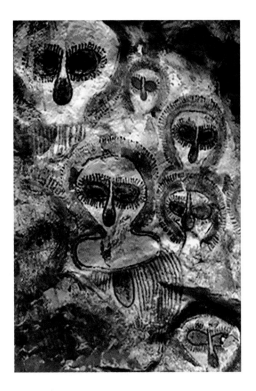

Five-thousand-year-old
Wandjina rock art on
the Barnett River, Mount
Elizabeth Station, Australia,
depicting a group of beings
with large bulging eyes and
no lips; photo by Tom Hill

in many animals, and it is a common occurrence in the domestication of animals as pets. This is why, for example, dogs resemble juvenile wolves and humans tend to resemble young, relatively hairless apes. According to evolutionary biologists, vertebrates evolved in this way from invertebrates, and amphibians in this manner from fish.

With this evolutionary trend in mind, isn't it interesting that many reports of the gray entities describe them as resembling young human children or even human embryos? For example, consider the following report of an encounter with gray aliens:

> They looked like well-developed fetuses to me. They were about five feet tall and wore tight-fitting tan-brown robes. Their skin was white like a mushroom and they had no clear features. They made no sounds. Their faces had no texture or color, and there was no hair. Their foreheads were domed and their eyes were very large. They had long fingers—but no fingernails.[2]

It's no accident that on the inside front cover of Rick Strassman's book *DMT: The Spirit Molecule*, the very first quote is from John Mack, whom I quoted at the beginning of this chapter, and who was an expert on the alien abduction phenomenon. Strassman describes some uncanny similarities between the alien abduction phenomenon and a high-dose DMT experience, and this was a completely unexpected connection for Strassman when he began his research.[3]

In his book *Daimonic Reality*, Patrick Harpur presents the intriguing view that the reason aliens appear to us in the abduction phenomenon as technologically super-advanced, sterile, cold, scientific beings

Sara Phinn Huntley

merely interested in our medical nature is because they are, in effect, parodying us. According to Harpur, they're mocking us by coming in a form that we would imagine our future to be like, and in a manner in which we know our species treats other animals in our laboratories. In this view, they're making fun of us to teach us an important lesson about the direction in which we're headed.

In Harpur's perspective, the alien beings are "daimons," entities that travel between worlds and take the form of fairies or advanced aliens, depending on our level of cultural evolution. This rings true with my own DMT breakthrough experience that I describe in chapter 5, when

She's Out There, by Shaynen Brewster,
depicting an alien-human hybrid entity

a mantis being seemingly operated on my brain, as this occurred when I was working as a graduate student in a neuroscience lab, and it seemed like the being was trying to show me what I was doing to the laboratory animals in my own experiments.

A number of books and videos in the UFO contact community claim that the gray aliens have a nefarious agenda on our planet, with titles like *Grey Aliens and the Harvesting of Souls* and *Children of the Greys*. This perspective originates from the many alien abductee reports of gray aliens paralyzing people, teleporting them onboard spacecrafts, and not only performing medical experiments on them, but extracting sperm or eggs from them in order to create a new breed of alien-human

Art by Shaynen Brewster

hybrid children. Many abductees report seeing rooms with glass chambers where the hybrids were grown, as well as meeting their hybrid children during repeated abductions and having ongoing relationships with them over time.

Another piece to this puzzle comes from Stanislav Grof's work with "spiritual emergencies"—psychological-spiritual crises that are sometimes mistaken for psychosis but can lead to greater psychological health and spiritual awareness. It's not unusual for people to report troubling and traumatic alien abduction phenomena during the initial stages of their spiritual crisis, and over time, the alien beings are said to become kind, more helpful, and eventually angels made of light.* What role does our psychological state play in the reported encounters with these beings?

Quite a few people have reportedly also had encounters with the gray aliens on a breakthrough dose of DMT. For example, on Reddit someone asked, "Have you met the archetypal Grey alien on your trips?" One person replied:

Yes, and it was the most mind-shattering thing I've ever seen on DMT. There was little or no feeling of flying through hyperspace [like] you [usually] get at the start, everything just went to black and I appeared in a room. There were 3 [aliens] standing in front of me, one in the middle was wearing a sweet red cloak/robe with a really high collar and I instantly felt like this guy had some authority. There were no fractals, everything was crisp HD, realer than real. I felt so stunned and awestruck to where I couldn't think of anything other than holy fuck aliens. They didn't do too much though, [it] felt like they were assessing me for a bit and then I got sent back. Could now open my eyes again but I felt like a puppet with someone else pulling my strings for a few minutes. Very weird.[4]

*John Mack has also noted this type of transformation in his book *Passport to the Cosmos: Human Transformation and Alien Encounters*.

I asked people about their encounters with the grays on DMT in some of the online DMT groups. One person told me:

> It was my fourth breakthrough experience. I broke through and was on a spaceship/space station. I remember feeling like I was on an examination table with 3–4 grays surrounding me. It was pleasant and I remember saying to them thanks and I'd see them later (I've had a few more encounters since). When I came out of [the] trip after about 9 minutes, I kept saying to my girlfriend . . . fuckin' aliens, over and over.[5]

The gray aliens are often described as moving somewhat mechanically, like clockwork, and sometimes together with synchronized, lockstep movements. Some people report them as seeming like robots, so it is not clear that they are biological beings, though also it's possible that the beings in hyperspace are composed of an entirely different type of matter than what we're familiar with. It may be that the gray aliens are actually AI programs housed in advanced robotic bodies sent on interstellar missions to collect data about other species by extraterrestrials in a faraway star system, or they could be an extraterrestrial species seeking some type of genetic union with us. When alien abduction reports are compared with historical stories of fairy kidnappings, it seems that they may be the same kind of interdimensional beings in some sort of ancient symbiosis with our species.

8

...

BLUE- AND PURPLE-
HUED BEINGS

Sara Phinn Huntley

As mentioned in chapter 1, comedian Shane Mauss reported encounters with a "dancing purple gypsy woman" that he's "known for lifetimes" at an inner space carnival.[1] However, he's not the only one to have encounters with interdimensional purple women while tripping. They have been reported throughout history in various ways, and a number of shamanic voyagers, alien abductees, and UFO contactees have reported encounters with blue- and purple-colored people and beings.

Blue and purple hues are located on the higher end of the color spectrum, so it's interesting that some people have encounters with beings of this skin color, which sharply contrasts them with the more commonly reported alien grays. People tend to have more positive or welcoming experiences with blue-hued beings than with gray-hued beings. They are often described as humanoid beings with blue and purple skin, and their presence is often associated with a feeling of great peace, love, and understanding. Seen as guides and teachers, they are said to provide wisdom, offer insight into the mysteries of life, and help facilitate spiritual growth, but as we shall see, they are not always predictable.

In the book *Sativa Psychonaut*, R. Kirk Packwood describes his encounter with iridescent blue humanoids while on a psychedelic dose of cannabis:

> I found myself in the presence of a large group of iridescent blue semi-opaque hominid figures. Whether these figures were alien, extradimensional, or intradimensional was not clear. Each blue being appeared very similar to its peers. Each being was standing/ kneeling in a different position examining things in the immediate environment. As I looked past the beings, I saw a large iridescent blue lighted semi-transparent semi-circular craft. It might have been a space or dimensional craft. The circular craft was very impressive in its color and complexity. Triangular and semi-square at the same time (suggesting higher dimensionality), with roundish glowing panels covering its surface. Looking upon the craft introduced me to the concept of creating complex semi-transparent, semi-opaque

art by attaching a number of interlocking elements in a multi-level creation.[2]

Many UFO encounters report blue or purple light shimmering around the UFO. Sometimes the whole world in which one finds oneself is blue. For example, one DMT user reported on Reddit, "I was catapulting, hurtling through hyperdimensional tunnels at extreme velocity. . . . I looked around and saw several alien life forms standing around in a purple-hued universe."[3] Another person told me that he was "engulfed in violet flame for a glorious eternity, but didn't sense beings, just the fire of purification."[4]

The blue or purple color of the beings themselves is usually reported

Sara Phinn Huntley

to be either the color of their skin or an aura of blue or purple light that glows or radiates from their bodies. One person told me, "I've seen blue-hued entities a couple of times. It seemed almost to be a skin, a basic something they used to characterize themselves to a human brain."[5]

Another person told me that he saw "something similar to this on DMT. They were white but around them were blue and purple hues." He continued, "There's no way that my drawing is completely accurate, . . . but there were about five of them and it was very welcoming. The experience almost felt familiar."[6] You can see the drawing he sent in the figure below.

Another person I spoke with had repeated experiences with a "welcoming" purple being. "I've met a purple lady," he said. "I couldn't see her face, but I knew by her expressions in my mind [that] she was warm and welcoming. She has also kicked my ass a few times when I thought I knew it all."[7]

Yet another person I corresponded with through a Facebook group

Drawing of five white beings encountered on a DMT journey, with blue and purple auras, shared with me in a personal communication via Facebook.

about psychedelic exploration encountered a faceless blue being while on DMT. She wrote:

> I took 0.05 mg—three long "hits" [of DMT]. It was like I was in a tunnel falling downward slowly, [with] lots and lots of purple and pink lights (almost like a paisley pattern) shooting past me fast and spinning round. I kept seeing a woman (no facial features or anything—kind of like a cartoon woman but all purple). She was facing forward and kept turning around to look at me and beckoning me. The full surroundings turned to her x1000's [in sensory intensity], beckoning me.[8]

Sometimes multiple people seem to report the same blue beings, as in the story I recounted in chapter 1 with comedian Shane Mauss introducing his friend to DMT. Here's another example that a friend sent me:

> Blue-hued female apparition was seen by three witnesses individually at a Shipibo ceremony I attended in Peru. These individual accounts occurred independent of one another, all noting the same characteristics and location (near a stream), which, to my mind, is meaningful confirmation of the legitimacy of the entity. Multiple sober witnesses are the Gold Standard, and this was very close to that criteria![9]

Sometimes the blue-hued beings seem to have healing abilities and can help us. For example, one person told me:

> I have [encountered blue entities] several times—once where I was crying out for help as I was suffering from scoliosis at the time, which progressed over a decade, and I needed my back to straighten. I asked for galactic help, and later that night I was awoken by two blue beings hovering above me with their hands over my body and I felt them straighten my back. I woke up the next morning, no pain, all straight and haven't had any issues since and it's now been five years since that had happened.[10]

Interestingly, blue is the color that psilocybin-containing mushroom stems turn when freshly picked. Another person I met online in a Facebook group devoted to psychedelic exploration, Roar Ladd, told me about his experience with psilocybin mushrooms and DMT:

> Both colors are common for me. One of my first experiences with psilocybin included a vision of an immense Shiva. His body was translucent and looked like the night sky. The outline was dark blue, but the body itself was translucent with dark blue/purple space and stars within. On DMT I've seen many "beings" that seem to be made of incredibly complex geometric forms that are moving and changing and incredibly colorful. These are hard to remember or describe, but blue and purple stand out in a lot of the memorable encounters. One was sky blue and white and felt very threatening, but it dissolved and vanished almost instantly. I didn't really "fight" this thing, but I just instinctively refused to accept it. It seemed to be there to scare me and when I didn't take the bait it just went away. Several months later, something made of dark purple and black circles succeeded in scaring the hell out of me. Many of these trips included very healing and comforting beings, which also had a lot of purple and blue. With ayahuasca, I caught a glimpse of a purple woman. It was just a brief flash during a quick series of images, but in the context of the conversation I was having with the plant, she seemed to be a representation of ayahuasca.[11]

Similarly, someone else told me, "My encounter with Ganesh was notably blue/purple with the surrounding cloud forms being an almost electric pink/yellow. Ganesh's skin was blue/purple."[12]

Although one person told me that "blue [beings] are always benevolent for me," and this seems to match many of the reports, it's not always the case. For example, one person told me:

Sara Phinn Huntley

Yes, definitely blue-hued people. I left my body and traveled up a birthing canal of sorts, and the vortex I was traveling through had all these blue Hindi-looking deities looking at me. A lot made faces that were horrifying. It was hard to keep moving through the canal. But once I made it through, I found myself in deep space. I was a ball of white light energy amongst a field of other orbs. I felt like a star in the sky. But I felt more content than I'd ever felt before. Like I was back home or in the womb. It was a very powerful trip.[13]

Bestselling author Whitley Strieber describes encounters with small blue-skinned alien beings, which he calls "kobolds," from northern European folklore. In *The Super Natural*, Strieber connects the

"little blue men" of his close-encounter experiences with the kobolds of German folklore:

> Like so many of the aliens believed to have recently arrived, little blue men have been with us for a long time. As is the case with most of the other forms, they were originally identified in folklore—most frequently, in this case, in northern European folklore. . . .
>
> In the past, they were most often found in mines. Now they're known as "blue aliens." They were observed by German, Welsh, Cornish, and English miners. The folklore was most developed in Germany, where they were given the name kobolds. Because of

ET Soul Aspect, by Marina Seren

its dark blue color, the metal cobalt, discovered in a German mine in 1735, was named after them. But the word "kobold" ultimately derives from the Greek for "rogue." Most appropriate, judging from my own experience with them.

They were said to carry, at the level of the heart, a small orb, glowing red, and, in point of fact, I've seen that myself.[14]

As Strieber points out, blue- and purple-skinned beings commonly appear in myth, and they also appear in popular culture. In addition to the kobolds, one thinks of the Hindu god Krishna, the forest-dwelling alien race in the *Avatar* films, and the comic-film-toy franchise of blueberry-colored Smurfs that live in mushroom houses. Someone even once told me that purple-skinned Barney the Dinosaur was his spirit guide on the astral plane.

The blue beings also frequently appear in alien abduction and UFO contact scenarios. One person in an online chat group about alien abduction experiences wrote: "Little blue aliens about three feet tall, they were the ones that shot me out of their ship in an air bubble toward a planet that looked like Earth but was alien, although I wasn't allowed to go with the blue guys where they were going."[15]

Another person in the alien abduction community told me, "I woke up in bed to a little blue alien sitting cross-legged on my ankles. She smiled and rose up in the air and backward out through the glass window. That was about thirty years ago, and I still have the strange triangle on my ankle that I found after the episode."[16]

Marina Seren—a channeler, psychic medium, mystic, and speaker who, at the age of five, began talking about how her soul was teleported into her mom's womb from another star system—described an encounter with a blue-skinned entity: "In 2017 approximately, I had one of my first ET contact encounters with my closest ET family, which is the blue-skinned Celtic Anunnakis, once considered gods in Hyperborea. They presented themselves to me in ancient Celtic robes and forming a ritualistic circle."[17]

Someone else in an online UFO contact group responded to my query about encounters with blue or purple beings:

> Yes! A lot of these kinds of experiences for me are more so in the "spiritual" realm. I believe the purply blue beings are definitely more inclined to interact with those who can accomplish outer body experiences. It's not always the case. . . . Mine are always extremely pleasant and I've been accepted and deemed trustworthy enough to ride in the spaceship and see things I cannot describe with words.[18]

People usually describe their encounters with the blue and purple beings as generally friendly and "welcoming," and sometimes with romantic or sexual overtones, but it seems that they can also be mischievous or have intensions that humans have difficulty understanding. They are often seen as benevolent and caring beings who are here to help humanity evolve, and they are an integral part of many people's spiritual journeys.

9
■■■
CLOWNS, JESTERS, TRICKSTERS, HARLEQUINS, IMPS, AND JACK-IN-THE-BOX ENTITIES

The late ethnobotanist Terence McKenna once said that "the archetype of DMT is the circus,"[1] and to this day, a considerable number of people note that they see clowns, jesters, or similar trickster beings in their trip reports.[2] In Rick Strassman's original DMT study a number of subjects reported encountering clowns, jesters, jokers, and imps.[3] For example, one subject in Strassman's study reported:

> I started flying through an intense circus-like environment. I've never been that out-of-body before. . . . We went through a maze at an incredibly fast pace. I say "we" because it seemed like I was accompanied. . . .
>
> There was a crazy circus sideshow. It was extravagant. It's hard to describe. They looked like Jokers. They were almost performing for me. They were funny looking, bells on their hats, big noses. However, I had the feeling they could turn on me, [that they were] a little less than completely friendly.[4]

While some writers try to explain these encounters by describing them as archetypal, meaning, in the Jungian sense, that they are manifestations of the collective unconscious,[5] the strange mystery of why they occur with such frequency still remains. However, examining the archetypal meaning of clowns and jesters might give us a clue into what these mysterious beings are trying to communicate. It may be that the way we see the entities in hyperspace depends more on how they wish to present themselves to us than their physical morphology. If this is the case, then the visual forms these entities present in hyperspace may be more like the avatars we wear in virtual reality than their true physical form.

In *The Cryptoterrestrials*, author Mac Tonnies suggests the following:

> The psychedelic realm has the visual flexibility of a multimedia installation or high-bandwidth website, forcing me to consider that it's

Architect of Divine Madness, acrylic on wood panel by Jeff Sullivan

actually designed as a communications system, a sort of neurochemically derived "chatroom" populated by all manner of colorful "avatars."

It's conceivable that "trippers" can access this interzone, even if inadvertently. The beings seen—described similarly in UFO and drug narratives—might be the equivalent of neuropharmacologists and system operators.[6]

Perhaps these beings present themselves as clowns to send us a message of some sort? Jungian analyst James Hollis suggests that the trickster archetype might be symbolic of "the personification of the absolute autonomy of nature," that "disrupts the flow of daily life."[7] However, like all the DMT entities, when we actually encounter these beings, explaining them away as "archetypes" rarely seems satisfactory, although this may give us insight into the message that they're trying to communicate to us.

In a personal communication, one person described a frightening and meaningful encounter with a jester on DMT. He wrote:

> Another time I encountered a jester, which was a little bit traumatic, but it turned out to be very profound. It started to take away my identity and my place in things. Like it took away my place in humanity, then my place in my family, then my memories, then my body, then thoughts, etc. When I realized what was happening I freaked the fuck out, but it got to a point where I was just a ball of consciousness. Dude, at that point it could have been 2 seconds or 200 years, I have no idea, but it was bliss. Then it started to give me back all of my "identities" and I could see them with fresh eyes and I got to see what shapes my personality, what was serving me, and certain loops I've created in my mind that cause me and others pain.[8]

A graduate student working on her master's thesis about the appearance of the trickster archetype in the DMT experience sent me the following account of an experience she had after taking "three big hits [of DMT] from a bubbler (until I couldn't possibly smoke any more)":

After a fast-paced journey through brightly colored and constantly moving checkered rooms, I arrived in a courtly hall, which is where I encountered a single entity: a jester. The jester was positioned in my left peripheral vision, as if hovering just over my shoulder. He was wearing red and white and black and white harlequin checkered clothes and a traditional cap and bells-style jester hat. The one atypical feature was that he wore a plague doctor's mask with a long pointed nose or beak. He seemed like he was there to show or tell me something. He did not say anything with words, but he did seem to communicate nonverbally. It was as though he was my tour guide to this spirit dimension. My feeling about his presence was awe, like it was something unfathomable and also very important. He seemed to be neither good nor evil, but there was a mischievous quality to him as well. The messages I took back from this journey were: reality was not what I had thought it was and some kind of higher power/intelligence does exist.[9]

Sometimes one of these entities might appear as a living jack-in-the-box, similar to the childhood toy, where we turn the crank of a box to play music only to have a jester or clown leap out to surprise us. In response to an informal survey I put out, one person told me about an experience they had with jack-in-the-box entities:

Had a "lock out" on N,N-DMT. Entire "panel" of 2-D to 3-D jack-in-the-box boxes (complete with question marks on the outsides) as a field of vision with entities laughing but unseen "hiding" in them. It was like a VR 3-D neon holographic space. I remember a thought of "did I just fall into a video game or slot machine?" The feeling conveyed/message was like . . . laughter and a middle finger instead of finishing/falling through the tubes and blasting off. Sing-song "neener neener" or "nanna nanna boo boo" feeling to it. Like a joking friend giving you the finger. There was like a focused intent to let me know I didn't have clearance/ticket for the full ride that time, and a desire to play with my awareness there at the edge.[10]

Purr-plex, by Harry Pack

Other people have reported this same experience of the jesters flipping them off. Comedian and podcast host Joe Rogan has described how jester entities on a DMT trip gave him the middle finger as an attempt to teach him that he was being too defensive. Rogan said:

I always feel like it's lessons. I always feel like it's time to go to school. Sit down, here's what's going on. One of the last ones, most profound ones, was a bunch of jesters that were all giving me the finger. They were all circling around me, like giving me the finger. [Joe holds up his middle fingers with both hands.] . . . It's teaching, if you're tense, if you're reacting negatively to this jester giving you the finger, like how do you feel about yourself? Are you in constant defensive mode? Then when I sort of relaxed myself, they started wagging their finger back and forth, like yeah, that's it. It was very, very strange.[11]

Another example of a jester flipping off a DMT user came from someone on Reddit, who reported:

Yeah, the jester's given me the finger a couple times. First time he was wearing a white suit with both hands flipping me off. His head was also a giant hand giving me the finger. Lol. I got a feeling that he was just messing with me, seeing how I'd react. I found it funny and welcomed the mocking.[12]

Interestingly, the day after I wrote the above section about DMT entities giving people the middle finger, I interviewed Alexander Beiner, one of the subjects in the Imperial College London extended-state DMT study, who told me about the following synchronicity that he experienced soon after a DMT session:

I was living on a houseboat at the time, and there were around fifty boats there, a nice community. I had a friend there, and we always

used to give each other the middle finger when we saw each other as a joke. This particular day, I was on my way to a meeting, and he flicked me off with both fingers, and that was new and different, so I did the same to him. We just had a laugh and a chat, and I went. Then I was on the escalator from the London Underground, in London Bridge. It's quite a busy station. It's this really long escalator up the street, and there's another escalator coming the opposite direction on the other side. I was just standing there. I didn't have headphones in or anything, and I was just looking around. Then this guy on the opposite escalator turned to me. He was wearing a mask, I remember. He turned to me, looked me straight in the eyes, and flicked me off with both fingers. And I was like, what the fuck? It was just such a strange, uncanny feeling. Then I was going through a whole process of trying to make sense of it, trying to stay agnostic, and then I was like, okay, did I imagine it? But I don't think I imagined it because that's not the kind of hallucination I've ever had. That's more like a delirium experience if you just imagine something that's just absolutely not happening. Because I had a media channel, Rebel Wisdom, I thought, maybe he watches our stuff, and he recognizes me and really hates me? Super unlikely, though. We weren't that big. I'd been recognized maybe two or three times in public, and it was super rare. But it's the only explanation I could really find because he really looked right at me. He really made eye contact. Then I thought, well maybe he just didn't like me, but it was just so fucking weird.[13]

It was weird indeed that Beiner shared that story with me right after I had been writing about DMT entities flipping people off, although I'm not sure what it means.

Sometimes the jesters in DMT experiences present more specific messages, but their communications don't always make it through. Another person responding to a survey I'd put out shared the following experience:

One of my most favorite experiences ever . . . was a group of female jesters who were spelling letters out to me by doing acrobatic formations with their bodies (a few of them stacked on top of each other to spell out each letter). [I] was in a beautiful court garden with topiary. And I would give anything to have remembered or realized what they were trying to spell out to me. . . . [I] will never know . . .[14]

Apparently the clown entities were trying to spell out a message that didn't quite get through to her.

EXI(S)T, by Salvia Droid

Is it possible that the reason we have people performing as clowns in our world is that they are reflecting what occurs in hyperspace with the jester encounters, and not vice versa? In his book *Visionary*, Graham Hancock suggests that shamanic journeys could be the origin of clowns, rather than clowns appearing on the cultural landscape first and then making their way into people's psychedelic experiences. Hancock writes:

> Where did the idea for clowns come from in the first place? Were the visions of carnival-type figures seen by Strassman's subjects, Maria Sabina, Michael Harner, and others influenced by strictly modern and culturally contingent television and circus spectaculars? Or is it possible that the direction of influence really flows the other way, and that the inspiration for the earliest clowns came from visions and hallucinations seen in altered states of consciousness—whether entered spontaneously or under the influence of DMT-linked hallucinogens? We know that at least as far back as ancient Greece, a land rich in psychoactive plants, stage plays, farces, and mimes frequently featured performances by dwarves and children dressed up in ways quite similar to modern circus buffoons. Before that, the history of such theatrical figures is obscure—as well it might be if they had emerged from occult realms that were originally accessible only in visions.[15]

Although reports of encounters with these interdimensional clowns often describe them as slightly menacing tricksters, more often they seem to be mocking our seriousness and toying with us, or sometimes trying to teach us lessons. Nonetheless, it's probably best to use caution when interacting with these beings.

10

∙∙∙

GATEKEEPERS AND THRESHOLD GUARDIANS

Many people have reported shamanic encounters with entities that appear to stand guard over the entrance to extracorporeal or spirit realms and allow entry only to those whom they deem worthy or who can pass certain tests—such as with bravery or pureheartedness. These beings are often referred to as gatekeepers, threshold guardians, or dwellers on the threshold, and they are described in many shamanic cultures and psychedelic experiences. The archetype of these entities occurs in various forms, such as a serpent or a dragon watching over the entrance to the spirit world. However, depending on one's cultural background, it seems that the form of the gatekeepers can vary quite considerably.

This sort of entity is described by a number of esoteric teachings as a spectral menacing figure that manifests as soon as a student of the spirit ascends upon a path into the higher worlds of knowledge. According to Patrick Lundborg, in shamanic cultures these guardians can take on many appearances and serve an important role:

> In his main role to scrutinize aspirants to higher realms of Innerspace, the Gatekeeper may take on any number of outward appearances, where known examples include a sluggish reptile monster, a brutal prison guard, a Native American chief, a cartoonish nightclub bouncer, and the frequent alien-insect variants. On a purely anecdotal level, the Gatekeeper may most readily appear on direct inquiry ("application") from the psychedelicist to ascend to a higher level. . . . If found properly cleansed, mentally and physically, the applicant will be given access to the higher level with its previously unseen wealth of insights and experiences. This psychedelic visa is not temporary but will remain valid on later trips, facilitating a swift passage through the lowest level and its colorful abstracts to bring the traveler to the next level quicker than before. In other words, provided that the good spiritual and physical status has been maintained, the Gatekeeper guarding the second level will not reappear; however, higher Gatekeepers and other rites of passage may still be encountered further ahead in Innerspace.[1]

In other words, according to Lundborg and others, these beings grant us the privilege of accessing higher dimensions of reality. This is an idea I've frequently encountered and personally experienced in my own psychedelic journeys. A good example can be found in Dan Carpenter's wonderful book *A Psychonaut's Guide to the Invisible Landscape*, in which he describes his experience of ascending a hierarchy of levels in hyperspace (what he calls the "Hive Mind"), encountering astral police, and earning the special status of being "hollowed out now like a donut," which gave him greater freedom to explore these other realms that he accessed through the dissociative anesthetic DXM. Carpenter writes:

> I am taken to a place where people such as myself, who have had such a tour, are being "processed." My turn comes and my being is "cored." What was a blob (me) has been hollowed out now like a donut—without a middle. I understand it is an honor. It comes with the price of no return (to the old me). I have carte blanche in the Hive Mind now.[2]

Lundborg describes a specific form of the gatekeeper specific to indigenous ayahuasca lore in the Amazon, "which, despite the mythical variation between tribes and language groups, appears to be fairly common across Amazonia. In the mythical-visionary space that the ayahuasca drinker enters he will encounter a giant serpent, typically an anaconda or a boa, who is present not only as the guardian of the spiritual world but also incarnates ayahuasca itself."[3]

Western culture certainly has its share of spiritual gatekeepers as well. One thinks of Cerberus, the three-headed dog from Greek mythology who guards the entrance to Hades, and Saint Peter, who guards the pearly gates at the entrance to Heaven in Christian traditions.

In my research for this book, I heard many different descriptions of gatekeeper beings. For example, one person told me that a guardian he encountered looked like "Goldar from Power Rangers, but with

The Guardian, by DMT Vision

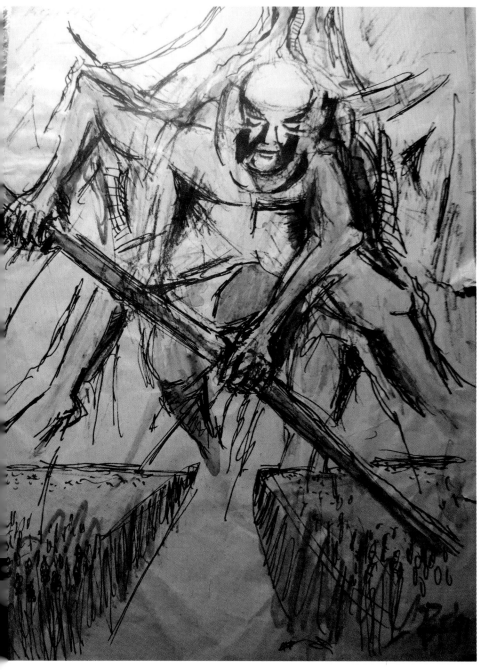

Blue God on a Cornfield, by Björn Freiberg

hairless satyr legs. He wore sleeveless, dark blue almost black robes, with a couple stripes of dark red. He wouldn't let me pass unless I did his very non-specific scavenger hunt in another area. I found what felt like appropriate items, but never made it back to him."[4]

Another person said the threshold guardian they encountered looked like "Merlyn from Arthurian legend," and someone else said they met one resembling "a train conductor that looks a little like [rapper] André 3000." Another person said that there were "two of them, hooded, brown rough cloak, large folded-down wings at rest, face hidden, flanking a circular portal."[5]

Someone else described their experience with the "hat man":

> The hat man that lets you into the DMT realm, I know him as Yahweh. He's the same person who I spoke to when I watched my life play out as a child, and he asked me, so you want to do that for me? I said sure. Because it was either do that or go back to hell. Pretty obvious choice, eh?[6]

A DMT user posted the image (on p. 144) on Reddit, with the attached text: "DMT space: The guardian of dimensions. I saw this giant being many times. He is prohibiting the access to some places, or finding me and bringing me to some being to talk to. He can see everything and opens dimensions like boxes."[7]

Sometimes guardians appear in dreams. Björn Freiberg shared with me the drawing (on p. 145) that he did of a "blue giant" threshold guardian in a wheat field, a figure he encountered that led to a major transformation in his life.

Gatekeepers and threshold entities appear common in essence but vary considerably in form. Be prepared for a challenge when you encounter one.

11
...
SPIRIT GUIDES

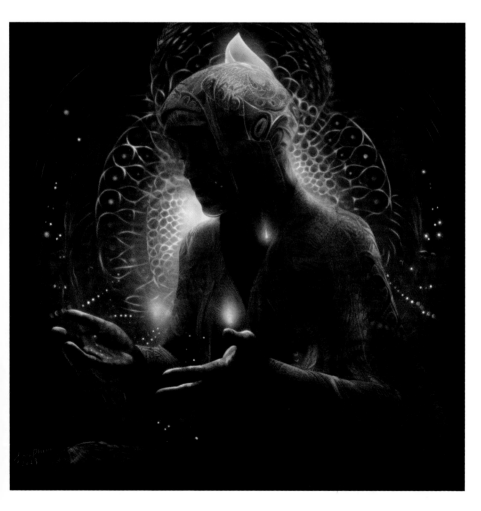

It's not uncommon for people on psychedelic journeys to encounter entities that they describe as spirit guides, who act as teachers that show them around the dimensions of hyperspace and teach them various life lessons.

Many people report connecting with spirit guides on New Age–style "shamanic journeys," and there are numerous guided visualizations and meditations designed to help people do this. For example, yoga and meditation teacher Alyssa Snow demonstrates how relaxation, often with drums and rattles, can help us "travel deep within ourselves to connect with spirit guides," and she takes people on guided visualizations "to the lower world where you can connect with your spirit guide to get clarity on a life question or situation."[1] Snow guides people on meditative journeys through what she calls "different dimensions," where they encounter "lights" that bring them to their spirit guide, as a way of getting in touch with deeper, spiritual aspects of themselves. However, it's unclear in these types of experience whether the spirit guides are actual independent entities or aspects of one's higher self.

Nonetheless, spirit guides also appear on psychedelic journeys with various psychoactive substances. For example, in *The Scientist*, neuroscientist John C. Lilly describes having encounters with beings, or guides, on ketamine and PCP journeys. These beings arrange coincidences for him, explain his state of evolution, and take him on a tour of the cosmos in order to educate him.[2] Lilly describes encounters with different alien intelligences, such as ECCO (the Earth Coincidence Control Office), who orchestrate synchronicities in his life; the Solid State Entity, a hyperintelligent computer entity from the future composed of super-advanced electronic circuitry; and the "three beings" or guides, wise entities that teach him various lessons and show him around the universe. When I interviewed John in 1991, he described how his guides educated him:

> When I was out for five days and nights on PCP, the guides took me to planets that were being destroyed and so on. I think ECCO made me take that PCP so they could educate me. And they kept hauling me around and I tried to get back, but they said, "Nope, you haven't

seen all the planets yet." One was being destroyed by atomic energy
of war, one was being destroyed by a big asteroid that hit the planet,
another was being destroyed by biological warfare, and on and on
and on. I realized that the universe is effectively benign; it may kill
you, but it will teach you something in the process.[3]

Psychedelic spirit guides appear in numerous forms, and in addition
to being teachers, they are also reported to have a protective function.
One person shared this with me about their psychedelic spirit guides:

Mine are cats. They show up when I am about to encounter some-
thing scary and are a presence, sometimes made of stars, sometimes
just a sense, but they always let me know they're there to protect me
if I need them. They show up less and less the more I build confi-
dence, but I can call them forward if I need them.[4]

When I interviewed Alexander Beiner, one of the subjects in the
extended-state DMT study at Imperial College London, for this book,
he shared with me his encounter with an entity he described as "the
Spider Queen," who was accompanied by a "teaching presence":

The most memorable entity I encountered was what I called the
Spider Queen. This was in the second dosing, and I had broken
through. I often had this experience of entering—a little bit like
Strassman's subjects—a kind of holding area, and then break-
ing through that to a different dimension, is the best way I could
describe it. So, for the first few minutes of the experience, I'd be
in the same place every time, and then I would—through an act
of experimentation and, I guess, of will—eventually move and
then be guided by this, I call it the "teaching presence," the pres-
ence of the DMT. I'm not quite sure how to describe it. Maybe
my higher self or it's kind of hard to put my finger on. But so, I
would be guided through different places. And in this instance,

I was in this space—outer space. And the entities were planet-sized, gigantic, and I was floating past them. They all looked like planets, really, and didn't really register or care about me at all. I was pretty insignificant.

Then I came across one that was quite dark in color, complex, and spider-like. If you mix together a spider and a cocoon, that's the best way I could describe it. It was huge. And it was incredibly feminine and incredibly alluring, but really dangerous. And I got charged up, almost sexually. But I had this feeling that I had my arms crossed, and I was like, Oh, it's trying to seduce me, but I'm not going to be seduced because I'm too centered in my masculinity. I suddenly felt very masculine, basically. I was like, I'm too centered in my masculinity, it's not going to happen. And then, as I was saying that, it had wrapped me in a web, and I realized I'd been played.

I'd been seduced, and I was really impressed. Then I was inside. I don't know if I would say I was inside the entity, but I was certainly in its realm. It was this gorgeous dark, like browns and blacks, with really intricate patterns, and I was quite amazed by them. There was this real sense that it wanted to merge with me, and I felt very reluctant to do that. It was a push-pull, and then there was a whole negotiation and conversation around, okay, why should I merge? Then the word "love" was written just right in front of me. Basically, there was a bigger lesson around where it was, a bigger inquiry, and the question was really around me and intimacy, and why should I merge with another person to begin with?

So with all of my dosings—except for the final one, which was very metaphysical—the theme was mostly to do with intimacy in some way, with myself, with others, and feeling my feelings fully. So, this was all part of that wider story. Then I didn't want to, and I started to feel like the entity was quite dark, in a sense. But I was really hungry to see all the darkness. So I said, bring it on. Then the scene changed, and it was incredibly, almost aggressively dark, like with gravestones and just gnarly as hell. I was leaning into it, and

asking for more, like, Yeah! Great. Let's see how dark it goes. Then there was a process of me deciding I'm not going to merge with this entity or whatever it might be, and then it left. It was a little bit pissed off and it drifted away.

Then the DMT, the "teaching presence," showed me that there was a whole learning around this, that this was a metaphor. This is what's really fascinating about this for me, and that I'm still sitting with: The whole experience was, on one hand, a metaphor and symbolic of my own relationship to the feminine. It was also [on the other hand] an independent entity, and this is what my experience was. It wasn't like it was there just for my edification of "Hey, this is all for you." It was more like the DMT had guided me to this experience, and there was a lesson in it for me. It was a bit like if you had a guru and they took you to a marketplace and they were like, "Hey, I'm going to introduce you to this person who runs a stall because they're going to trigger the hell out of you and that's going to be a lesson for you." Right? And then process it afterward. That doesn't mean that the person running the stall doesn't exist or isn't an independent entity. It just means that it was part of it. So that's what was so confusing and fascinating about it. So that was one of my most vivid entity encounters.[5]

On the online community of Reddit, someone posted the following request about DMT spirit guides: "Describe what they looked like and what they were trying to show you." One person responded:

I'm not sure what "they" looked like, but they took me to see god, or the head of it all, who was an orange-red-yellow kaleidoscopic image without any discernible features, and I could tell it was angry, but not at me. Then they showed me the eleven dimensions, and I was given the knowledge that we are all part of one life force, and we are all connected.[6]

Another respondent said:

Sara Phinn Huntley

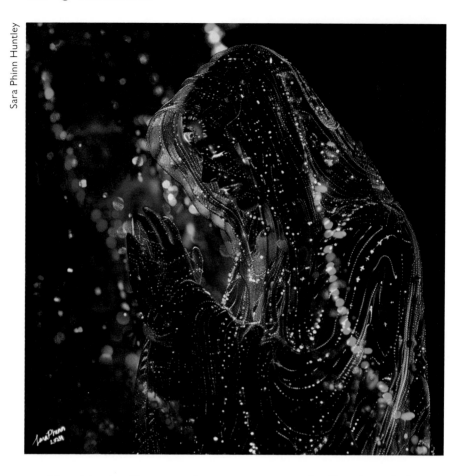

My spiritual guide appeared to me as a woman who flew through the air. The only reason that I call her a woman was her face; the rest of her was just streamers of blue and yellow light that looked like hair. From the position that I was laying in she plucked me up and flew me through the most beautiful and indescribable world imaginable. It was and is to this day the most beautiful moment of my life.[7]

Yet another person posted:

They were barely discernible, "there" but not in a totally visual sense—my perception of them was probably 80% mental. It was the best I could do to even realize that they were beings at all. What

they tried to teach me, on the surface, is still quite clear. They "told" me that I had left Earth and my previous life behind forever, and that I was now embodying some kind of destiny for the human species. . . . This destiny, in part, was to embark upon "the next level of human existence," and the beings were patiently trying to guide me along that path by teaching me how to live in their utterly strange hyperspace dimension—skills like how to navigate the infinite convergence of thought, sensation, and physicality that I was witnessing so spectacularly.[8]

Yet another person shared this encounter:

Blocky humanoid entity resembling "The Thing" from The Fantastic Four, covered in Aztec/Mayan patterns and geometric lines with no discernible facial features—just a blocky head and rectangular-ish "arms." My vantage point was that of the baby velociraptor hatching from the egg in the original Jurassic Park. It felt like it had been waiting for me the whole time, as if it saw me vape and inhale the DMT on my couch and drift way. I could tell it wanted me to pay attention, because I felt resistance every time I heard a noise or tried opening my eyes. It seemed to be guiding me, manipulating my brain, and communicating through feelings, emotions, and math. "Everything is math." That's the first thing I uttered after coming back. It also felt like it knew when I was "going back" before I did. It seemed to have sort of "gave up" and let me wake up. Afterward I shook intensely and involuntarily, while seeing LSD-like visuals for approximately three minutes. It was awesome.[9]

Although spirit guides encountered on DMT and other psychedelics can come in many forms, they generally seem like benevolent teachers who hold the possibility of imparting to us valuable lessons, protecting us from harm, helping us navigate the realms of hyperspace, and making difficult experiences seem more bearable.

12
...
EASTERN, MIDDLE EASTERN, AND INDIGENOUS AMERICAN DEITIES AND DEMIGODS

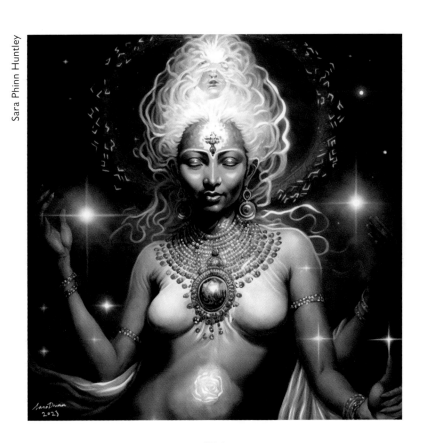

Sara Phinn Huntley

As with the sections on Jesus, the Virgin Mary, and the Devil, which are largely associated with Christian backgrounds, many people have reported shamanic encounters with beings that appear to be deities and demigods from varying religious backgrounds and cultural traditions. These commonly include encounters with Egyptian gods and goddesses, as well as with djinn from the Middle East, Hindu and Tibetan deities, and South American deities.

Surprisingly, sometimes these deities and demigods appear in the visions or psychedelic encounters of people with no background in the tradition from which they originate, implying the possibility that at least some aspects of these beings transcend culture. British biologist Rupert Sheldrake's morphic field theory, the occult notion of egregores,

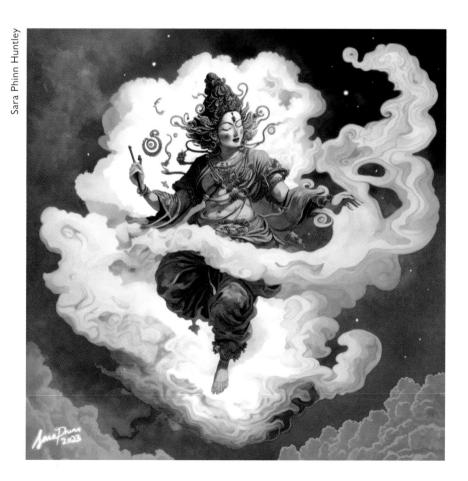

and psychologist Carl Jung's idea of the collective unconscious offer other possibilities for how people are able to observe the transcultural aspects of these beings. Sheldrake theorizes that nature has an inherent memory, and that all forms, physical and mental, have fields that resonate across space and time. An egregore is an occult concept representing a nonphysical entity that can arise from the collective thoughts of a group of people. Jung's notion of collective unconscious supposes that all humans share a common, collective sub-awareness that contains archetypal or universal mythic forms.

Some of the Egyptian deities commonly encountered include Ra, the god of the sun, and Bastet, the feline goddess with a powerful protector aspect. In chapter 17, I'll describe my encounter with Bastet as a cat-headed goddess. Someone online shared with me his DMT encounter with Egyptian deities on Easter Sunday in 2014:

> I blasted off and saw Anubis, who was surrounded by the planets orbiting him, with the sun above his head. He began to try to explain to me the origins of Easter and instantly zapped multiple words into my head at once: Ishtar, Astarte, Aether, Asheroth, Innana, Asherah, and more I can't remember. I had never heard or known of any of those names but some research afterward yielded fascinating possibilities.[1]

Anubis is the Egyptian god of the underworld. Ishtar is a Babylonian goddess associated with beauty, sex, divine law, and political power. Astarte is a Near Eastern goddess with similar associations as Ishtar. Aether in Greek mythology is thought to be the pure essence that the gods breathed, filling the space where they lived. Asheroth or Asherah is the mother goddess of the Canaanite pantheon in the Bible. Innana is the Mesopotamian goddess of love, war, and fertility.

The djinn (or jinn) are invisible beings who appear in the early pre-Islamic Arabian religious systems and in Islamic mythology. Genies that emerge from a polished lamp and grant wishes in Arabic tales are

said to be of djinn origin. Like humans, they aren't inherently good or evil, and they may represent a pagan influence in Islamic religion. It is said that although they are generally invisible, the djinn are supposed to be composed of thin and subtle bodies that they can change at will. They often appear in the form of a snake, although sometimes also as scorpions, lizards, or humans. One person described his psychedelic experiences with a djinn as follows:

> I have a Jinn. Her name is Jenn. Her favorite color is purple, which she embodies. She likes to look simple and let personality do her talking. One of her favorite forms is as a cat. Feminine and passionate, highly sexual, as well as creative, Scorpio dominates. She has a

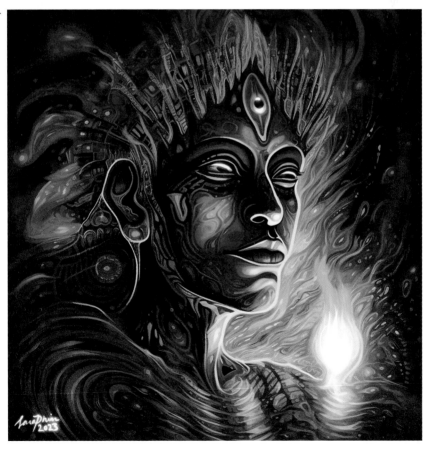

Sara Phinn Huntley

feminine hourglass figure. The top of her head is hair, but it coils into a horn-type style, with strands coming down on both sides of her face, sharp like blades. She is all purple, but her eyes, lips, hair, and parts of her figure hold different shades of metallic purple. She is one of my past/parallel world wives, who is aware of being connected to me, even if we aren't in the exact same realm anymore. There are other wives, but nonetheless, I love my Jinn. From what I understand, she is also my servant, to do as I ask and please. I don't use or need her for that, so I just talk to her and love her. But I could use her for things. Like when you hear about witches sending spirits after others. She can do that, if wanted.[2]

It's not uncommon for people to describe encounters with Hindu gods and goddesses, such as Kali, Ganesh, and Shiva, during psychedelic experiences, and even people with Christian or Western backgrounds report this. One person told me about a DMT experience in which he saw "the Hindu god Ganesh while breaking through."[3] Another person described a psychedelic encounter in which he "met Ganesh, a pink baby Ganesh." He continued, "The vision was so moving that I couldn't stop saying thanks and crying."[4]

Another person described having the following experience after smoking DMT:

[I] began to see this bright color of brilliant blue. The color started to move away and as it did, I noticed intricate patterns appearing, and as the color moved further away I could now see these patterns were a part of the headdress of what I could now see was this incredible blue elephant! The next thing I know I am standing at the bank of a river. In front of me I could see a wall of green bullrushes. Through these bullrushes I saw these eyes staring at me. I said, who are you? She rose up, with all these arms, she seems to be about 12 to 14 ft tall. She was staring at me like she knew me, with love and excitement. She was sitting on a lotus flower, dressed

all ornate and looking so beautiful. She floated across the river and met up with this other man who had a white top hat, who was also floating on a lotus flower and had many arms. He started talking to her and appeared to be upset with me! Then when I came round I had no idea who they were! I live in England and have been bought up as a Christian. I started to research my experience on the Internet and after several weeks I discovered they were Hindu gods. But I didn't know who! I came across an image of Lord Shiva and found his wife Privati. I was convinced it was her who I saw. Several months later I came across a Hindu shop in Brighton, so I went in and asked for any information on Privati. I explained my story to the shopkeeper, and he said I don't believe you saw Privati, I believe you saw Lakshmi! (They look very similar). He explained that Ganesh appears with a mouse, Shiva appears with a cow, Privati appears with a tiger, and Lakshmi appears with an elephant. So, I googled Lakshmi and I even found images of her siting in bull-rushes and the man with top hat, who, I saw, was Lakshmi's father Lord Brahma! I thought to myself, what did this vision all mean? The meaning of this vision was unbelievable, and it took me over a year to understand it. In the vision I was Lord Vishnu! I know I am not a god, but I now know I am part of Lord Vishnu and he is a part of me. Lord Vishnu is the reason for my consciousness. I thought this sounds crazy, but I found out that the ultimate goal of practicing yoga is to have the experience that you are divine and to have a direct effect connection with Lord Vishnu![5]

Carlos Castaneda is well known for his books about his shamanic adventures, including *The Teachings of Don Juan*, *A Separate Reality*, and others. Castaneda said that Don Juan, the shaman in his books, gave the name Mescalito to the deity of the peyote cactus. According to Jay Courtney Fikes, a researcher who has studied peyote in depth, the name Mescalito had "never been mentioned by any of the three hundred thousand NAC [Native American Church] members, who belong to some seventy distinct

tribes within the United States, nor by members of Mexican Indian tribes such as the Tarahumara or Huichol, whose reverence for peyote is unsurpassed."[6] Nonetheless, thanks to the popularity of Castaneda's books, this name for the spirit of the peyote plant has entered Western culture and can be found in the writings of numerous authors. One such author is Robert Anton Wilson, who, in his book *Cosmic Trigger*, told the story of his encounter with Mescalito shortly after a peyote experience. Wilson described Mescalito as a dancing green-skinned figure with pointed ears.[7] This was similar to what Castaneda had described, but Wilson saw the little green man before he had read Castaneda's accounts.

Thanks to the late Peruvian shaman Pablo Amaringo, many of the South American deities and demigods that are commonly encountered

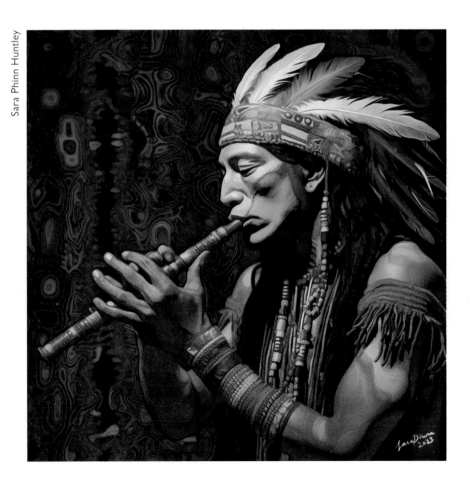

Sara Phinn Huntley

during ayahuasca ceremonies have already been categorized. There are two beautiful coffee-table art books of Amaringo's paintings that describe the different types of beings and entities that interact with people under the influence of ayahuasca. These books, *The Ayahuasca Visions of Pablo Amaringo* and *Ayahuasca Visions: The Religious Iconography of a Peruvian Shaman*, contain dozens of paintings by Amaringo of ayahuasca visions and encounters with otherworldly beings, as well as detailed descriptions of the entities, such as Ila, magical tree beings that uproot themselves and fly through the sky, and the Unai Shipash, winged muses that maintain the cosmic forces that govern the physical universe.

When I was in Peru, I smoked some changa, an herbal blend containing both DMT and harmaline, like ayahuasca. After three tokes, I found myself lying in a huge crib, like I was an infant, and these beings with huge faces were making funny, goofy faces at me, similar to how parents do when they look down at a new baby to try to get the baby to laugh. These beings looked almost monstrous, with horns and fangs, but also kind of silly, and I laughed out loud. They reminded me a bit of the characters in Maurice Sendak's children's book *Where the Wild Things Are*. The next day I was in downtown Iquitos looking through a pile of trinkets in a souvenir shop when I spotted a little carved figurine with one of the same faces I had seen in that changa encounter. Later, while looking through my copy of *The Ayahuasca Visions of Pablo Amaringo*, I spotted the entity again. It was Alpha Manchari, described as "guardian of heart and earth."

One person described an encounter he had on magic mushrooms with the Aztec deity Xochipilli, prince of flowers and god of psychedelic plants:

> I saw Xochipilli in my last high dose sessions, 2 weeks ago, on Mexicana. Wasn't aware of the culture, so I got anxious a little bit, turned out to be one my best rides so far. After research I did, [I found that] he's a protector, known as the prince of flowers. [It] was one my clearer vision so far.[8]

Someone else shared with me their psychedelic encounters with an Aztec god:

> I often run into a serpent-type guy who I'm quite certain is Xiuhcoatl, the Aztec fire deity. The first time we met he tasked me with finding a structure under a river in the Amazon. I was given maps and details of the importance of the thing (which I definitely forgot). Needless to say, I never went. Now, every time I run into him he is super frustrated that I haven't completed his mission.[9]

Encounters with deities from different religions and mythologies from around the world are commonly reported in psychedelic experiences, suggesting that there is a deeper reality to these beings than what anthropological theories of culturally bound traditions might imply. Although encounters with these deities tend to be extremely powerful, they are usually experienced as positive and beneficial.

13

...

JESUS CHRIST

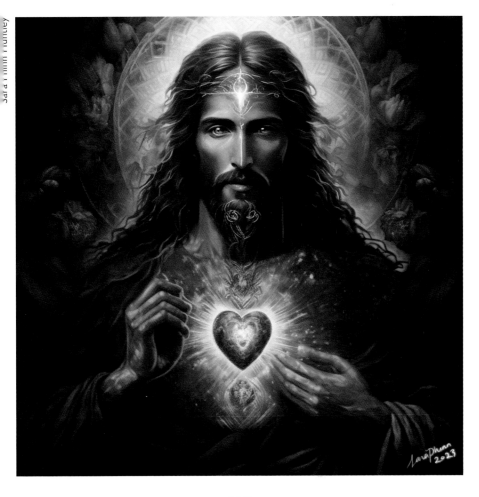

Encounters with Jesus Christ, the messiah of the New Testament, and sometimes other biblical characters are not uncommon during profound psychedelic experiences, especially among people who adhere to one of the Christian faiths.

In fact, DMT is sometimes referred to as the "Jesus drug." Why? According to Got Questions Ministries:

> For at least two reasons: (1) some people who have taken dimethyl-tryptamine believe they encountered God and/or Jesus during their hallucinogenic vision, and (2) after experiencing a DMT-induced vision, some people have drastically changed their lives. Some even appear to have become dedicated Christians, crediting a dimethyl-tryptamine "trip" with opening their eyes to spiritual realities.[1]

In a personal communication, one person described their encounter with "Space Jesus" while on an ayahuasca journey:

> I met Space Jesus after an intense ayahuasca experience. I call him Space Jesus because he was with a small crew of men. They were in Star Trek–type uniforms, but Space Jesus was in a white robe that was glowing slightly. We spoke for about 5 minutes, and then shook hands. I touched the robe. We hugged, laughed. I then noticed a ship across the street above the corner house. I asked if that was their ship and he said yes. Then he said, "Do not believe anything they say about me, most of it is wrong. However, I did say that you will do all I have done, and so much more." I watched them leave and "beam up" to the ship. I live in the Bronx, NYC, and am not religious. I did not even think that he was real to begin with.[2]

It seems likely that encounters with Jesus may be resonant with personifications of what has been referred to in the mystical literature as "Christ consciousness," or an awareness of one's higher self as being part of a universal system, and often a meeting with Jesus during a psyche-

Sara Phinn Huntley

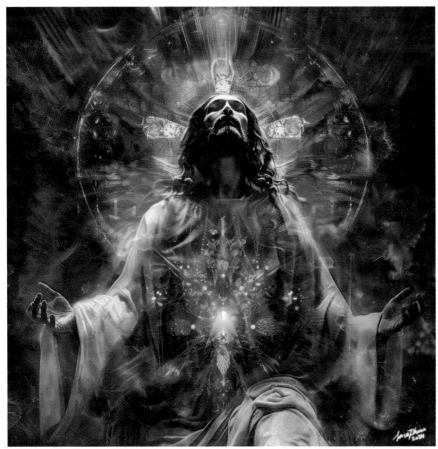

delic experience will bring feelings of love, peace, and serenity. Perhaps not coincidentally, a recent study revealed a connection between regular DMT use and belief in a higher power. Researchers at Johns Hopkins University discovered that people who had previously identified as atheists described encountering a "benevolent entity" upon ingesting DMT that caused them to revise their beliefs.[3]

However, it also seems possible that various hyperspace entities are masquerading as religious icons from our memories. As one person told me, "I have encountered a lot of entities which claimed to be the 'only true god,' 'the son of god,' 'your creator,' and concepts like that, with the implied connotation of needing worship and adoration—or else."

Perhaps it is important to remind ourselves that we need to approach our encounters with otherworldly beings with some degree of caution; just as in the human social world, trust builds over time, with repeated interactions, and it isn't wise to trust everyone upon first meeting them. There's no reason to assume that the personalities we meet in hyperspace are necessarily wise beings acting with honesty and integrity. They could be deceptive, and they may be hiding selfish or malicious intentions. Some Christians are convinced that they are "demonic entities waiting to manipulate us."[4]

That said, could Jesus be who he says he is: a divine being that lives eternally in an alternative dimension, "Heaven," and makes contact with religious humans who ingest DMT? Maybe. Meetings with Jesus are also commonly reported during near-death experiences, and there is a strange link between alien entity encounters and spirits of the deceased we'll discuss in chapter 18.

In *DMT and the Soul of Prophecy*, Rick Strassman explores the similarities between the visions of the Hebrew prophets and the DMT state described by his research volunteers.[5] Others have pointed out that DMT and harmaline-containing plants (like the acacia tree and Syrian rue, which grow naturally in the Middle East) could have been used to create an ayahuasca-like brew during biblical times.[6] In fact, the acacia tree is mentioned in the Bible. The historical Jesus was a Jewish prophet; did he have elevated DMT levels, natural or otherwise?

Could one of the machine elves, fairies, or other shape-shifting entities be impersonating human religious figures? Maybe. Nonetheless, encounters with Jesus in hyperspace are generally described as positive and comforting.

14
...
THE VIRGIN MARY

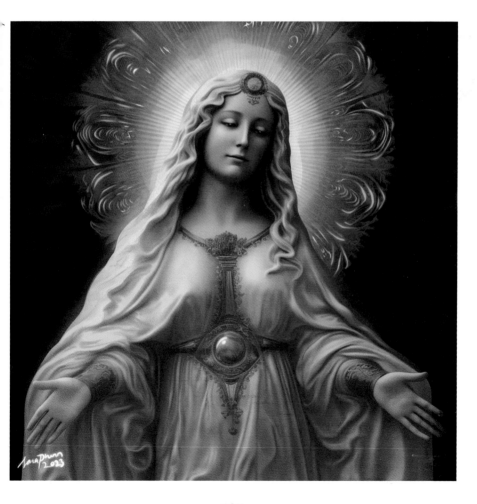

Many people have reported healings by, and sightings and visions of, the Virgin Mary throughout history. So common are these visions of the divine female figure that there is even a term for this phenomenon: Marian apparition. As is the case with Jesus and other biblical characters, sometimes people report contact with this powerful female entity on psychedelic journeys as well.

Although the New Testament frames Mary as the virgin mother of Jesus, she also seems to merge with divine female archetypes from various other religious traditions, especially those that incorporate elements of Christianity. For example, it's said that the founder of the Santo Daime religion, Master Irineu, during a retreat in the forest, received visions of the Virgin Mary in the form of the "Queen of the Forest," and she revealed to him a religious doctrine that he was to bring to the world through specific rituals involving the use of ayahuasca. The doctrine of Santo Daime came to blend Christian theology with Indigenous traditions and a profound reverence for Mother Nature, especially the forest, which is personified as the Virgin Mary. Today, users of ayahuasca in the Santo Daime church in Brazil (and elsewhere) regularly report contact with the Virgin Mary.

Similarly, the Mazatec people, who have a shamanic tradition of utilizing psilocybin mushrooms and *Salvia divinorum* for healing rituals, report a long history of encounters with the Virgin Mary. In fact, most of the names for *Salvia divinorum* illustrate the relationship between the plant and the Virgin Mary; it's called, among other names, ska Maria Pastora (herb of Mary the Shepherdess), hojas de Maria (leaves of Mary), and yerba Maria (herb of Mary). Mazatec tradition holds that the plant is an incarnation of the Virgin Mary, and it is treated with great respect.

The Virgin Mary is often seen in visions as a powerful, compassionate figure who offers comfort and protection. She is often depicted as a beautiful, serene woman with a gentle face and a halo of light around her head. She is usually dressed in a long, flowing white dress and a blue cloak, and sometimes she holds the infant Jesus in her arms. She is often seen as a source of strength and guidance in

difficult times, and her presence is thought to bring peace and hope to those who seek her aid.

In psychedelic visions, the Virgin Mary is often seen or encountered as a kind of spiritual guide or figure of comfort and compassion. She commonly appears as a motherly figure, with a warm, compassionate presence that offers guidance and reassurance. She is usually seen as a glowing, ethereal figure surrounded by light and a feeling of unconditional love. People often report feeling a deep connection to the Virgin Mary during psychedelic experiences and characterize her as a source of divine wisdom and support.

Numerous friends and acquaintances shared with me their psychedelic encounters with the Virgin Mary. For example, my friend Katara Lunarez offered the following account of her encounter with the Virgin Mary while she was tripping on psilocybin mushrooms:

A blue goddess then appeared behind me. . . . That felt very warm and motherly. Surprised, I said hello. She looked very familiar to me but was a foreign deity I did not know the name of. So, as not to be rude, I asked her name. She smiled and said, telepathically without physical sound, "I am neither he nor she, but both He and She. I have many appearances. I go by many names, even one of them yours. I appeared to you this way as I know you would be comfortable but I have many forms." She then began to show me, changing to different ethnicities with different styles of attire, but the colors remained the same, the blue, green, gold, and red. "You are most familiar with me as Mother Mary or lady of Guadalupe," she said. I was very shocked by this as I was trying to understand what it meant. Then she smiled at me and said, "We are all connected. We are all one, simply seemingly separate now in order to understand ourselves, but we'll all meet again, and we'll be more progressed each time. . . ." She then leaned toward me, with her many arms, and embraced me, while poking right between my eyebrows with her pointer finger (not truly physical but telepathically) and proceeded

to say, "I am you and you are me. You are him (she motions to my boyfriend asleep on the bed), and you are she (she motions to my dog lying next to me). We are all gods and goddesses, simply gods that have forgotten they are gods (she pokes the middle of my chest), with power to create the very essence of existence, but you forget, unaware of your power. Some have chosen to forget, some are seeking to remember. Remember what you are. Remember your power and create. Build, bring into existence your visions, our visions. Do not forget. Do not doubt yourself, grow. Remember we are one. Your power is not alone. We ARE. So let US be. Create, build, and bring into existence. Do not forget." She stayed with me for the remainder of my trip.[1]

Sara Phinn Huntley

Encounters with the Virgin Mary are often marked by peaceful and comforting feelings. Another friend told me about an encounter he had on DMT in which—although he hesitated to call her "the Virgin Mary"—he had contact with a "three-eyed mother goddess" who was "kind and comforting," and she reminded him of the archetypal religious figure. He said that she "appeared in the cool air" blowing out from his window AC unit.[2]

Another person told me that during a psychedelic experience he saw the being that he "associated with the Virgin Mary of Christian belief" and "is our divine mother. Our *real* mother." The entity explained to him that "life is a gift made specifically for us to enjoy."[3]

Sometimes statues or figurines of the Virgin Mary take a special significance when one is under the influence of a psychedelic. One person told me, "Coming down from a small dose of acid, I looked at a Mary ceramic figure and it seemed like space shrunk into it, like it was a wormhole sucking portal."[4] For myself, a Virgin Mary statue sits at the top of the staircase in my home, and a glow-in-the-dark Virgin Mary figurine rests on my bookcase, and both have taken on a powerful presence when I've been under the influence of LSD or mushrooms.

It seems that there is only one Virgin Mary entity, which lives eternally, and not a race of such entities. It also seems that one's cultural background plays an important role in how this entity is perceived. However, as I suggested with the Jesus entity encounters, it could be that the machine elves, fairies, or other shape-shifting entities are impersonating human religious figures. This seems a distinct possibility, although encounters with this particular entity are often reported to have a powerful transformative or healing effect and leave one with a great sense of peacefulness.

15
•••
ANGELS

Sara Phinn Huntley

Numerous New Age books, with titles like *Ask Your Angels*, *Seeing Angels*, and *Connecting with the Angels Made Easy*, promise communication with angels, but is there any reality to angel communication, and can psychedelics help? As with the sections on Jesus, the Virgin Mary, and the Devil, in which the encounters with these beings are largely associated with Christian or religious backgrounds, angel visitations are not uncommon during psychedelic experiences, and, like demons (see the following chapter), they can be associated with a variety of different cultural belief systems. The English word *angel* comes from the Greek *angelos*, "messenger," and certainly many of the entities encountered in hyperspace seem to be trying to convey messages to us. Although many people report seeing angels on DMT, mushrooms, and LSD, they're not necessarily seen with large white wings and halos around their heads. According to the DMT-Nexus website, the angelic entities commonly encountered on DMT:

> . . . don't necessarily look like typical pop culture angels, but they can. They tend to emanate light and are often keenly watching the humans present.[1]

This description seems accurate from the reports that I've collected as well. Angels seem to vary greatly in appearance and are often times even invisible; it's more a feeling that people get from the beings that causes them to be perceived as divine messengers. For example, to get an idea of the wide variation, one person told me that he saw, "futuristic robotic looking angels, composed of geometric shapes and bright colors that [he didn't] . . . even believe exist in this world." Another person said that they saw "beings of white light." Another person said, "they looked like me and they said be yourself."[2]

Even the Bible doesn't describe angels as looking like they do in pop culture. The Book of Ezekiel, which many scholars suspect may actually be an ancient report of a psychedelic experience, describes angels like this:

Sara Phinn Huntley

And from the midst of it came the likeness of four living creatures. And this was their appearance: they had a human likeness, but each had four faces, and each of them had four wings. Their legs were straight, and the soles of their feet were like the sole of a calf's foot. And they sparkled like burnished bronze. Under their wings on their four sides they had human hands. And the four had their faces and their wings thus: their wings touched one another. (Ezekiel 1:5–9)

In *DMT and the Soul of Prophecy*, Rick Strassman highlights striking similarities between the visions of Hebrew prophets and the DMT state described by his research volunteers, and he points out numerous descriptions of angel encounters in the Hebrew Bible that seem remi-

niscent of reports of entity encounters on DMT. Strassman notes that the Hebrew word *kavod*, which has numerous meanings in the Bible, including "incredible," "glory," "reverence," and "divine presence," is sometimes used to describe angels, and its meanings share features with some of the entities described in DMT trip reports.[3]

Reports of psychedelic journeys frequently mention seeing angels as beings of radiant light. For example, a Reddit user wrote:

My friend on DMT saw two benevolent massive orbs of light, and then months later while I was on shrooms, these two orbs came to save me from a bad trip, and negative entities. They gave me a beautiful energetic hug, and psychically said, "Be careful." Then they left in a microsecond—"woooosh"—and I remained in a glowing positive vibe for the rest of the trip. While they hugged me, I could hear their buzzing vibration. I believe the true form of an angel is that . . . a massive orb of bright light. Humans may perceive angels with wings: it's a simplification but it's also highly symbolic. Wings are surely linked to the higher world.[4]

Another person sent me the following description of their angelic encounters with ayahuasca:

Two beings of white light drinking ayahuasca in the Amazon. Three beings of white light while fasting and praying intensely the night before I was to drink ayahuasca in a cabin in the forests of central Washington. It was as if they came to prepare me for drinking the ayahuasca. They made it clear that they were protecting the cabin for my spiritual journey. Both sets identified themselves as Finnish ancestors. So . . . That seems like a meaningful aspect, somehow![5]

Even when the angels are invisible, their presence is strongly felt. Someone online shared with me the following anecdote:

Paradiso, Canto 34, by Gustave Doré, 1868

Invisible but tangible. I was climbing in the Sierras in California back in the 1970s, while tripping on 3 purple microdots, and I slipped and fell down a smooth rock ledge into a huge waterfall, a sheer drop of close to 100 feet with sharp rocks at the bottom. Halfway down, I felt myself lifted and shifted to the cliff face, where I was able to cling to the rocks with tiny finger and toe holds, probably around 50 feet from the top. Some friends I was with spotted me and told me to hold on while they hiked back to their car, where they happened to have a large coil of rope in their trunk. Lowering the rope to me, they were able to haul me up to safety. I had no doubt at the time that an angelic force had affected my rescue from certain death in the white-water rocks at the bottom.[6]

Here's another encounter with an invisible angel, sent to me by a friend:

Not shrooms or DMT but years ago I smoked something with a total stranger and freaked out. I think it was PCP. I ended up trying to dig a hole under a small front porch while walking home. I didn't know these people, but I crawled under their deck and started digging a hole in the dirt with my bare hands. I do not normally partake of such bizarre behavior, but I was experiencing a sort of psychotic break from the drug. It was around 11 o'clock or so at night. I suddenly felt a presence with me. It was a male presence, and he was sitting on the steps above me. He made me feel safe. The thing is any normal person would have been alarmed to see a woman digging a hole under some stranger's deck with her bare hands in the middle of the night but he was as calm and as strong as can be. He was a guardian, or sentinel for me. When I finally calmed down and straightened out enough to crawl out, I sat next to him. He was on my left. I whispered with a shaky, raspy voice, "Thank you." And he replied without turning his head, "Thank YOU." That's all I remember. I truly believe he was an angel.[7]

Many people throughout history have reported communications with angels. John Dee, a mathematician and scientific advisor to Queen Elizabeth, is a particularly dramatic example. Between 1582 and 1589, he and a "disreputable, criminal" psychic named Edward Kelly claimed that they held regular conversations with angels and the archangels of God.[8] These communications, Dee said, provided him with the keys to a magical ancient language, called Enochian, that humanity supposedly spoke before the fall of Eden. I couldn't find any convincing evidence that Dee used psychedelics, but there are some possible suggestions—such as mentions of smoke, which some scholars think might be a reference to cannabis, and a mysterious red powder that Kelly described as "the magical philosopher's stone of alchemical lore."[9] It seems that

psychedelic plants and extracts may have been a closely guarded alchemical secret at the time, so it's not unreasonable to think that Dee's angel communications may have been assisted by potent psychedelic elixirs.

In *Talking with Angels*, Gitta Mallasz recounts how she and three Hungarian friends recorded dialogues they had with "luminous forces" that "came to be known as angels" over a period of seventeen months during the time of the Holocaust. These spiritual dialogues serve as inspiration for many people, and Mallasz said that she was "merely the 'scribe' of the angels."[10]

Terry Lynn Taylor's book *Messengers of Light* describes how it's possible to communicate with angels "for every occasion, including personal angels such as guardians, spiritual guides, cheerleaders, and soul angels; angels of the moment, such as healers and rescuers; and angels who embellish human life, such as worry extinguishers, fun executives, and prosperity brokers."[11]

Angelic beings are among the most common otherworldly entities people encounter, and they seem especially common during psychedelic experiences, in which they are almost always described as positive, beneficial, comforting, and sometimes healing. Is it possible that angels are creatures of light that are more spiritually evolved than beings like the elves and fairies, vibrating at a higher frequency, so to speak, and coming from the Kingdom of Heaven? Or does it rather seem like that angels may actually be other entities—such as fairies, daimons, or djinn—who are masquerading as divine messengers or who are interpreted through the lens of the belief system of a particular religion? While they may be comforting messengers from a divine dimension, as with all entities, we suggest building trust over time with angels.

16

...

THE DEVIL AND DEMONS

179

Terrifying encounters with the Devil or demons from various religious systems are not uncommon during profound psychedelic experiences, especially among people who adhere to one of the Christian faiths, and they can be extremely frightening.

The Devil is described as the supreme spirit of evil in the Christian faith and the ruler of Hell, the netherworld of eternal punishment, misery, and torment. Demons are often described as evil spirits, and they appear throughout Eastern and Western religious systems, as well as within shamanic frameworks. Ayahuasca cultures warn of dark and parasitic spirits and the nefarious intentions of evil entities encountered during ayahuasca sessions.

People who encounter demons during psychedelic experiences often describe them as horrifying, ugly entities who overpower and possess them, torment them mercilessly, and often encourage them with dark advice, such as with thoughts of violence, self-mutilation, or suicide. Sometimes they appear within psychedelic visions. For example, one person told me that, while on DMT, he once saw "demons eating Jesus on the cross."[1] However, on breakthrough doses of DMT, the demons can become full-blown personal encounters.

A writer online who goes by the name Owen Cyclops works on a project called PSIDAR (Psychological Spiritual Imagery Demonic Archetype Research), in which he collects reports from people who, in DMT experiences, go to Hell and encounter demons. He has an X (formerly Twitter) page where he posts reports of DMT or ayahuasca encounters with, among other dark visions, Baphomet, voodoo spirits, demonic possession, "beings cutting bodies," the "red realm of blood visions," a "dark evil jester shadow entity," and "beings that say, if nothing matters, you should kill your friends."[2]

Encounters with seemingly demonic entities are not restricted to psychedelic experiences; they can occur in other altered states of consciousness as well. For example, a person posting on the DMT-Nexus website shared her encounter with a dark entity that she believed to be a demon in a dream:

Sara Phinn Huntley

I am mildly psychic, and [demonic entities] used to suck a lot of energy from my chakras when I was lying down and also just sit in my aura and harass me. I was able to block out clairvoyance and clairaudience for the most part and just felt them touching me. However, I have seen Zeta Extraterrestrials when I was astral projecting from a sleep state. I have also seen what I have learnt to be a demon. It got into my dream one night and it looked very similar to Gollum in *Lord of the Rings*. It had an evil grin on its ugly face. Normally I don't experience fear in my dreams, but something triggered that this was real, and I got afraid and my heart rate elevated. I woke up in fear to find it was trying to pull me out of my body and my astral arms were out of my physical arms. I just

moved a bit, and it broke the spell it had over me. I have also seen a dark cloudy mass of an entity over me just when I was waking up, but I always filter this stuff out when I am wide awake. Also had a few psychics tell me that I had octopus looking entities attached to me. I still deal with the odd entity issue, but I have managed to get rid of most of them.[3]

Some Christians believe that all of the entities encountered on DMT are demons. According to Christian writer Rod Dreher, "Exploring the realm opened up by DMT is to put your soul and your sanity in grave peril." He writes:

One religious believer who strongly believes that they do create a portal to alternate realities, and that these doors should never be opened, is a man I'll call "Andy." He is a research scholar at a major American university. For years he took heavy doses of psychedelic drugs as part of occult ritual worship. He became convinced eventually that the entities with whom he was in regular contact were not (as they claimed to be) ancient gods, but demons. He put it all behind him and converted to Christianity. . . . Andy is extremely adamant about the dangers of all psychedelic drugs, arguing now that they really do open one up to malevolent discarnate intelligent beings—"demons," if you prefer. Any drug that has the effect of making the boundaries of the self porous is spiritually risky, he said, even a mild one like cannabis. But DMT is in another category. He pointed me to some resources on the Internet where DMT users, in particular, report hellish contacts with entities while tripping on the drug.[4]

One person responding to my query about psychedelic demon encounters in a Facebook group told me about experiences their friend had on DMT that convinced them to become a member of the Christian faith:

I have a friend who had intense visitations from a dark entity. He kept going back to continue seeking, and in that, suffering. He is now a devout Christian. . . . DMT was a pivotal moment in his change of life patterns that dealt with meeting the darkness.[5]

Although encounters with dark and terrifying entities don't always change one's religious views, they are often seen as part of a larger transformation. British author Graham Hancock describes a particularly hellish encounter with seemingly demonic entities on one occasion when he smoked DMT as being part of a "great transformation":

As soon as I took my first long draw I had the unsettling feeling that something intelligent and not necessarily friendly had leapt into my head from the spherical glass pipe. . . . The first thing I saw was something like a mandala with an ivory background and intricate brick-red geometric lines—like tracks—inside it. . . . Then I realized that the mandala . . . was sentient and focused on me. I got a hint of eyes or feelers. There was something very menacing about the whole scene, and I . . . felt myself struggling—uselessly of course—against the effect. Then I heard an ominous voice, filled with a sort of malicious glee, that said very clearly "YOU'RE OURS NOW." And I thought, shit, yes, I am yours now, not much I can do about it, but it's only for about ten more minutes and then I'm out of here.

Since it was pointless to struggle I resigned myself to the situation and thought, OK then, get on with it, and immediately the mandala/intelligence and lots of its little helpers (who I felt but cannot describe) were all over me. I had the sense that my body was a huge, fat, bloated cocoon and that these beings were tearing it apart, tearing off lumps of matter and throwing them aside, getting access to the real, hidden me. I was aware that this was a place of absolute truth, like the Hall of Maat in the ancient Egyptian tradition, and that everything about me was known here, every thought, every action, good and bad, throughout my whole life—and the sense

that the real hidden me within the cocoon was utterly transparent to these beings and that they were finding me wanting. About as far from being "justified in the judgment"—as the Egyptian texts put it—as it is possible to be, and that therefore I might face annihilation here. And I heard something like a trumpet blast and a loud voice that announced, as though this were a proclamation at court: "NOW THE GREAT UNFOLDING WILL BEGIN." Or possibly: "NOW THE GREAT TRANSFORMATION WILL BEGIN."

That was the point where I lost consciousness of the material realm completely, and indeed of everything else. Feeling utterly helpless, utterly in the power of whatever process I was going through and of the intelligence that was running it, I fell into a darkness that seemed to last forever. I have no conscious recollection of what happened to me in there, only the conviction that it was something massive.[6]

The DMT-Nexus website carries numerous reports of encounters with demonic beings and negative entities. Here one DMT user writes about his experience with dark entities, and his realization that these entities are both a part of us and only as powerful as we allow them to be:

The negative entities seem to like to get inside of you or at least right in your face. They attempt to trigger fear. As soon as the fear comes they have some control over you. I do not see them as anything but a part of me now. They only have power if I choose to give it to them.[7]

Despite their initial fear, some people experience positive outcomes from their encounter with "the Devil." For example, one person shared with me this experience, which he had while under the influence of ayahuasca:

I had a really intense experience with the Devil my second time drinking ayahuasca. He came to me and told me I needed to explore darkness too in order to understand light. He told me he was there too, and I had to know that. He told me I couldn't avoid him. I was literally vomiting/purging in a porta-John out in the middle of the woods, outside the ceremony circle when it happened. I was terrified at first. It was a very intense energy. I took a deep breath and eventually shook his hand (in my mind of course). I felt like I was acknowledging his presence in the world as a part of duality. I saw all the fear mongering surrounding the Devil that I was raised with walk through my mind like a parade, and then I let it all go. I started laughing, and the rest of my journey that night I was thrilled by a new sense of freedom and

Sara Phinn Huntley

fearlessness. Like what's left to be afraid of if I'm not afraid of the Devil anymore? I grew up with fire and brimstone Christianity, which I totally reject, and I let that last bit of programming leave me for good. I don't know if I believe he's an actual entity, but he's definitely an energy part of balancing the universe.[8]

Someone else told me about an experience he had, while on magic mushrooms, in which he encountered "the Devil" and had a positive outcome:

On a large dose of mushrooms listening to a black metal record I felt like the devil was coming in through the fractal cracks in my reality. I decided to give myself to it entirely. Then I could feel horns growing on my head, which eventually turned into a majestic pair of antlers. Was a good night.[9]

Another person shared with me this psychedelic vision, in which he witnessed a balance between light and dark entities:

I've seen them. I've watched them consume souls. Shrouded by darkness. And I've seen the brightest white beings surrounded by glowing white human souls. And every level of brightness in between, calling toward them the souls that match them in purity and light.[10]

Some people believe that it is our own fear that causes us to see the entities we encounter on psychedelics as demonic. For example, one person shared with me this summary of their experiences:

I've encountered DMT "aliens" that sometimes frightened me. My fear made them seem demonic. I sometimes encounter people that seem paranoid and are convinced DMT entities are demons or archons.* So far, it's seemed to me those are just projections of our own fears.[11]

*Within the Gnostic tradition, archons are the rulers of a realm within the Kingdom of Darkness.

Encounters with entities described as demonic are among the most frightening of psychedelic experiences, although they can often be part of a positive transformation. Many shamanic traditions describe beings who appear as demons, tearing and shredding us apart, as preparation for a rebirth. Similarly, psychiatrist Stanislav Grof has noted that, during what he calls a "spiritual emergency," it's not uncommon for a person to experience frightening alien abductions and demonic encounters that, over time, transform into encounters with angelic beings as the person heals.[12]

So, what people experience as the Devil or demonic entities seems likely not only to be influenced by psychological projections of fear onto beings that are too complex for us to currently understand but also to hold the potential to help us heal by eventually leading our minds and spirits into a greater sense of wholeness.

17

...

THERIANTHROPES AND ANIMAL-HUMAN HYBRIDS

Sara Phinn Huntley

Many people have reported visions of or encounters with entities that appeared to be part human and part animal during their psychedelic experiences. These are therianthropes, whose name derives from the Greek *therion*, "wild beast," and *anthropes*, "man." Therianthropy is described as the mythological capacity (or affliction) of individuals to metamorphose into animals or animal-human hybrids by means of shape-shifting, meaning the ability to physically transform—an idea that's found in the oldest forms of shamanism. Therianthropy includes the phenomenon known as lycanthropy, in which people believe that they transform into werewolves, and it's not uncommon for people to feel like they sometimes become different animals on their psychedelic journeys.

Numerous South American shamans are said to have the ability to transform into jaguars and other jungle animals while under the influence of ayahuasca. Human-animal hybrids also often appear in ayahuasca visions, as well as in other psychedelic or visionary states of consciousness. In *The Way of the Shaman*, Michael Harner describes a common experience in which shamans encounter "the mythical paradise of animal-human unity."[1] Animal-human hybrids also appear in the Hebrew Bible in the form of cherubim (or cherubs), humans with birdlike characteristics, tasked with guarding the Garden of Eden against mankind.*

In his book *Visionary*, maverick archaeologist Graham Hancock discusses how therianthropes have been reported in visionary states of consciousness since ancient times and can be observed in some of the oldest cave paintings found in Europe. For example, in southern France, there is cave art dating back from the Upper Paleolithic, more than 30,000 years ago, of "lion-men" and "bison-men."[2] A striking example of a therianthrope in Upper Paleolithic cave art is the painting called "The Sorcerer" of the cave known as Trois Frères, in France, which is part lion, owl, wolf, stag, horse, and human.[3]

*The cherubim are the most frequently occurring heavenly creatures in the Hebrew Bible, as the Hebrew word appears ninety-one times. The first occurrence is in the Book of Genesis 3:24.

A sketch of "The Sorcerer," Paleolithic-era cave art found in France

For her master's thesis at Sonoma State University in California, Melissa Anne Rohrer studied humanity's "numinous encounters" with "animal allies in the imaginal realm." The imaginal realm, according to Rohrer, is "where spiritual realities can be seen in visionary experience"[4]—a description that seems to apply equally to psychedelic experiences. Rohrer's analysis noted themes that emerged in the data, which included "imagery, feeling the essence of the ally, shapeshifting, belonging, reconnection with nature, individuation, calling in the ally, and feeling love." Her work also considered the beliefs participants held about the animal allies, finding that the majority perceived the ally experience as "sacred."[5]

I personally had a powerful encounter with Bastet (or Sekhmet), the Egyptian cat-headed goddess, in a vivid dream while I was visiting a friend in Israel years ago. The goddess had a woman's body, with a wild cat's head, and she sat on a majestic throne in front of a large group of followers. I was among the followers, and everyone was feeling frightened. Suddenly a beam of light shot out of Bastet's eyes and one

of her followers in the crowd immediately fell over dead. Then every-
one there was relieved, and they rejoiced at this point, as Bastet's eyes
became temporarily lifeless and statue-like. I awoke from this intense
dream sweating and feeling shaken up.

I had no recollection of ever having seen this feline-headed the-
rianthrope before my dream, but weeks later I discovered images of
Bastet and Sekhmet, who are considered to be two aspects of the same
Egyptian goddess, and these images seemed just like the powerful entity
from my dream. Years later, I was invited to speak about lucid dream-
ing at a symposium in Las Vegas, hosted by magician Jeff McBride, and
I stayed at his magnificent home in the city. One of the first things I
saw when I arrived at his home was a huge statue in his backyard of

Bastet or Sekhmet, the Egyptian cat-headed goddess

Sekhmet sitting on her throne in the backyard of Jeff and Abigail McBride in
Las Vegas; photo by David Jay Brown

Sekhmet sitting on a throne, looking just as she had in my dream years earlier. My mind was blown by this extraordinary synchronicity!

My friend Kaleb also reported an encounter with feline-headed women, while under the influence of ayahuasca, although his encounter seemed a bit more pleasant than my experience with Sekhmet. Kaleb's encounter seems more reminiscent of the furry, playful, *kemonomimi* "cat-girls" from Japanese anime and manga:

> Three female Finnish cat hybrid teens. Blonde. Radiating blue-white light, standing hand in hand across the doorway to the cabin. The one on the left turned her head over her shoulder and looked down to me in the bed. . . . And I'll never forget that smile. Pure love, but also slightly flirty, young, sexy . . . also with whiskers. I later learned that Michael Harner describes animal beings and ancestral beings often combining.[6]

Numerous deities from different cultures are human-animal hybrids, and these entities sometimes appear in psychedelic visions, regardless of whether or not the person having the vision has a cultural connection to them. Examples include Anubis, the jackal-headed Egyptian god of the underworld; the Bird Goddess of the Neolithic Vinca culture, who has a human female body with a bird's head; and Ganesha, the elephant-headed Hindu deity, who appeared in a story someone recounted to me about his experience on DMT: "I saw Ganesha, the Hindu elephant god, waving his trunk at me. . . . There were no words spoken, just lots of colors, and the elephant seemed to be happy."[7]

I received a number of other reports of animal-human hybrid beings as well. One person told me that on LSD he "kept seeing a Native American man turning into an eagle hybrid."[8] The stories were mostly very positive. My friend Alexa Baynton sent me this beautiful and reassuring account of a DMT experience in which she experienced contact with a sacred mermaid:

So, this experience was while on DMT. One of my very first times. Also, my very first time being able to actually "accept" the trip and allow myself to let go. It felt as if my soul was lifted from my body, shooting through the astral planes. I suddenly came to a realm where I was floating on a cloud. I looked to my right to see a little boy sitting on a hammock. He was speaking to another entity (about 20 times the size of a human), to his left, who was floating on some sort of chair or modest throne, placed on this cloud. All around us was just bright, beautiful light and positivity. The most peaceful, beautiful, positive energy I've ever felt. She was very fair skinned, with long flowing beautiful blonde hair. She radiated a warm positive light. Her lower half was that of a mermaid. Her face was nonexistent, but not in an eerie way. She was glittering and glowing. She turned her attention away from the boy to look at me. Everything around us faded away, as I felt I was in a trance with her. Our communication was all that mattered. She then began to telepathically speak to me. She said things like "please let go of your insecurities and your fear. You are worthy, you are beautiful." I could feel the most love I have ever felt. I felt as if she were a goddess, giving me her words of wisdom. I felt beyond honored to be communicating with her. She confronted a couple of my deepest-rooted insecurities. And I remember crying tears of gratitude and happiness. To be truthful, I don't remember what followed. But this, to me, was the most important and amazing part of my trip. It stuck with me for years. Her energy was just inexplicable. She reminded me a lot of myself, just in a different form—as if she were my conscience, projected as a beautiful goddess.[9]

In his book *The Law of One by Ra: DMT Transmissions*, Oscar Moya Lledo presents 338 pages of "channeled" communications that he received while on DMT from an entity he identifies as Ra, the ancient Egyptian deity of the sun, who is commonly portrayed as a

therianthrope, a man with the head of a falcon. Lledo believes that Ra is an extraterrestrial intelligence, and the book contains several years' worth of channeled information that resulted from numerous meetings between the author and Ra. Here is a sample of the transmissions:

> I am Ra. The One breaks into a legion that co-exists, but remains One. Only One exists. The Big Bang of Creation started from Oneness, the Primeval Seed, a microscopic particle that instantly swelled into Universal size. All is therefore One and remains connected by the invisible cords of Entanglement. Only you exist. Only I exist. Only the neighbor exists.[10]

It's not uncommon for psychedelic users to have transformative spiritual experiences with therianthropes that profoundly affect their lives. Are these animal-hybrid entities actual physical creatures residing in another dimension, or are they visionary composites created from our genetic memories interfacing with the collective unconscious? It may be hard to differentiate between these possibilities, but regardless, people usually describe these encounters as powerful and often sacred.

18
...
ANCESTORS, DEAD RELATIVES, FRIENDS, AND STRANGERS

Sara Phinn Huntley

Does DMT allow one to talk to the dead? Could the entities that people meet in hyperspace actually be the spirits of those who have died and crossed over to the other side?

Many people claim to have experienced contact with loved ones who have passed on during shamanic voyages with DMT and ayahuasca, and a scientific study has shown similarities between the DMT experience and the near-death experience.[1] Some people believe that the DMT experience models the near-death experience and, as such, allows us to communicate with those who have crossed over.

Others say that they were able to resolve conflicts with relatives or friends after they died, or to get some type of reassurance that they were

Sara Phinn Huntley

okay in the next realm. One person told me that he spoke to his father and grandmother on an ayahuasca journey. "Whether it was real or not," he said, "it was very healing."[2] Another person told me a story about how he had a profound encounter with his brother, who had died a few years earlier, while on a DMT trip. He said that his brother introduced him to God.

Some people report contact with the spirits of dead animals or pets during shamanic journeys. Someone once told me that on a DMT journey he had "the most beautiful 10 minutes" with a dog that he had to "put down."[3]

Ayahuasca literally means "vine of the dead," and it is traditionally believed that ayahuasca can be a portal to spirits who have passed on and to allow contact with one's ancestors or ancestral lineage. Terence McKenna spoke about this:

> When you talk to shamans, they say, oh yes, the helping spirits. Those are the helping spirits. They can help you cure, find lost objects. You didn't know about helping spirits? . . . Then the other thing they say, if you'll press a shaman [and ask] what exactly is a helping spirit? They say, well the helping spirit is an ancestor. You say, you mean to tell me that those are dead people in there? They say, well, yes, ancestor, dead person. You didn't know about ancestors apparently. This is what happens to people who die. You say, my God, is it possible that what we're breaking into here is an ecology of souls? That these are not extraterrestrials from Zebaganumbi or Zeta Reticuli Beta; these are the dear departed, and they exist in a realm, which for want of a better word, let's call eternity. And somehow this drug, or whatever it is, is allowing me to see across the veil.[4]

In a personal communication, Derrick S. described a beautiful encounter he had while on DMT:

> I was visited by my deceased grandmother. It started off with the smell of her perfume, and then the melting and melting of very

specific colors from a painting that she always had hanging in her living room. It felt like unconditional love, and it brought me to tears. After that experience I stopped taking opioids, and I stopped drinking alcohol. As soon as I came back, a light bulb in my kitchen started flickering. It did this for a few weeks until I changed it. My grandmother was a baker and cooked most of her life for a living, so it makes sense that the kitchen light bulb would be the one affected. Ever since then I experience entheogens in a completely different way than I did before. It saved my life.[5]

Sara Phinn Huntley

As bizarre as it may seem, it's also not uncommon in alien abduction reports for people to claim that they saw dead people aboard the spacecrafts among the aliens. Alien abductee and author Whitley Strieber describes this happening to him and others in his book *The Super Natural*. Strieber saw a "familiar face" among the aliens that had abducted him, a "school friend who had joined the Central Intelligence Agency." But later, Strieber writes, "when I tried to look him up, I was appalled and confused to discover that he had died months before the night in question."[6]

Joshua Cutchin has written at length about the connection between alien abductions, fairies, and spirit encounters. In the opening of his book *Ecology of Souls*, Cutchin quotes journalist John Keel:

"A New York psychiatrist once asked me if I'd ever heard of deceased people appearing in flying saucers," wrote paranormal researcher John Keel in 1976. "He told me how a young patient, a teenaged boy, claimed to have witnessed a UFO landing and was astonished to see his late father emerge from the object. The psychiatrist knew nothing of UFOs, and assumed the whole thing was nothing but a childish fantasy. Actually, however, there have been hundreds of similar reports although they are usually ignored by the hardcore believers in extraterrestrial spaceships.[7]

There are interesting psychological connections between those people who experience alien contact and those who experience contact with the dead. The late psychologist Kenneth Ring explores the uncanny similarities between UFO encounters and near-death experiences in his book *The Omega Project*. He notes that UFO abductees share striking similarities with, and bear strong psychological resemblances, to near-death survivors and surmises that certain people have an "encounter-prone personality" that makes them more likely to have these types of transformative experiences.[8]

Many people experience contact with a loved one who has passed

on in their dreams or lucid dreams, shortly following their loved one's passing. I'm reminded of a story in which a woman had an encounter with her uncle, who had recently died, in a dream. In the dream, the puzzled woman asked her uncle, "How can you be here? You died." Her uncle responded, "Honey, when you die you lose your body, not your sense of humor."[9]

Could some of the different entities cataloged in this field guide actually be the spirits of those who have passed on? It may be possible. Personally, I've noticed a profound phenomenological difference between ayahuasca journeys and pure DMT experiences in this regard. It seems to me that ayahuasca encourages contact with earthbound beings—ancestors, animal and plant spirits, the web of planetary life, Gaia—and pure DMT seems stranger, opening up portals to more bizarre alien or extraterrestrial life forms, seemingly from other star systems, galaxies, universes, and dimensions. So, although it seems that both the spirits of the dead and alien life forms may coexist in the realm of hyperspace, like flora and fauna do in our world, there may be different levels, or territorial boundaries, between realms within the DMT dimension.

19
...
FAIRIES

Hyperspace is a magical place where anything can happen, and in some ways it seems reminiscent of the "fairyland"—another dimension or realm that is thought to interpenetrate our world—described in English and Scottish folklore and anecdotal accounts. Fairies have been reported to abduct humans and lure them to fairyland and to swap human babies for "changelings," or fairy children. The similarities between these stories and the many alien abduction cases reported in recent years, as well as the hybrid human-alien children described as playing a role in these cases, are startling, to say the least. This idea has been explored in depth by numerous writers, such as Jacques Vallée and Graham Hancock.

Fairyland is not Disneyland. Like the mythical fairies of European folklore, the fairy-like DMT entities are not only beautiful and awe-inspiring but also often dangerous, powerful, and unpredictable. Although they may sometimes seem friendly, playful, and helpful, like Tinker Bell, they are also reported to be mischievous or even darkly cruel with humans in their enchanted realms.

According to European folklore, fairies are a type of nature spirit, and generally described as small humanoid creatures with magical powers and a penchant for trickery. Celtic myths offer a recurring theme about a race of little people who were driven underground by invading tribes, and these people became fairies.

There are hundreds of accounts of fairy sightings in both contemporary and historical times.[1] Although the popular conception of fairies is often tiny angelic creatures with wings and childlike human features, they also have been depicted as troll-like gnomic figures or tall handsome beings, and thus can be variable in size. They are also reported to be able to appear as animals and birds. Some accounts seem rooted in beliefs associated with ancestral spirits, describing fairies as having the appearance of a young child who resembles a bearded old man. It seems that fairies, like the self-transforming machine elves, are shape-shifters, able to change their form or appearance at will, and appearing sometimes beautiful and other times hideous.

In folklore, fairies are described as having magical powers. In addition to having the ability to shape-shift, they are said to be able to become invisible and to cast illusions. Although they have a propensity for malice, mischief, and trickery, it is often said that fairies cannot tell lies in their interactions with humans. In any case, it's considered wise to be careful when dealing with fairies.

Fairies encountered in contemporary psychedelic experiences are usually reported as being young, female, and winged, like butterflies or flying insects, and they are able to fly like hummingbirds. It's not uncommon for people to see fairies flying around in their garden or frolicking in the forest—looking like they just stepped off the page of a fairy tale—while having a psychedelic experience, especially with magic mushrooms and DMT.

One person on Reddit described their DMT experience like this:

> I was visited by a lovely lady whom I shall call the DMT fairy. A small, indescribably beautiful woman, with a Brazilian accent, made of green earthen colored energy. . . . I said hello and she replied, she told me not to talk to her but to enjoy myself. She was there as a guide through the trip. If I asked her questions she would answer them with a yes or no answer, and if I tried to repeat my question she would say don't waste your time, enjoy yourself. She was like the guardian to the spirit world, showing me what lies beyond. When I stopped noticing her, she faded away, but if I thought about her with a small amount of my thought she would be there watching over, stretching her legs like she was getting ready for a run.[2]

Some DMT users report encounters with entities they call the "flirty fairies." One writer describes them like this:

> They can be amorphous and ever-changing, complete with wings as in folklore, or more abstract, but always easily categorized as

fairies from fairy lore. These entities are an embodiment of beauty and joy. They are so excited to interact with the viewer, it appears, as they can hardly contain it in saying that their behavior is urgent with their body language mirroring this excitedly burlesque intensity. They are universally beautiful and often emanate with flashing light.[3]

In his essay "Faerie Entities and DMT," Neil Rushton observes that some DMT entity reports bear resemblance to folkloric accounts of encounters with fairies and fairy queens. In particular, he points to an account from a subject in Rick Strassman's study describing a powerful

but benevolent female entity with an elongated head and a reassuring presence that seemed reminiscent of a fairy queen.[4]

Fairies are also sometimes encountered during near-death experiences. As an example, Tyler Deal saw fairies after a mountain bike accident in a forest, which turned out to be a transformative near-death experience leading him to become a spiritual healer.[5]

Lucid dream researcher Ryan Hurd notes that he himself is "no stranger to visitations by elves, trolls, and otherworldly creature, thanks to sleep paralysis." Hurd recounts a lucid dream he had after a nature meditation: "Two small fairies visit my bedroom. I try to talk and one of the fairies flies into my mouth, muffling my words. I have to gently remove her, careful to not hurt her delicate wings. She laughs and flies off." Then he writes:

> The embodied mind learns to pick up on subtle interactions and communicate by synchronicity when an "exterior" event is mirrored simultaneously as an "interior" feeling. . . .
>
> Like dreaming, the edges between self and other blur when you are immersed in nature. And like lucid dreaming, directing your attention to this dynamic flux of self/other can result in profound transpersonal experiences, new information or solutions, and feelings of love and connectedness with everything.
>
> We seem to have entered the domain of magic, where internal thoughts appear to cause external action. . . . Humans have been doing this a very long time.
>
> And fairies want to help us remember.[6]

Like the elves and gnomes, fairies seem to visually resemble their characteristic representations in traditional folklore, and tend to treat us in unpredictable ways, ranging from seemingly altruistic to mischievous to nefarious. In folklore they are said to have life spans corresponding to those of human beings, although longer.

ANDRA SKYE'S FAIRY ENCOUNTERS

My friend AndRa Skye shared with me the following narrative, which details the relationship she developed with a fairy through her psychedelic experiences. It's rather lengthy, but I wanted to include it all here at the end of this section, because it's fascinating.

This is a relationship that developed slowly, over the course of three years and many psychedelic ceremonies. Between 2019 and 2021, my ex and I used to do regular ceremonies every eight weeks. The ceremonies we did were always at home, and we'd always do the set and setting thing, we would fast the day before, it was a whole process that we both enjoyed and looked forward to. About halfway through 2020, some really interesting things started to happen. By this point, we were both very familiar with that space, with the psychedelic experience, [we] had experimented with various substances and dosages, so we both knew what to expect with these experiences.

Well, at some point during one of these ceremonies, I saw (and heard) this tiny, gray, blurry thing, zipping by in a circle, close to the ceiling. It was very unusual, and didn't really "fit" with any of the effects I was used to experiencing in these ceremonies. It seemed solid, and EXTREMELY fast. I've never seen anything move that fast in my entire life. And then it did it again . . . and a while later again . . . this thing would periodically zoom by, completely out of the blue, completely unexpected. I kept asking my ex if he saw it, and he kept saying no. This experience started repeating during every ceremony after that. The little, tiny blur would zoom by, making a zipping kind of sound, like its sheer speed is making noise. . . . This went on for months, maybe close to a year, multiple ceremonies during which it kept zooming by periodically, of its own accord, and I was the only one perceiving it.

Sara Phinn Huntley

After a while, I started wondering if I was actually losing it, because this thing seemed to have mind of its own and just didn't fit in with the rest of the psychedelic experience. Finally, after about a year of this, during one particular ceremony, this entity (whom I call Toby, so I will refer to them by their name from now on) flew by as they always did, and I saw my ex lift his finger and point to the corner of the room where I always caught glimpses of Toby, and said, "What was that?" And I replied, "Oh, thank goodness!" because I was so relieved that he finally saw it.

That night we were both aware of Toby, each time they zoomed by. During later ceremonies, Toby started getting closer and closer

(went from flying way up high close to the ceiling to where we were sitting on the couch). We watched them zoom right in front of our faces, then over to our dogs and cat, who immediately jumped up and started playfully chasing Toby around. At this point, we're absolutely sure it's not an insect, simply by how fast it moves and how intelligent and purposeful their moves are.

So every time we did a ceremony, Toby would pop in and zoom by, and we never saw more than a ridiculously fast, flying tiny dot blur. Then, one day, my ex had fallen asleep and I was listening to music, and I suddenly saw Toby in a different spot than usual, it almost looked like the little dot was standing still (which it never did before), and before I could even think about what was happening, they zoomed across the room, right in front of me, grazing both of my hands as they flew by. They actually touched the tops of my hands, and they felt VERY warm and kind of squishy, like not fully solid.

I actually jumped and screamed at the top of my lungs, because I really did not expect them to touch me, and at this point I still had no idea what this being was. My body consciousness just reacted with fear of something "unknown" having just touched my hands. And the WEIRD sensation of how incredibly warm, temperature-wise, and how strangely squishy it felt. I'd never felt anything like it. This was so shocking to me, in the moment, that I actually tried to convince myself it didn't happen, I thought maybe I just imagined the whole thing.

As if they could read my mind, within ten minutes they did it AGAIN. [They] repeated the same move, once again grazing both my hands, once again super warm and squishy, and once again I jumped and screamed. And this time, I knew it was real, and that they wanted me to know it was real. I still didn't know what exactly they were, and at this point I started looking for answers. I was led to this idea of elementals, and let me tell you, I did NOT believe in fairies at that time. Which is funny, because I believed in ETs,

and I believed in angels and all kinds of "paranormal" phenomena, but somehow . . . I had drawn an imaginary line above "fairies" and decided surely THESE can't be real.

After all, "fairy tales" is a term we use to describe the opposite of "reality." But I decided I was willing to temporarily suspend my disbelief . . . and was eventually led to a channel who has since become my mentor, and he told me—very matter-of-factly, like it's no big deal—that I was dealing with an elemental who wants to be friends. He told me elementals are nature spirits, they are not physical beings, but temporary crystallizations of Gaia's consciousness, they take temporary form out of the "clay" of the morphogenic field to interact with humans. And the form they take is usually reflective and representative of certain aspects of the consciousness of the human they are interacting with.

Apparently, they are very high-frequency beings, which is why I was only seeing an incredibly fast blurry dot, and why they felt so warm to the touch—because their high frequency activated more molecular action in my skin. And my own frequency wasn't synchronized enough with theirs for my eyes to be able to keep up with them. Their high frequency is the equivalent of them being on a different "time track" or something. [My mentor] told me that was the reason they touched my hands, because they were sharing their frequency so that we could synchronize more, so I would be able to see them more clearly.

I took this information, and in a meditation before my next ceremony, I reached out to them and said, "Ok, I understand what you were trying to do, I'm not afraid anymore, I would love to see you more clearly." Now, I didn't believe it would happen right away. I figured it would take me some time to acclimate to their energy and so I completely let go of that wish, because I fully expected it would take some time. However, later that night, during the ceremony, I suddenly heard the words Are you paying attention? in my mind, and I thought, "Huh? Paying attention? To what?"

And that's when Toby popped out from behind my left shoulder, flew up and across right in front of my face, and then stopped and hovered about ten inches over my head, under the lamp above me. As they appeared from behind my shoulder, I had this feeling of time slowing way down, I could feel myself breathing and it seemed so slow. Toby's movements seemed slow motion. As they hovered above my head, for what felt like at least a couple of minutes, I got a really good look at them. And I say "they" and "them" because it seems inaccurate to say either "he" or "she," as the being seemed very neutral in terms of gender.

[Toby had a] humanoid-looking body and head, but the arms and legs were extremely thin and reminiscent of grasshopper legs. The face had huge eyes that reminded me of the gray aliens. Tiny nose and mouth. And gossamer dragonfly wings. I vividly remember seeing the wings flutter in slow motion. They looked right at me, I looked right at them, and I had the strangest feeling like we'd known each other forever. And then they simply dissolved into thin air. I never looked away and I didn't see them flying away from that spot, they were just suddenly gone. It's almost impossible to describe the effect that encounter had in my life. It shattered every notion I had around what I believed to be "real" and possible.

Nothing rocks your world quite like staring right at something that isn't supposed to exist. That was actually the only time I saw Toby fully, in that way. And I understand now that they purposely slowed down and showed themselves to me as an incentive for me to keep working on my energy, so that I can see them. After that, they still visited during every ceremony I did, only they were once again fast and blurry. Except now, instead of a tiny blurry dot, I see a longer, blurry silhouette, about the length of my pinky finger. And they fly very close to my body, usually doing a few laps around me (ALWAYS clockwise—I don't know why but I've never seen them move in the opposite direction), and they leave this trail of warm energy behind that feels like they're wrapping me in a warm energy hug.

Since 2021, I haven't done as many ceremonies, because I felt it was no longer necessary to partake every two months. I did a total of three ceremonies in 2022 and one this year, so far.* Toby still never fails to make an appearance, and this last time they were flying so close to me that I had this impulse to hold out my hand, because I felt like they might actually land for a second. They didn't land, but they did graze my fingers each time, so I'm getting the feeling that may happen at some point in the future. I do know that their energy is high enough that it can be a bit too much for my human body, so they're giving me as much as I can handle without being overwhelmed.

My experience interacting with their energy has included periods of integration, where some of my old fears and compartmentalized negative beliefs were pushed to the surface by this energy. It's definitely an interesting process, because on one hand I want them to stop and land in the palm of my hand, and on the other hand I realize I'm not quite ready for that because I'm still integrating various disowned portions of my consciousness, which their energy is bringing up to the surface for me. Even though I can only see them with the help of psychedelics, I have come to realize Toby is with me all the time. They have been guiding me in very specific ways (often by playing little trickster pranks on me) throughout my entire life. I started seeing them when I had let go of enough of the "seriousness" and heaviness that comes with growing up. I sometimes get little telepathic messages from them, always something short and sweet, and I recognize them as different from my own thoughts, because they come with a feeling of "giggles," if that makes sense.

One time they told me, "I play with the animals (meaning my pets) all the time, feel free to join us if you can be in the moment." They are always helping me notice the little things, the little miracles all around that most people seem to be unaware of. They insist

*In 2023, at the time of this writing.

on specific things, like not rushing. If I ever find myself in a frantic rush, the things that start happening around me are completely ridiculous. Things I need disappear, I start tripping over my own feet, things fly off the wall and land in front of me, making me stop in my tracks, etc.

Oftentimes I will open a kitchen cupboard with the thought of getting out a specific item, and that exact thing just flies out and lands in my hand. When I go for walks, I often find little tiny gifts, like tiny toys or pins, painted rocks, etc. I have an entire collection of fairy gifts. I could go on and on and on, they are always with me and interacting with me in a multitude of ways, day to day. The main thing they have been teaching me is to be a "grown-up child," and to really enjoy life, like little kids do. My life over the last couple of years has felt like heaven on Earth. And even though I'm used to it now, it never gets old. It's just constant magic, everywhere, all the time.

I keep thinking, "I didn't know it could be like this! Do people know life can be this much fun?" I think that's part of why I haven't felt the need to partake of psychedelics as often as I used to, because my day-to-day life experience is quite psychedelic in many ways. Which is not to say that I don't have bad days and challenges and all that good stuff, because I do. But there's just this underlying sense that life is magical, even when it's hard, and that's so comforting to know.[7]

20
...
GNOMES, KOBOLDS, AND GOBLINS

Like fairies and elves, according to European folklore, gnomes are a type of nature spirit. They are usually portrayed as small humanoid creatures with pointed hats, looking like impish old men and roughly the size of a human child, though they can sometimes have animal-like qualities. They are said to live and work in underground mines and are generally portrayed as being hunched or ugly in appearance, although sometimes they can also be somewhat cute. They are sometimes depicted wearing pointed hats and peasant-style clothing.

Gnomes appear similar to what are described in European folklore as kobolds, goblins, or sprites. Although the mythic gnomes and kobolds are considered mortal enemies in the popular role-playing game *Dungeons & Dragons*, in Germanic mythology and reported sightings they seem generally similar to one another. Kobold traditions date back to at least the thirteenth century, when German peasants carved kobold effigies for their homes.

Many people report encounters with gnomes while under the influence of DMT and other psychedelic substances. With breakthrough doses of DMT, many people report feeling as though they are in a cavern deep underground, the traditional domain of gnomes. Similarly, many people also report that during alien abduction experiences they are taken to underground alien bases far below the surface of Earth. Here Terence McKenna describes the commonly encountered underground environment that many people report on DMT:

And then you are there. Where is there? It's underground. How you know this, you cannot say, but there is an irreconcilable sense of enormous mass surrounding you. . . . You're at the center of a mountain or something.[1]

Gnomes are often reported as being playful when encountered on shamanic journeys, but they are also said to have a dark or mischievous side. They can be comical, entertaining, or reassuring, but they are known to sometimes trick or frighten people. As is the case with fairies

Sara Phinn Huntley

and elves, it's not uncommon for people to see gnomes playing in their garden or on the edge of a forest, and this is likely why many people to have gnome statues in their gardens. Gnomes that look like they stepped off the page of a children's book are also commonly reported as materializing out of living room carpets while people are under the influence of magic mushrooms or LSD.

On various online community forums, a number of psychedelic users have shared their experiences seeing gnomes while under the influence of LSD and high-dose psilocybin mushrooms:

On LSD I used to see them in my carpet, gnomes building little huts and bridges made out of wood, but if I got closer they would disappear.[2]

I used to see little villages in my carpet when I'd go deep on LSD. Little gnomes. With pointy hats. The best way I can describe it is like the Smurfs. But the closer I got, the farther away they got.[3]

It was on acid and DMT, like actual elves or gnomes with those pointy hats in my room running around, and hiding every time I looked at them. They were so tiny.[4]

A gnome 1.5 feet tall with a red hat and white beard starts sprinting around me, with sparkles jetting behind him. He has a large grin and I'm instantly filled with much needed relief.[5]

Sara Phinn Huntley

As you can see from the encounters detailed above, gnomes can be somewhat elusive when brought to manifest by LSD and psilocybin. DMT appears to facilitate deeper encounters with gnomes, and they tend to be less elusive in these scenarios. For example, one person on Reddit wrote:

> I've done DMT twice now and have seen elves/gnomes in both experiences. I didn't close my eyes either time. I have this photograph-like memory of these tiny beings running and teleporting around "my room." They had pointy hats and a mischievous vibe to them, and I could feel their presence as if they were a person/animal. They looked so real like they were separate from me, and that they are always there, but I could only see them in that state.[6]

Another person reported the following encounter they had while on DMT:

> The first entity I met was a gnome-type figure. At first I saw him dancing. Then he multiplied into hundreds of replications, and formed a spiral that seemed to be infinitely swirling into "everythingness." He wore tattered and patched clothing, made from organic material, such as leaves and moss.[7]

Like elves and fairies, gnomes seem to visually resemble their common representations in traditional folklore and fairy tales and have similar characteristics. They are often reported as being mischievous and unpredictable, tending to treat us in ways that are hard to foresee and not always to be trusted. Folklore suggests that these entities are a type of nature spirit, and according to myth, they can live for hundreds of years or more. Many people believe that gnomes are always present but can be seen only in certain states of consciousness. LSD and mushrooms seem to make them visible, and DMT makes them appear more solid and less elusive.

21

...

MOTHER AYAHUASCA, GRANDMOTHER AYAHUASCA, AND AYA

Sara Phinn Huntley

The ayahuasca vine—and the ayahuasca brew, which contains DMT and harmaline—is said to contain a living spirit with a healing, nurturing, teaching, and compassionate personality. This spirit is usually described as being female and matronly, and although she takes many forms, she is generally characterized as having a motherly or, even more commonly, grandmotherly presence.

The spirit of ayahuasca is generally invisible, but she speaks to us during shamanic encounters. She is described as a voice that guides and communicates with us during ayahuasca encounters, in our own native language and through meaningful visions. She is said to have a wise, stern, and forceful yet gentle, loving presence, with great intelligence and knowledge about us and what ails us.

This spirit is often personified as the Great Mother of All Life, and as such she sometimes merges with the archetypes of Mother Earth and Gaia. She is said to be deeply connected to all of nature, to all of plant and animal life.

My friend Damon Orion described his experience with Mother Ayahuasca like this:

Horror—the kind you might feel if you were standing in front of an oncoming tsunami—froze me in place as the ayahuasca hit.

I was used to waiting about an hour for the special effects that signal the start of a psychedelic adventure. Instead, no more than 20 minutes after I'd taken the mystic jungle juice for the first time, galactic tremors were rattling the wall between this world and the next, and my vision was filling up with pixelated oil slicks made of neural electricity.

The spirit of ayahuasca had answered my call with outrageous speed. I pictured it as Lurch from *The Addams Family*, greeting me with a low, ominous "You rang?"

What I really wasn't prepared for, though, was the sheer steamroller wallop of the brew's first effects. For a few terrifying moments,

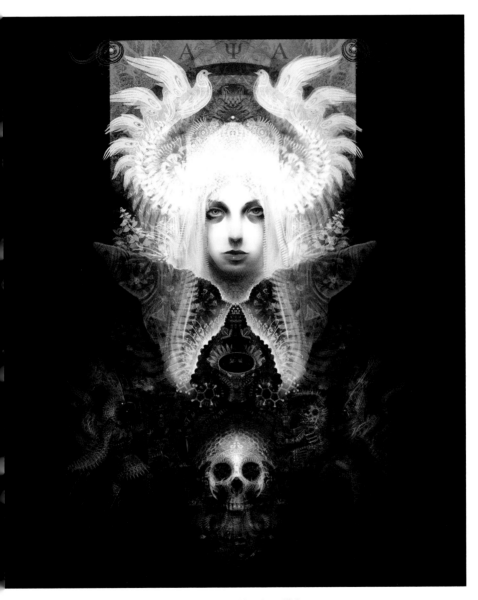

Aya, by Andrew "Android" Jones

as I sat under the stars in a location that shall go unnamed, the forest around me seemed to come alive and grow fangs.

Then a gentle voice spoke four simple words:

I'm here to help.

The voice was deeply compassionate. Though I heard it with my mind rather than my ears, it felt distinctly "other," as though a PA speaker within my temples were carrying the signal from elsewhere.

I wasn't so deep in medicine trance as to forget what the word "hallucination" means. Yet it felt for all the world like this was Madre Ayahuasca herself letting me know she had no intention of harming me. In fact, she was offering love, healing, and intense beauty.

My shoulders receded, and a smile of relief and gratitude blossomed on my face.

Then She spoke again:

Watch the fire.

I was in no mood to argue. I fixed my eyes on the bonfire not far from where I sat. Its flames were hypnotic. They roped and darted, forming a crackling column of primal magic. Their sparks appeared to drift all the way up into space, where the stars absorbed them back into elemental light.

We had liftoff. My invisible guide had talked me down from the shortest bad trip ever, and what followed was one of the most profound, enriching experiences of my life.[1]

I personally encountered Grandmother Ayahuasca when I traveled to Iquitos and did the sacred plant medicine in the Peruvian jungle. This powerful encounter with the spirit of the vine was a surprising discovery, as I had done the chemical components of ayahuasca previously in California numerous times without such an encounter. Using the traditional native plants ceremonially in the Amazon jungle made all the difference and brought me into intimate contact with this ancient spirit.

Sara Phinn Huntley

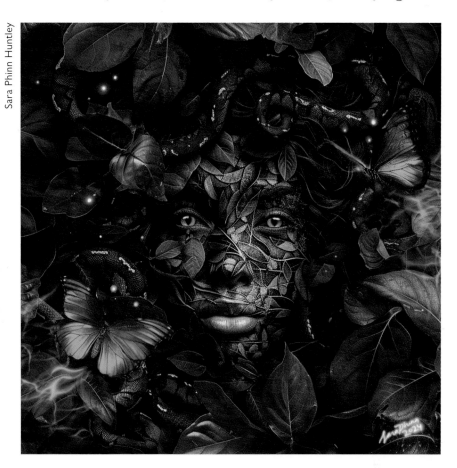

One's relationship with Grandmother Ayahuasca is said to persist long after the visionary experience from the plant medicine wears off. In her book *Listening to Ayahuasca*, psychologist Rachel Harris describes how people can turn to the ancient spirit for help during difficult times:

A frequent shamanic suggestion is to turn to Grandmother Ayahuasca for help during a ceremony, especially when feeling overwhelmed. Likewise, many of the people in my research study who reported an ongoing relationship with her said they turned to her for support in day-to-day life, especially during stressful times. With her support and guidance, these people described how they made

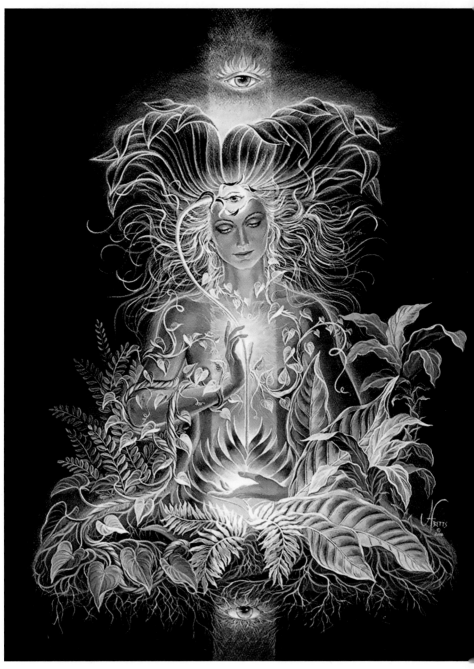

Eternal Moment, by Jan Betts

major lifestyle changes in career, health behaviors, and personal relationships. Their relationship with Grandmother Ayahuasca served as the secure base from which they could change their lives.[2]

Mother Ayahuasca is more of a spirit than an entity, it seems, and as such falls into a similar category as the sprits of shamanic mushrooms and cacti. Perhaps different planetary systems and biospheres have their own planet-bound ayahuasca-type spirit, or maybe the spirit is interstellar and intergalactic in nature? In any case, your secret grandma seems to be timeless and immortal, or as old as the Earth, and for many people she is divine, a deity and a goddess.

22

...

NATURE, PLANT, AND FUNGI SPIRITS

Many people under the influence of magic mushrooms report encounters with an intelligent, living spirit that resides inside the flesh of the sacred mushrooms—which contain the potent psychedelic substance psilocybin which is chemically very similar to DMT. They say that when they are under the enchantment of the mushrooms, this spirit speaks to them in their native tongue. These encounters are similar to those of Grandmother Ayahuasca presented in the preceding chapter. The mushroom spirit is usually described as having a female presence. Sometimes this spirit is described as gentle and wise, with a sense of humor, and said to act as a trusted teacher, healer, or ally, and at other times she can seem more aggressive and seemingly "tear back the fabric of reality" in disturbing ways.

I've personally experienced this spirit numerous times. Every time I've ingested magic mushrooms, a discarnate voice and presence speaks to me and shares wisdom and healing. Although sometimes she speaks in English, she more often speaks to me through visions that, when viewed in sequence, seem to be a kind of visual language, similar to the symbolism in dreams.

María Sabina, the Mazatec curandera who lived in the Sierra Mazateca of southern Mexico and was responsible for introducing magic mushrooms to Gordon Wasson, and through him to the entire Western world, believed that the mushrooms contain healing spirits. She called the mushrooms her "holy children." According to Mazatec historian García Flores, "For us, the mushroom is a very sacred being. It is a deity because it has a spirit, it has a voice, and it is a sentient being."[1]

Intelligent spirits are said to live in not only magic mushrooms and ayahuasca but all plants and fungi. In his introduction to the book *Plant Spirit Shamanism*, visionary artist and ayahuasca shaman Pablo Amaringo expresses how plant spirits can be profound teachers and healers:

> I owe my life to plants, and they have informed everything I have
> done. From the time when I was young, I liked to work with plants
> and knew that they gave me daily sustenance, not just as food for

my body, but in my soul . . . I healed myself with the sacred plant, ayahuasca, after years of suffering. . . .

That's how I came to be a shaman, ordained by the spirits.

My visions helped me understand the value of human beings, animals, the plants themselves, and many other things. The plants taught me the function they play in life, and the holistic meaning of all life. . . .

Plants are essential in many ways: they give life to all beings on Earth by producing oxygen, which we need to be active; they create the enormous greenhouse that gives board and lodging to diverse but interrelated guests; they are teachers who show us the holistic importance of conserving life in its due form and necessary conditions. . . .

Plants—in the great living book of nature—have shown me how to study life as an artist and shaman. . . .

The consciousness of plants is a constant source of information for medicine, alimentation, and art, as an example of the intelligence and creative imagination of nature. Much of my education I owe to the intelligence of these great teachers. Thus I consider myself to be the "representative" of plants, and for this reason I assert that if they cut down the trees and burn what's left of the rainforests, it is the same as burning a whole library of book without having read them. . . .

My most sublime desire, though, is that every human being should begin to put as much attention as he or she can into the knowledge of plants, because they are the greatest healers of all.[2]

Ethnobotanist Terence McKenna spoke of encounters with the spirit of magic mushrooms on many occasions and suspected that it was an intelligence of extraterrestrial origin. When I interviewed McKenna for my book *Mavericks of the Mind* and asked him how he differentiates the voice of the mushroom from the possibility that he is just communicating with another part of his own brain during his mushroom spirit encounters, he said:

It's very hard to differentiate it. How can I make that same distinction right now? How do I know I'm talking to you? It's just provisionally assumed, that you are ordinary enough that I don't question that you're there. But if you had two heads, I would question whether you were there. I would investigate to see if you were really what you appear to be. It's very hard to tell what this I/thou relationship is about because it's very difficult to define the "I" part of it, let alone the "thou" part of it. I haven't found a way to tell, to trick it as it were into showing whether it was an extraterrestrial or the back side of my own head.[3]

Some people report that the mushroom spirit is aware of our encounters with other psychedelic entities. Sara Phinn Huntley, the illustrator of this field guide, describes the mushroom spirit as an "energetic cousin" to other psychedelic entities and says that her experiences with magic mushroom shaped her growth as an artist:

Fungal visionary experiences hold a particularly special place in my heart as they were my first psychedelic teacher. I started quite young, at sixteen, and that certainly isn't for everyone, but it was for me. I was a strangely philosophical teenager, obsessed with comparative religious studies, mythology, and folklore. I had a desperate need to touch magic in a visceral way, to know the world was more than its surface appearances and be in the presence of what I felt must exist yet couldn't see. My primary teacher for about the first four years of my journey was psilocybin mushrooms, integrating and processing a lot of traumatic childhood experiences. I spent several journeys doing deep hikes in the old-growth redwood forests of central California. The strong connection with the natural world it nurtured made an enormous impact on my emotional and spiritual well-being, it connected me to something eternal that was unshakable by social and interpersonal affairs. That work primed my consciousness for later journeys and deep work, and the messages I was

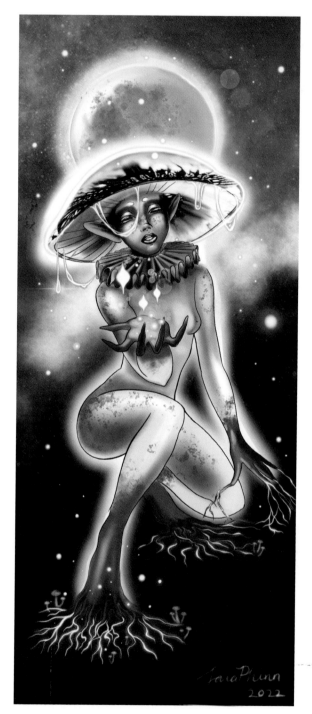

Fungi Fairy, by Sara Phinn Huntley

imparted accelerated my growth in a way that shaped who I became, as an artist, philosopher, and explorer. I came to understand them truly as beings, that there was an intelligence in nature that communicated through them, and that they were part of a larger family of nature spirits and beings. At one point during the beginning of my tryptamine exploration in my early twenties, I took a break to re-commune with mushrooms. Oddly enough, the mushroom spirit knew I'd been talking to DMT elves. They explained to me they were energetically cousins. They showed me their similarities and common lineage visually through the hallucinatory lexicon of form constant (the patterns one sees in visionary states). As someone with aphantasia, a condition that leaves my mind's eye without the ability to generate visuals in normal states of consciousness, being able to experience these states of mind is novel for me in a heightened way and deeply informs my work as an artist both aesthetically and emotionally.[4]

I had an encounter with the spirit of iboga after consuming a microdose of a tincture made with the psychedelic African shrub. It happened in a powerful dream that night. One of the characters in my dream seemed to be the teaching spirit of the iboga, and it was leading me around an alternative version of my hometown, and we kept winding up in the same place, until it showed me a new way, and this felt like it was trying to show me how to break out of predictable patterns on a symbolic level.

Others report different types of entity encounters under the influence of psychedelic mycota. Here is a report someone sent me about their experience after ingesting psilocybin mushrooms, during the winter, in the woods of Vermont:

I dropped to my knees in the snow before the tree and put my head at its base in a kind of devotional prostration. I closed my eyes and suddenly had the perception that there was an entity inhabiting

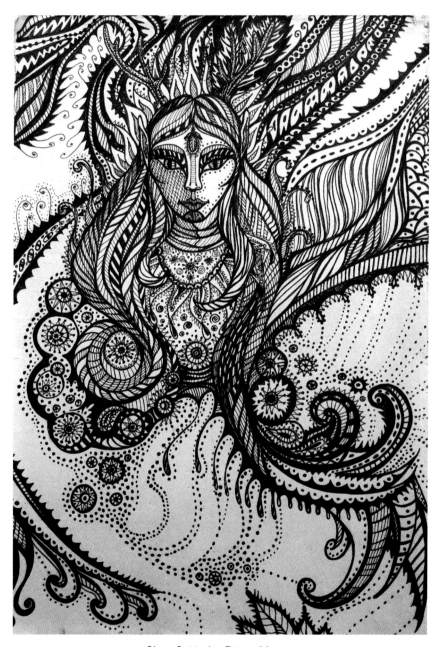

Plant Spirit, by Diana Heyne

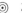

the same place the tree was standing but in another dimension. It felt like this loving, embracive, motherly-type Goddess energy that was just radiating care toward me. I opened my eyes and laughed at myself, kneeling in the middle of an empty frozen forest, but when I closed my eyes, the female entity was still there. . . . The next day . . . I told one of my friends that I had this tree I really wanted to revisit. We followed my footprints back into the woods and to the tree. I bent down and put some tobacco at its base, saying thank you, and my friend examined the trunk at his eye level. I heard my friend exclaim, "What the fuck is this?" I looked up to see him pulling bunches of black hairs off the bark of the tree. We . . . eventually concluded it must be black bear hair, and that a bear had used this tree to scratch its back and its hair was clumped into the sap of the tree. This provided me some interesting kind of validation about the experience with the Goddess the day before. I looked around and didn't see hair in any of the other trees. And so, in a big forest, both this bear and I were drawn to the same small tree for our own individual purposes. I remember wondering if it was actually the energy of the female bear that I had felt the day before or if there was a deity inhabiting this tree and bear had also felt drawn to caring energy emanating from the spot. I'll never know, but I did collect some of the black bear hair and put it in a little jar in my bedroom to remember the experience.[5]

Daniel Siebert, the ethnobotanist who discovered salvinorin A, the active component of *Salvia divinorum*, describes his discovery as being led by the spirit of the salvia plant. He began a series of experiments producing concentrated extracts and trying various methods of administration. During his experiments, Siebert felt that the plant's spirit was issuing a kind of intuitional guidance, encouraging him to continue with the extraction process and discover a means of achieving a full salvia experience. However, when I interviewed him for my book *Frontiers of Psychedelic Consciousness* in 2014, I asked him about this and he said,

"That is true. I did. But that was years ago, and I've reconsidered what I think about that now. I'm not totally closed off to that possibility, but I don't think it likely."[6]

Simon Powell, the author of *Magic Mushroom Explorer: Psilocybin and the Awakening Earth* and *The Psilocybin Solution: The Role of Sacred Mushrooms in the Quest for Meaning*, came to a similar conclusion. In his books he explores this topic in great depth. He describes how psilocybin mushrooms facilitate a direct link to the wisdom of nature, enhance biophilia, and enable access to ancient wisdom that binds all life on Earth. Although Powell initially considered psilocybin mushroom to contain a spirit or link to "the other," with time he came to revise his understanding:

> It is interesting for me to look back on these early visionary episodes. Often I convinced myself that I was in communion with an external Other, which is to say some sort of intentional being or entity totally separate from myself. You commonly hear this kind of interpretation. Author Graham Hancock, for example, often talks about entities from other dimensions and such, which he infers on account of his ayahuasca experiences. I now favor a Jungian approach, I think all these "beings" and otherworldly sources of teachings and insights that manifest with psychedelics are part of the "higher self" and that the higher self is an emergent aspect of the unconscious. Which means that the Other is actually part of us.[7]

Nonetheless, many people believe that all psychedelic plants and even psychedelic chemicals contain a unique spirit, and for those who have had the experience, it's very difficult to know the truth. If there is an independent spirit or entity within the mushroom, does the spirit truly live in the fungus or is it activated through psilocybin? After Swiss chemist Albert Hofmann isolated psilocybin from magic mushrooms, on a later visit to Mexico he gave a bottle of psilocybin tablets to Maria Sabina, the shaman noted above who had given the mushrooms to

Niños Santos, by Jag Wire

Gordon Wasson. "When we left, Maria Sabina told us that the tablets really contained the spirit of the mushrooms," Hofmann said.[8] Sabina "helped to confirm that their synthetic psilocybin pills were experientially identical to her 'saintly children' (i.e., psilocybin mushrooms) that she had used in her healing ceremonies."[9]

23
...
SNAKES, JAGUARS, AND OTHER ANIMAL SPIRITS

People routinely report animal spirit encounters during psychedelic experiences. When I put up an online query for experiences about psychedelic animal spirits, I received one of the largest responses to any of my entity queries for this book.

Many people under the influence of ayahuasca report encounters with animal spirit entities, particularly in the form of snakes and jaguars. Jaguars and serpents are commonly portrayed in paintings of ayahuasca experiences, such as in the artwork of Pablo Amaringo and Felix Pinchi Aguirre. In his classic book *The Cosmic Serpent*, Jeremy Narby describes how serpents encountered during ayahuasca experiences may be representative of the double-helix DNA molecule that resides within the nucleus of our cells, and that this may help explain why serpents appear so frequently in shamanic traditions around the world.[1]

Sara Phinn Huntley

One person who responded to my query for psychedelic animal spirit encounters told me, "I keep seeing rainbow serpents and rainbow jaguars in my visions, along with feathers and wings and humanoid faces. All symmetrical visions, while in medicine spaces."[2]

Another person sent me the following account:

I had an ultra-impressive encounter with a snake. I had a vision of being in a jungle with a rope over my mouth, with people holding the rope with a stick. I had a physical sensation but without any pain. I saw a vibrating snake over my head, and he swallowed me from my head to the bottom. I opened my eyes for few seconds, I saw that I was inside his body, he was glowing iridescent color, then I saw the spirit of a flying jaguar that came right into my face, in colors. I closed my eyes again and I felt like I merged with the snake. I felt like being a snake with poison glands in my jaws. That's just the tip of the iceberg. Crazy stuff happened after and keeps happening.[3]

Sometimes even cannabis, in sensitive people, can invoke animal spirit encounters. For example, my friend Katara Lunarez shared the following experience:

I'm really sensitive to marijuana, to the point where I trip. One time my wisdom teeth were growing in and the pain was really intense. I smoked a big hit, and although my pain didn't subside, I began to have this wild experience where I was surrounded by my ancestors. I could hear the drums and the dancing as if a ceremony was taking place. They began to show me a snake writhing around shedding its skin, and then opening its jaw and unhinging it. I was shown to lay my head back over the edge of the bed (to allow gravity to help in the task of opening my jaw as much as I possibly could to help the molars). I was constantly shown this snake writhing and unhinging its jaw from the ancestors, and was essentially told to take advice and analyze the behaviors of nature around me. They wanted me

to remember the lessons of the snake and apply them to my current pain. Lo and behold, it gave me relief to open my jaw in that way. I genuinely believe it helped me. I always remember that as the lessons of the snake from the ancestors.[4]

My personal ayahuasca experiences have often contained many visions of twisting snakes, and I've heard of numerous similar encounters from others. I've also heard a number of ayahuasca accounts in which people experience a visionary snake rushing into their mouth and then traveling through their body, after which they experience being swallowed by a snake and traveling through its body. This seems to be an archetypal ayahuasca experience.

When I was in Iquitos, Peru, in 2013, where I had several ayahuasca experiences and spoke at a conference, I witnessed an incredible performance by a sexy young woman who held a snake in her hands and danced with it, symbolic of the snake encounters that people commonly experience on ayahuasca. Below is a photo of that dance.

Ayahuasca snake dance performed in Iquitos, Peru; photo by David Jay Brown

In his book *The Psychedelics Encyclopedia*, Peter Stafford discusses how components of yagé (another term for ayahuasca, specifically the harmala alkaloids) can invoke visions of jaguars and snakes in people who have never been to the Amazon jungle:

The harmala alkaloids, with and without accompanying DMT-like compounds, have fascinated psychologists and others because of the unusually wide incidence of particular images. Outstanding in this regard are visions of tigers, snakes, and naked women (often [Black]); the color blue seems to predominate when ayahuasca is taken without additives. Although this imagery is not universal, it is common—sometimes frightening—and is closely aligned to the archetypal symbolism that so fascinated Carl Jung. When [Claudio] Naranjo gave harmaline and harmine in psychotherapeutic situations to city dwellers (people who had never been in the jungle), he

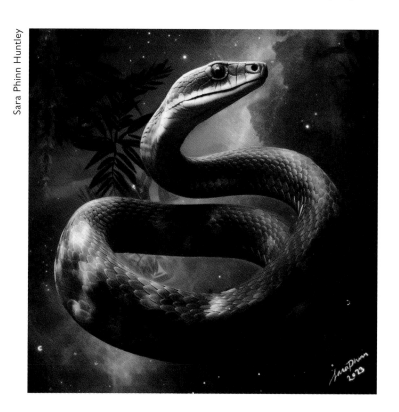

Sara Phinn Huntley

observed that much of the imagery that was aroused had to do with snakes, panthers, jaguars and other large felines. The recurrence of such images led him to speculate about the action of harmaline on "the collective unconscious."[5]

In addition to Carl Jung's theory of archetypes and the collective unconscious, these common visions may possibly be explained by Rupert Sheldrake's theory of morphic fields, which postulates that there is a telepathic resonance and collective memory among people using the same psychedelic compounds in different parts of the world. Discussing the same experiment that Stafford describes above, Sheldrake writes:

> This hypothesis may help to explain the observations of the psychologist Claudio Naranjo, who gave ayahuasca to people living in urban settings in South America. Although these were middle-class people who knew nothing about tribal cultures, they had visions of jaguars and snakes, which are major features in the mythologies of the cultures that used this visionary brew traditionally. It seemed as if they were tapping into a kind of drug-specific memory.[6]

As I discussed in relation to therianthropes (see chapter 17), it's not uncommon for people to report shape-shifting experiences in which they believe they transform into animals during psychedelic experiences, and that this is a way of communing with animal spirits. This phenomenon may lie at the root of myths of werewolves and the psychological phenomenon of lycanthropy. Many Amazonian shamans believe they can become jaguars and other rainforest animals under the influence of ayahuasca. James Dearden Bush shared with me the following experience that he had under the influence of magic mushrooms:

> The shape-shifting was coming on thick and fast, rapidly hinting and mutating back and forth between various animals, their coruscating morphogenetic fields chaotically dancing through me. As each animal

engulfed my psyche, I absorbed its emotional and energetic state, I grokked them, I could feel, in the truest sense, what it meant to be each of the animals. The intense and watchful poise of an eagle, the loving yet ferocious strength of a grizzly bear, the calculated and alert intelligence of the snake. And while I look back on this gnosis with reverence, at the time I was still terrified. Am I being possessed? This was the only thought my logical mind seem to be able to grasp onto in its sea of panic: probably a remnant from some deep Christian indoctrination in my youth. I remember the absurd thought racing through my head of having to tell my mother that I was now part human, part fully antlered deer! "James . . . why do you have deer antlers coming out of your forehead?" The conversation was rolling. Suddenly and in an instant the rapid shifting stopped. The battle of the animals has been won, I thought. Thick black illuminated whiskers protruded from my cheeks, huge, padded tiger paws for hands, neon orange and black stripes glistening across my arms, and a translucent golden lion's main flowing from my face. I was a cat. Now when I say I was a cat, I was part cat. All the transformations had been therianthropic to some degree. I was a humanoid feline of some kind, no doubt. I was still there but the feline energy was superimposed over mine, intertwined with my human energetic form.[7]

Sigalit Sol Avigdory shared with me the following experience in which she took on a leopard's appearance while under the influence of LSD:

My first LSD trip related to a leopard, in 1984. I was in Kibbutz Ein Gedi, in Israel. Three of us ingested LSD. About an hour later, the trip was bad for me. After seeing orange demons dancing, nonstop, I then went in front of the mirror and saw my whole face filled with orange spots, resembling the spots of a leopard. I tried to remove them but couldn't. I asked my two friends if they saw it too on my face and neck, but they said they didn't. But I saw my whole face

turn into that of the skin of a leopard with orange spots. It lasted for hours. Every time I looked in the mirror, I saw leopard's skin covering my whole face. Only years later I found out that around the same time, the very last living leopard in the Judean desert passed away just a few hundred meters away from where we were, but up the mountain. I wonder if it was related.[8]

Owls are often connected with UFO encounters, and many people report seeing owls, or having memories of owls, in association with alien contact, as well with powerful archetypal dreams, unusual coincidences, shamanic experiences, and personal transformation. UFO researcher Mike Clelland has collected many of these accounts and explores them in his books. In his foreword to Clelland's *Stories from the Messengers: Accounts of Owls, UFOs and a Deeper Reality,* Whitley Strieber writes about how owls and alien abduction encounters can carry similar symbolic messages, mark the genesis of a powerful personal transformation, and awaken us to a greater reality:

> When we look at the owl through the medium of the close encounter experience, it turns out that something is being explained to us. Like the owl, our mysterious visitors come by night. Like the owl, they are silent and all-seeing. And like the owl, they can reach right into our little burrows and carry us off into a transformative experience.[9]

Personal transformation and awakening to a greater reality lie at the heart of many psychedelic and shamanic experiences in which animal spirits are commonly encountered. Such animal spirit entity encounters may arise from archetypes of the collective unconscious, a resonance with morphic field memories, tapping into DNA, genetic memories, or genuine encounters with living animal spirits in the global biosphere. Regardless of their origin, these encounters are extremely common during psychedelic visionary experiences, and they are often profoundly meaningful for the person undergoing the journey.

24
...
OCTOPUS AND OCTOPOID BEINGS

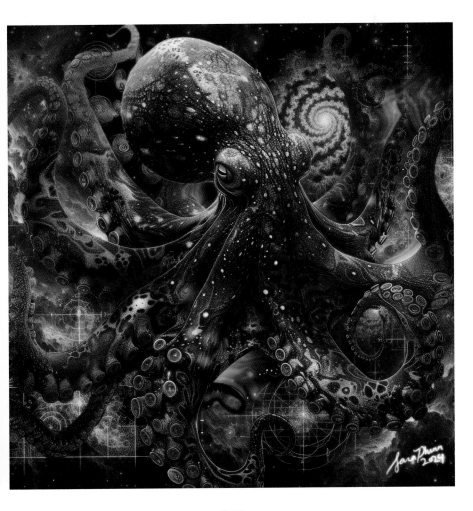

People have been reporting encounters with octopus and octopoid entities while under the influence of ayahuasca and South American psychedelic plant snuffs for centuries, and they are common in the recent DMT trip reports as well. They are often described as having multiple tentacles that seem to operate somewhat independently from one another, just like wild octopuses, and are said to have many eyes. Some people report them as benevolent and others describe them as malicious, but they seem to respond and change according to human thoughts, feelings, and intentions.

Octopuses in the Earth's oceans are known to be extremely intelligent animals, and their highly developed brain and nervous system structures appear quite alien compared to those of other creatures on our planet, with multiple partially independent mini brains throughout their bodies. Each tentacle on an octopus gathers sensory information to control its own movements, as well as those of other tentacles, without consulting the major brain regions, so it's especially intriguing that similar beings with comparable characteristics are also encountered in hyperspace journeys.

Psychedelic guide Dawid Rakowski observes that octopus-like creatures appear in the art of ancient South American cultures, such as in pre-Columbian Peruvian and Bolivian stone carvings. For example, a deity with many arms radiating out from its head is portrayed in the Gateway of the Sun of the Tiwanaku temple in western Bolivia. In a post on Graham Hancock's website, Rakowski describes his own encounter with an octopoid entity while under the influence of a snuff made from seeds of the South American tree *Anadenanthera colubrina*, which contains bufotenin, DMT, and 5-MeO-DMT:

> The entity I've encountered on numerous occasions was an octopoid entity with countless tentacles that looked like snakes coming out of the carcass. The tentacles end with bizarre but friendly faces, and the whole thing is so animated it's really not easy to grasp any details besides these. Often the being would appear and

Detail from the Gateway of the Sun, Tiwanaku temple, Bolivia. The being on the right of this carving shows many arms extending from its head.

react to me and my behavior. If I stayed peaceful, loving and open, it would come to me, open up, and begin to operate on my body. The moment I started analyzing or had second thoughts, the entity would move away and hide like an octopus behind its tentacles and the curtain of reality.[1]

Other people have also reported that these beings operated on their bodies. One person recounted the following octopoid being encounter that had doctor-like qualities:

I only took one hit and within about 10 seconds things dissolved around me, into what felt like a digital world with bright colors and

shapes. I found myself lying on an operating table with low buzzing sounds and vibrations in my ears. An Octopus-like machine (like the probes in *War of the Worlds* with Tom Cruise, but it had eight or more arms) started scanning my entire body individually with various colored lights and sounds going through me as it scanned. It stopped on my lungs and made a red light to highlight my lungs. I knew that it knew I had asthma as a kid. I also have a filling missing from my one of my large molar teeth, and am seeing a dentist tomorrow, but it also scanned and stopped on my mouth to show me it knows what the problem is there with my tooth. I could not believe what was happening but at the same time I felt so good, like I was in good hands.[2]

It's not uncommon for these octopoid beings to be in technologically advanced environments. Sara Phinn Huntley, the illustrator of this field guide, told me about her encounter with an octopus-like being aboard a spaceship while she was on DMT:

When the DMT took hold, I found myself transported into a dark technological space, the interior of some kind of spaceship. There were tubes and geometrically intricate surfaces glimmering in the barely luminated space. Next to me was a large squid-like being, looking at me with its intelligent yet calm eyes. It was also dark in color, blending in with its environment, but it was neutral in its energy and attitude toward me. It didn't make an obvious attempt to communicate but sat silently observing me, as I observed it. I looked at its elegant tendrils, drifting gently in the space around itself.[3]

The environments these entities occupy can also be grand and seem more artistically designed. For example, someone shared with me this dazzling DMT encounter with an octopoid entity:

Sara Phinn Huntley

[It was] a multi-armed octopus-like creature, moving gems in the ceiling/membrane of a cathedral, inside a Fabergé egg-like dome, who communicated telepathically, and didn't say whether it was a god but was definitely an important entity.[4]

A DMT user interviewed for a study by researchers Pascal Michael and David Luke reported an encounter with beings that fused "octopoid and serpentine features," while incorporating elements "of elongation, popularly associated with the 'Grey' or 'Mantis-like' aliens" encountered in the alien abduction phenomenon:

If I need to compare with something on this planet . . . they are like octopuses, from . . . another planet. They had many similarities, like that long head. . . . The scalp . . . was big. . . . It's far from octopus, but that's the closest. . . . Long heads and faces . . . They did not have the nose, I think. . . . They had a flat face somehow, maybe they had some holes under that mask . . . and their eyes were much bigger than normal. . . . Yeah, I wasn't scared, it was like [an] alien eye, [a] big one. No, it was like an animal, lamb . . . feeling only kindness. . . . Very long hands . . . I could see very strange hair . . . very similar to very thin and long snakes . . . long and moving by itself.[5]

Encounters with these beings are not always pleasant. On the DMT Nexus website, someone reported the following encounter with an octopus-like entity that seemed malevolent, and they had a frightening experience:

From behind the white chair, or was it from inside it? A creature emerged. It was not a happy, smiley elf. . . . It had innumerable tentacles, like a cross between some weird octopus or jellyfish . . . and the EYES! OH MY GOD THE EYES!!! I froze on the spot, thinking, shit, that's it. I've gone and done it now. I'm fucking toast. I never believed; I should have believed. . . . And now. Now I am at the mercy of something much, much, bigger and complex, and clever, and definitely [more] malevolent than myself. I asked it its name. I wish I had not asked. Its voice utterly destroyed me. It was like being caught in a storm of psychic noise—a whirlwind of deadly electrical shrapnel. I think I shuddered and started to drool uncontrollably at this point. I think I also urinated in my jeans. With its innumerable eyes, it gazed at me steadily and extended a tendril. At the same moment, it fired a beam of light directly between and above my eyes. The alien laser was pinkish green. It hurt. I begged it to stop. I whimpered. Please stop, you're hurting me. I'm fragile. Please be careful—I am sentient and mean you no harm. . . . It seemed to

consider this; the laser was withdrawn but the tendrils (there were more now) still held me in place. I was trying to make out details of its shape or structure but the closer I looked, the more it slipped away from me. It seemed to tell me in some weird non-verbal fashion not to struggle, and to stop making noise with my eyes. I took this to mean "Be calm. Do not struggle. Clear your head. See, but don't look." Then it became a little clearer. It seemed to be cloaked in some way—some sort of organic hood and covering was wrapped around it—some sort of armor or protection. The tentacles had no substance as we know it, and the eyes were the most awe-inspiring, terrifying thing I have ever beheld. They defied counting. They defied reason. The whole thing was too much, and I felt myself losing my mind. I . . . JUST . . . LOST . . . IT . . . goooooooooonnnnnne . . . I can't recall all that much after this, except it rifling through my mind like it was a chest of drawers, some "re-wiring," and an awesome amount uploaded to my cortex, and a sensation not unlike being at the dentists while being semi-conscious from nitrous; the sense of voices telling you it'll all be over soon and you've done really well.[6]

Another person reported the following encounter with an octopus-like being that seemed feminine and had multiple eyes, as well as Egyptian characteristics:

I saw an octopus-like entity on DMT (Cthulhu?). It was feminine. It encompassed my entire reality, and it had endless geometric tentacles, which I was zooming into and out of. There were also ribbons of eyeballs, pyramids, and hieroglyphics.[7]

Sometimes the octopoid entities are reported to behave with us similarly to how we might act with our pets. In the following report of an encounter with an octopus-like being, a DMT user on Reddit describes being treated like a puppy:

Octopus Dreams, by Harry Pack

Last time I did DMT I went through a small door into an enormously large room. Inside this room was a giant pink octopus with thousands of busy arms going to and fro—apparently managing the experiences of thousands of others. It was somewhat surprised of me being there, and hadn't expected me so soon, but it was glad. It communicated with feelings or thoughts and told me a little bit about itself. It treated me pretty much like I would treat a puppy. It started telling me about how there were others like it in other rooms busy doing the same, and that there were beings higher in the hierarchy. However, once it had shown me all of itself, and told me these things, my fear rushed in, and I disappeared from the room. Afterward I was completely amazed [and] astonished.[8]

On the same Reddit thread, another person reported an encounter with an octopus-like being that slowly revealed itself, while providing a loving and healing experience:

I met her on Friday and, wow, I was scared at first. She was purple with no face and spoke to me telepathically and again told me all lovely things, like I was a small child. [She] told me I was beautiful and perfect. Because she knew I was scared of her, she only showed herself a little at a time. She kept coming in and out in waves until eventually she showed all of herself and engulfed me with love. After that she then helped pull childhood trauma from me. It was like she filled me with love before she then removed my trauma. It was a truly beautiful experience.[9]

Another person on the same Reddit thread responded with an encounter he had with an octopoid entity that had mechanical features and described an ancient hybrid project that its kind was conducting with humans:

Octopoid Entity, by David Jay Brown with Dall-E

Something pretty similar happened to me, it was a mechanoid octo-poid alien entity that initially was dismantling me with instruments attached to its tentacles, but later was explaining how we were a hybrid entity. The octopoid entity was non-corporeal, and wanted to experience physicality with an animal body, so they had merged with humans. This was some ancient project of hybridization that went back to the dawn of humans. Saw a lot of tanks with fetuses, and H. R. Giger-style, hi-tech reproductive machinery.[10]

Encounters with octopus-like entities are not limited to DMT journeys. Here a Reddit user describes an encounter with an octopus-

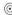

like being while under the influence of psilocybin mushrooms:

> I took four grams of magic mushrooms. (I don't know the exact species.)
>
> The octopus did not speak but communicated in a way that I still understood. It said, "Welcome, please enjoy this experience with me. We are all vibrations and not every vibration gets a body. You have a body, and you must take care of us. The purpose of life is to experience reality through sensory organs, pleasure, pain, and everything in between is good. You're going to miss your body when it dies so enjoy it while you have it." It also said, "Reproduction is important because we need more bodies to bond with, so that we can experience them.
>
> It also said, "I am the universe, and I am you and you are me."
>
> Then there was a lot of spoken tongues I didn't understand. One word that kept repeating was "yibra."[11]

Encounters with octopus-like entities are reported with a wide range of different characteristics, intentions, and agendas, but there are common threads, such as managing human experiences or forming a symbiosis with us. Their tentacles are often described as serpentine or biomechanical, and they tend to treat us as we might treat a child or a pet, or as subjects in an experiment, at times operating on us or rewiring our brains. They generally communicate with us telepathically, and although they are sometimes seen as friendly, sometimes as neutral, and other times as malevolent, they seem to respond and adjust themselves according to how we approach them.

25
...
CHEMICAL SPIRITS

Sara Phinn Huntley

Some people believe that, like plants and fungi, psychedelic chemicals such as LSD, MDMA, and 2C-B have a spirit that people can dialogue and commune with when they take these drugs. Chemists Alexander Shulgin and Albert Hoffman told me this, with regard to how they first formulated chemical discoveries in their labs. In one survey of entity encounters under the influence of DMT, 8 percent were defined as encounters with a "chemical spirit."[1]

When I interviewed Albert Hofmann, the Swiss chemist who discovered LSD, he said that he had a "peculiar presentiment" to resynthesize LSD and that the molecule "spoke" to him.[2]

Similarly, when I interviewed chemist Alexander Shulgin, I asked the following question:

Terence McKenna claims that there is a spirit, or a conscious intelligence, that dwells within certain psychedelic plants. In *PIHKAL* [Shulgin's book], you discuss how at times you've felt the presence of some entity or force guiding your work. Do you see this as being related to what Terence has claimed? And how do you explain this phenomenon?

Shulgin replied:

I think this is like the intuitive going through a dark room without lights on and being able to find the door. You don't see in the dark, and yet you know there's a door there. As you get more and more experienced at working with plants, or working in the laboratory and designing new structures, you get more of a feel for why they are and what they are.

One of the beauties of organic chemistry is that you cannot make a relationship between a continuing change here and a continuing result there. You cannot extrapolate from one molecule to another with any more confidence than you can extrapolate from one plant to another. So you begin to assign certain characteristics to what

you're working with. Is this talking to leprechauns? No. But it has some of the smell of that . . .

How do you discover the action of a molecule? A molecule, when it's hatched, is like a baby. There's no personality there. As the baby develops, your relationship to the baby develops, and eventually it forms into something of its own shape and character.[3]

On the DMT Nexus website, one person described an experience with the "ally presence" of the psychedelic 2C-B as follows:

I don't have extensive experience with 2C-B but the last few times I took it I felt a similar consistency to its ally presence. It feels to me exactly like a female mescaline. I think 2C-B is mescaline's sister. In some very fundamental ways, mescaline and 2C-B are preaching from the same book. I was brought to tears by how profound the experience was for me, and it wasn't even a very intense one. . . . I am very sensitive to most medicines and 14 mg was just enough to open the door so that I could get a full glimpse of what she is without falling over to the other side. I was so moved by her sweet presence; I even saw that she was worthy of the title "sacrament." If peyote is grandfather, and Trichocereus cacti are his children, then 2C-B is a disincarnate soul-sister, drifting through this dimension without the luxury of a physical body as the cactus alkaloids do. She is the etheric presence of expansive love that is trying, however subtly, to lure this lost humanity back to the fold of divine peace and contentment. I walked into my cactus garden as the peak subsided and gazed with reverence at all the [San] Pedros and torches and [Tom] Juul's giants and [Trichocereus] bridgesii. They glowed a touch brighter than any other plants in the backyard. They have more power in them than most plants do. Silently they said, "We love 2C-B too, she is ours." Granted, some phenethylamines may not have the glory of mescaline, not all are created equal. But think twice before you call Bumblebee [2C-B] a party drug. . . . the South Africans called her

"sacrament." What do they know that we are missing???? Approach her with reverence and devotion and she will reflect that love back 100-fold. Approach her with passing interest and distracted inattentiveness, and she will certainly buzz and buzz, but she won't speak.[4]

In the same thread, someone else commented:

It seems you're bringing something very special to the experience that is bringing something special out of the 2C-B interface. What you describe is certainly very similar to what I've experienced and read about, but very unique. One more thing; you mention 2C-Butterfly as "speaking," if you approach it with the appropriate respect. The first time I took it (the very powerful possessed experience), I asked the 2C-B-containing chocolate if it was a good time to take it; this was approximately 2 a.m. and I was alone, a time I normally wouldn't take such a substance, but it felt like the right time. The response came out of the blue: "HELLO 'LYSERGIFY,' WE ARE THE PHENETHYLAMINE FAMILY!", in a high-pitch, silly, almost Smurf-like voice. Something there's no way I could've imagined previously. Dr. Shulgin mentioned that in the lab, he would generally have a good idea of the nature of a given chemical before he (or any human) had taken it. Almost as if the chemical's "spirit" (which you describe as disembodied, cool) filled the laboratory. Very strange indeed . . .[5]

One person told me that "communing with the spirit of ketamine has been a delight." Another person also experienced ketamine as a spirit and shared this with me: "Me with ketamine! It tried to save my life while I was taking an antipsychotic that I was extremely allergic to, but I did not know that while I was actively taking it."[6]

When I first tried ayahuasca on my trip to Peru in 2013, I realized that the conventional guidelines used for describing the effects of a

particular psychedelic experience were inadequate; there was a factor that I had overlooked: the intention of the substance itself. Before visiting Iquitos, I parroted Timothy Leary's classic guidelines for planning a shamanic journey, about paying close attention to one's (mental) set, (environmental) setting, and dosage, as I thought that these were the primary factors in determining what happens during a psychedelic experience.

In Peru, I came to understand that there is a fourth important factor in this equation, and that is the intentions and reactions of the plant or sacrament spirit itself. This is very obvious when you drink

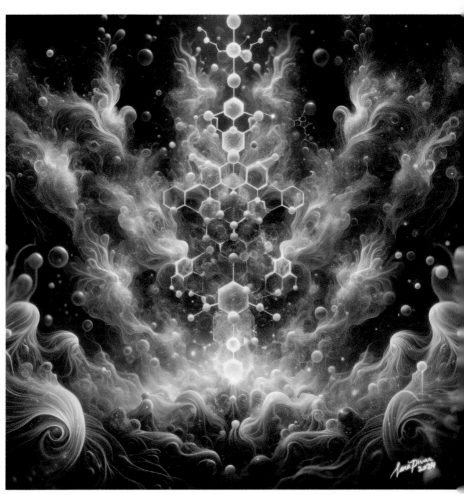

Sara Phinn Huntley

ayahuasca in the rainforest, but it's also true, I learned, whenever and wherever one does mushrooms, LSD, cannabis, MDMA, ketamine, and so on. These sacred psychoactive plants and psychedelic drugs appear to contain a living spirit, a form of botanical or chemical intelligence, a being, that sniffs you, scans you, assesses you, and interacts with you (by teaching and healing)—so that what happens during the experience is a truly co-creative act.

26
...
MOTHER GAIA

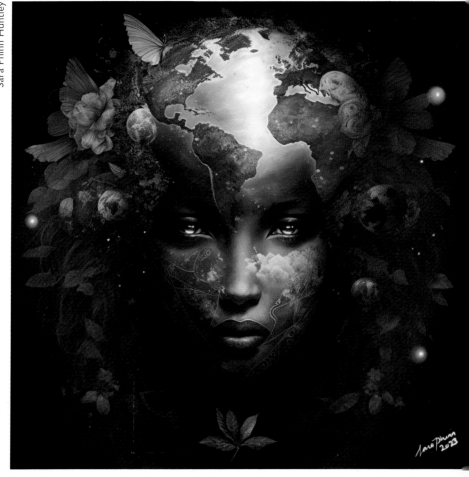

Sara Phinn Huntley

The Gaia hypothesis is a biogeological theory developed by environmental scientist James Lovelock and biochemist Lynn Margulis that proposes that the biosphere of Earth functions like a single, self-regulating organism or system, such that the oceans and atmosphere are maintained in a proper biochemical balance and temperature to sustain life on the planet. Many people believe that this self-regulating biosphere has an intelligence and a female spirit that one can commune and interact with. That sort of encounter is especially common for people under the influence of magic mushrooms and ayahuasca. Although related to the Mother Ayahuasca entity described in chapter 21, this is a distinct planetary spirit, sometimes called Mother Nature, the Gaian Mind, or Planetary Matrix. Many people report this feminine entity communicating a deep sense of urgency and pain regarding the ecological crisis on Earth. For example, Terence McKenna, who often spoke of connecting to the Gaian Mind using psilocybin mushrooms, here describes how our maternal environment is in crisis:

> It's always tricky to talk about the environment, because it is our mother, it is the matrix that sustains us. And yet all discussions gravitate towards the crisis that haunts it, generated by us, and now (hopefully) managed by us in a way that biological diversity and human diversity can somehow make a peace with each other, so that the glories of these domains of nature—and they are both domains of nature—are not compromised, one for the other. And . . . there's no dearth of current news on the front where this battle is being fought.[1]

Visionary artist Alex Grey depicts Mother Earth in ecological crisis in his famous painting *Gaia*. Grey describes this painting in his book *Sacred Mirrors*:

> Gaia was the tree of life or web of life with her roots in the subatomic, atomic, molecular, and cellular levels of matter (mater/mother) reaching upward through the oceans, stones, soil, grass, forests, mountains,

lakes, rivers, air, and atmosphere to nurture all plants and creatures. A natural cycle of birth, sustenance, and death was woven into the tapestry of Nature, Gaia continuously gave birth to life through the love energy in her heart. The future generations of humanity were symbolized by a human mother nursing in Gaia's cave.

Gaia's body was being ravaged and destroyed by man, reflecting the present crisis in the environment. A diseased and demonic phallus had erected structures all over the earth to suck dry Gaia's milk and turn it into power and money. The wasteland of a disposable culture was piled high and was seeping into the microgenetic pool causing diseases and defects in the Great Chain of Life.

Emerging also from that microgenetic level—but on the side of Nature—was an evolutionary alarm represented by a large "seeing" hand which catalyzed the collective will of the people, enabling them to see, with eyes of unobstructed vision, the actions necessary to stop the destruction of the world soul.[2]

Gaia, by Alex Grey

Visionary sculptor and pagan philosopher Oberon Zell first proposed the idea that Earth functions as a single organism in the early 1970s, predating Lovelock and Margulis's theory, as detailed in his book *GaeaGenesis*. Zell also designed a beautiful sculpture, *Millennial Gaia*, that he told me was inspired by a magic mushroom vision. I have a reproduction of the sculpture and have spent many hours staring at it in psychedelic contemplation. It depicts a green goddess with long flowing hair, sitting cross-legged and holding her belly, which is pregnant with Planet Earth. One of her breasts depicts a bounty of fruits and vegetables, and the other the moon. Her arms show redwood trees and rainforests. Long flowing hair covers her shoulders and back. On her legs are images of early marine forms of life, and climbing up the hair of her back is the evolutionary ascent of animals on Earth, from amphibians and reptiles to mammals, primates, humans, and butterflies.

As a psychedelic entity, Gaia takes many forms. One person shared the following psychedelic experience with me:

Millennial Gaia, by Oberon Zell; photo by David Jay Brown

I've seen trees turn into a celestial embodiment that connected me to Gaia. The plants and ground then shared energy with me and spoke to me through vibration. I've been connected ever since that evening. With my shoes off and my feet upon the ground, I feel its vibration.[3]

Another person shared this DMT experience in which they had an encounter with Mother Gaia:

Focused on my breath, tuned in to my heart, and took a hit of DMT—and then I was greeted by Mother Gaia. There were intricately beautiful green and blue patterns everywhere. She embraced me and engulfed me in her powerful healing energy. It felt like a spiritual orgasm, honestly. I felt my heart chakra explode. I laughed and cried simultaneously for a few minutes. Best DMT experience ever.[4]

Another person shared their encounter with the Mother Earth entity while on a powerful journey with 5-MeO-DMT:

I chose to be beside a large lake. I was crapping myself and almost hyperventilating with anxiety at taking this medicine again! I was so scared that all I could think of doing was to ask Mother Earth to help me get through this one. When it was my time to be served, I asked the servers to position me in the recovery position if I blacked out, but my intention was to try and stay seated on my mat overlooking the lake. Before the pipe had left my lips the scene started to change. I ended up on my hands and knees, trying to tell myself to stay with it, breath and relax as my world was shaking and changing all around me. Something external was gently shushing and telling me it was all going to be alright. My head got pulled to the ground and I began to gag and choke then this uncontrollable primal scream was pulled out of me. This happened several times. The earth . . . Mother Earth removed and absorbed my pain. At the same time, I

also felt the pain of Mother Earth; it was horrendous, yet she still selflessly took and absorbed my pain for me. It was very humbling. After I had stopped screaming! I came around, and again in a state of shock, got up and began trying to process things. I could barely stand, and I laid down on my back, looking up at the sky over the lake. There was a solitary eagle circling above me. I had a connection to it, and all this love energy streamed out of my chest up to the eagle [and] encompassed Mother Earth and then the universe. It was profound and incredibly healing.[5]

Another person shared the following psychedelic contact experience with me, expressing how Gaia is always in connection with us:

This is what I think I tap into with any plant-based psychedelic I use, for a finer tuning to something at the base that exists without them. You can feel it before you eat the seeds, or what have you, that thing that compels you to eat them. I think it is Gaia feeding itself. I [have] never seen this as a singular thing, more [as] a container for everything, including myself.[6]

Brian Christensen, whom I met in a Facebook group devoted to discussion about psychedelics, shared the following account of an experience he had while on DMT in which he encountered the Mother Earth entity, which he later recognized in other people's accounts:

I started doing DMT about five or six years ago. I was already an avid psychedelics user, and am great at full surrender with no fear. Also, a little side note: My wife had a doctor recommend that she try "earthing" (physically connecting to Earth, whether directly or through connection to a ground rod). I had started making "grounding sheets" for our bed, and it had an effect immediately, so I made a chair that had grounded arm rests for my office. I was in this grounded chair when I did my second attempt at smoking DMT. I

had made a big vaporizing contraption out of jars and a water bottle . . . you could heat the bottom of a jar to vape with. It worked well; it was just big. Nobody was home (wife and kids), so I turned out the lights and got some mellow instrumental hip-hop music going, and took three hits. I laid back in the chair, and whoosh, out into open space with her. She looked like rolling rainbow-colored ropes of geometrical tessellation tiles, coming out of the top, like a million arms then arced out, up and around, back down to her feet, like a toroidal field. She simultaneously looked like a Hindu goddess, with multiple arms and legs, a tree of life and a beautiful blue woman. I said telepathically to her, "Oh my God you're so beautiful!" To which she replied, "I know"—but it was an acknowledgment with ultimate humility, not like some pretty chick saying, "Oh, I'm so hot." I replied, "I won't abuse this and come back here too often." She lovingly smiled and said back, "You're always here." The trip started to end. I came fading back into my filtered reality of this body, no longer an atheist, and full of questions. I contacted my buddy Kevin to tell him what happened, and he had me start looking up toroidal fields and pictures of Mother Earth on Google, and I was like whoa! Other people have definitely seen the same shit! I also noticed a Mother Earth pic in an Alex Grey book soon after that was eerily similar. I contacted a visionary artist named Joshua Levin and had him try to recreate the image in 2-D digitally. It's a beautiful work of art, but it is not what I picture in my head about the trip. The images of all my DMT trips are so burned in, I could describe them perfectly to maybe a computer animator or something.[7]

My friend Rob Bryanton, author of *Imagining the Tenth Dimension*, shared a powerful experience he had on cannabis that seems like an encounter with Mother Gaia:

Here's what I saw. Two summers ago, I was out recording background ambiences for a movie. It was a beautiful sunny day. Making these

recordings is low stress, you just sit there quietly with an ambisonic microphone and portable recorder and listen to the world through headphones. I was sitting in a field with some tall grass around me, [and I] took a single puff of weed (that's the usual amount for me). Within a minute or two, something happened to the ground, where distances seemed exaggerated, kind of like the diffraction that happens when you look into an aquarium. Right in front of me, on one [of] the nodules on a wild grass stem, I saw an eye open up. It seemed powerful, but benevolent, probably female, thrumming with the energy of all the life around me. I sat, awestruck, for a few minutes, and then the illusion faded away.[8]

Contact with Mother Gaia may help explain why so many people report that their ecological awareness is raised after a psychedelic experience. It's also common for alien abductees to report that they are shown scenes of global cataclysm and ecological disaster while aboard flying saucers, as possible scenarios for Earth's future and warnings. Could these "aliens" actually be spirits of the Earth, or agents of Mother Gaia, sent to awaken a sense of ecological awareness in us?

Contact with the maternal entity we might call Gaia appears to almost always be a positive experience, although sometimes an empathic union with her can be painful when we come to understand the ecological destruction and environmental toxicity that humans have caused on this planet. But the lasting experience is almost always one of increased ecological awareness and commitment to helping the environment as much as possible. Considering the urgent ecological crisis our species is currently facing, and the desperate state of our endangered biosphere, these types of encounters seem to hold the capacity for immense survival value.

27
■■■
BEINGS OF LIGHT, PURE ENERGY, AND BODILESS BEINGS

Sara Phinn Huntley

In DMT, ayahuasca, and other psychedelic experiences, some people report encountering beings composed of light or pure energy, and without defined bodily structures. Many religious, spiritual, and mystical experiences also report contact with "beings of light" that often seem angelic. Beings of light are also reported in near-death and UFO contact experiences.[1]

One example comes from Peter Guttilla's book *Contact with Beings of Light*, in which the author describes a profound series of experiences that Dorothy Wilkinson-Izatt had with lights that she witnessed in the sky on numerous nights and that began to telepathically communicate with her. Describing Wilkinson-Izatt's first contact experience, Guttilla writes:

Dorothy stood, straightened her shoulders, and suddenly felt bewildered. Now she had the strangest feeling she was being watched. She walked across the room and peered out the window and drew a quick, involuntary breath. There, bright and crystalline, suspended in the middle of a clear patch of sky, was a beautiful spinning object that looked like a huge diamond with a horizontal ring of lights revolving around the middle. As she put it, "The object was magnificent and brilliantly lit by lights with a rotating disk of light at the base. I couldn't believe what I was seeing."

Momentarily doubting her senses, she turned away and shut her eyes, then looked back. The sparkling object was no illusion; it was definitely there, dazzling and crisp and seemingly alive. In her journal Dorothy wrote, "Then, as if it had read my doubtful thoughts, the crystal-like object began to dart in and out of clouds, and I instantly had the impression it was giving me further proof it was real. It really was quite wonderful to look at."

Dorothy was powerfully captivated by the warm brilliance of the UFO. There was something in it, or coming from it, that evoked feelings of elation, optimism, and expectation in her. . . .

[Later that night] she was half-surprised to see an enormous, stationary ball of light in the sky, low on the horizon.

The glowing ball was different from the spinning wheel that she had seen earlier—of this she was certain. Flashing brightly, it hovered, then started to wobble from side to side. When it did this, Dorothy became aware of something, something mental. "Communication," she thought, "Like it was touching and searching my mind. I know I heard the words, 'We are real; we are here; it is not your imagination.'"[2]

I also once had an experience with seemingly intelligent lights, and it involved hours of lost time, as is common in alien abduction experiences. As I describe in my book *The New Science of Psychedelics*, my girlfriend and I saw floating orbs of light outside our bathroom window, with lightning-like flashes in different colors. We saw circles of light with symbols or objects in

Sara Phinn Huntley

their center, and it seemed as if our emotional reactions were having an effect on the frequency of the lights' blinking. We both experienced the lights as being intelligent, alive, or conscious in some way, or as an entity of some sort. Although this experience seemed to go on for only about half an hour, when we looked at the clock afterward, several hours had actually passed. I recounted this experience to the late Harvard psychiatric researcher John Mack, and he was quite intrigued. Mack offered to put me into a relaxed hypnotic state to explore my memory of the event further and see if anything else may have happened that I couldn't immediately recall, although, unfortunately, we never had the opportunity to do this before he died.[3]

Light or energy beings can take on many different personalities, it seems. One person told me that he "had an experience of a vaguely maternal energy" that gave him a "hug" while he was under the influence of changa (a smokable blend of DMT and MAOI-containing Syrian rue).[4]

Another person shared the following experience that he had on "a little more than five grams of dry *Psilocybe cubensis*":

I've had beings of light lay hands on me . . . as I laid back like I was on a dentist chair. I felt like they went into my head, where my spine and brain meet. I felt and heard popping noises, felt pressure and relief in my back and spinal column. It went on for a few hours after. I felt happy and light on my feet. I was kicking my heels together in the air. Heard lots of sounds, as well the music, which was no longer music.[5]

My friend Katara Lunarez shared the following experience that she had with light entities:

Not a psychedelic experience, because I was completely without substance, but a trippy experience, nonetheless. It sounds funny, but I was at a concert recently, and the bass was so deep and powerful that it vibrated my whole body, and I had an out-of-body experience. It felt like I was in two places at once. Physically, I was in the crowd and immersed, while simultaneously being in another—I'm not sure

Sara Phinn Huntley

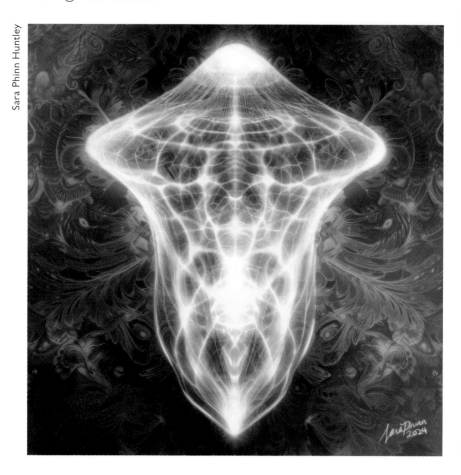

what to call it? Plane of existence? An out-of-body experience, where I was conversing with beings of light? But the beings of light weren't like we understand here in our existence; they weren't physical like we are. They were more freeform and telepathic. There was more to be felt and understood than actual words.[6]

Beings of light or energy are often described as amorphous or undefined, though with a distinct personality, and their presence is often physically felt. Most reports seem to indicate that these entities are generally friendly, and many are said to offer teachings or healings. It is also common for people to ascribe spiritual or sacred properties to their encounters with these radiant beings.

28

...

GOD

The figure known as "God" is generally characterized as the creator of us, of all life, of the entire cosmos, and of all of our reality. Some DMT reports include encounters with the pop culture image of God as a wise old man, in the clouds or sitting on a throne, but there are other manifestations of this archetypal figure. For our purposes, we are speaking of God as an independent entity, as distinguished from a mystical or religious experience of divine union—as is commonly reported in experiences with 5-MeO-DMT, psilocybin, LSD, and other psychedelics—and distinct from encounters with Jesus or other deities.

Some of these encounters with God as an entity tend to be rather bizarre and unusual. For example, in horror film connoisseur Stephen Biro's book *Hellucination* (for which I wrote the introduction), Biro describes encounters he had on LSD, combined with nitrous oxide, with a "true God" along with a "false God" and the Devil, who battled one another (as well as encounters with "reptilian demonoids").[1]

Studies show that psilocybin, the active ingredient in magic mushrooms, produces in 61 percent of participants religious or mystical experiences that are in every way indistinguishable from those reported by mystics and religious figures throughout the ages.[2] However, Biro didn't have a classic mystical experience on his psychedelic journeys. Instead, he experienced a progressive series of personal hells, created, it appears, by filling his brain with dark and violent imagery while tripping—and this caused him to experience states of consciousness in which he appeared to meet and speak with God. While encountering the presence of God, or a higher spiritual intelligence, is not uncommon on high doses of psychedelics, Biro's experiences stand out as unique among the reports I've encountered. For example, he describes how he and the "real" God team up in hyperspace to kill and destroy the "false" Western cultural image of God.[3]

Many of these types of unusual encounters with God seem influenced by readings of the Bible. For example, a friend shared this experience with me:

One time when I was tripping, I saw myself sitting at the feet of the traditional Judeo-Christian God. He was sitting on his throne, male, white beard, white robes, and all. Sitting at the foot of his throne, I kept tugging on his garment (as in the Sam Cooke song, "Touch the Hem of His Garment") and asking repeatedly, "Am I okay?" "Am I alright?" And he ignored me. At a certain point after making a bit of a nuisance of myself, I guess, this vision of God turned his hoary, infinite face toward me and, blasting me with the fiery hot breath of God, growled-shouted, "You're okay!"[4]

More often these type of encounters with God are experienced as just a presence or a voice. For example, another friend shared this experience that they had on a flood dose of iboga:

God was instantaneously everywhere. I was talking to God like I am talking to anyone in any normal conversation. No translation issues you can get with other psychedelics. Ask any question and receive a direct answer. So, I asked away about the nature of good, evil, entities, separation, unity, science, religion, humanity's purpose. It was just a normal conversation. Each question was answered in a direct voice and corresponding images. It was super-fast, like in the movie *The Matrix*, where Neo is download-ing Kung Fu. Years after, I am still having the same conversations, just in my sober solitude, but much deeper in my heart and much less in my mind conversations.[5]

The comedian Steven Wright is said to have asked, "If God dropped acid, would he see people?"[6] Encounters in which people report that they "see God" are sometimes viewed as a bit of cliché in Western culture, but they really do happen. Sometimes these types of encounters are reported as encompassing a morphing series of different deities that point to the deeper message, like in the following account:

I once saw the clouds in front of the moon slowly morph into a huge Mount Rushmore-like image, but the faces were of Jesus, Buddha, [and] Native American, Hindu, Norse, and [other] "gods" I know little about. The only real message beyond the amazing visual was: "We're all the same."[7]

Another person described their psychedelic encounter with God like this: "a localized singularity that absorbed all light, and literally twisted space around itself, so I could not look at or see it. It was radiating expansive bliss, awe, and security."[8]

Someone else sent me this description of their psychedelic meeting with the ultimate divine being, which they experienced as pure light:

In my experience "it" was a source of energy, emitting love. The excess love manifests as light, on or inside that which I believe I was traveling toward—the Source. Everything around was black (because I was inside a light beam). The entity (I prefer the word Source) itself kind of looked like a prism refracting in all directions. It was sort of like Pink Floyd's *Dark Side of the Moon* album cover, but with a single point at the center rather than a triangle. Kind of what I imagine it's like to be light traveling through a fiber optic cable. And for some context, I was raised in a fundamentalist Christian home, yet this contradictory experience has informed my personal cosmology more than decades of indoctrination. The only thing it communicated, or more like emanated, was love.[9]

Encounters with God as an entity seem largely dependent on cultural expectations and are almost always viewed as positive experiences, except in situations where "false" or "counterfeit" versions of God are experienced. As always with all psychedelic entities, it's wise to take into account the possibility that some entities could be masquerading as the icons they find inside our minds, while their true forms and intentions remain hidden.

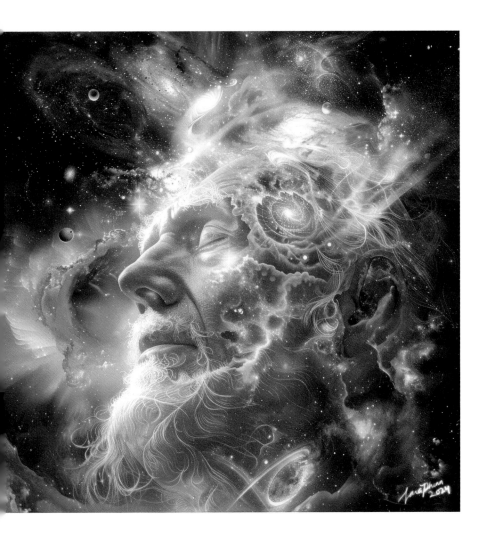

APPENDIX I

■ ■ ■

MY ARTISTIC JOURNEY AND ENTITY CONTACT WITH DMT

SARA PHINN HUNTLEY

I have a neurological quirk called aphantasia. This means that my mind's eye does not produce vivid visualizations the way most people do. This doesn't mean that I don't process visual memory; it just means that it is more spatial for me, and my "photographic" memory is very subtle. It's like having a desktop computer that processes all the same data sets, but there's no monitor hooked up to immediately visualize it. This makes for a unique experience as an artist, and for a much more impactful experience for me when I hallucinate, as the hallucinations are something I experience only when I dream or use psychedelic catalysts.

The first time I had a small toke of DMT, I had only very subtle visions at the very limited scale of visual phenomenon. I could feel the gentle euphoric tingling of the molecule as it traveled through my cardiovascular system, and I saw trails of fractals emanate out to form a seated meditating figure in my mind's eye. Surrounding the figure, I saw a soft blue mandala of a segmented, stained-glass-like motif. It was relaxing and gentle. During that time, I felt no "other" consciousness

interfacing with me. It was a wonderful "toe dip" into the new molecule, and it gave me the confidence to go deeper the next time.

The following evening it was time for me to dive deeper. This experience is what, in my own mind, I truly catalog as my "first time." I slowly took several large inhalations of the strange, acrid smoke, so as to not tickle my lungs into coughing heavily, as the thin stream traveled in from the smoking apparatus. As many people have reported, it smelled like a factory, new sneakers, mothballs, or melting lawn furniture—not a very pleasant smell, or taste, for that matter.

Within seconds of this inhalation, I felt my body tingling in that familiar way, but much more intensely; it became a profound buzzing, and I saw the room start to swim with iridescent glyphic shapes. I immediately closed my eyes and positioned my body into a comfortable reclining position, letting myself go into the visionary state, and opening up all my mental perceptions to the experience. I saw a brightly colored mandala swallow up my mind's eye. It was enormous, like being just a few feet from a body of energy as big as the sun. Within this rainbow-colored mandala, the reds and yellows in particular were predominant.

I looked up at this energy, and I immediately became aware of a presence within it, a kind of "other." I addressed it with a respectful acknowledgment. It seemed to be examining me, assessing the nature of my consciousness, as well as the orientation of my embodied being, and to recognize that I was a small bipedal primate. Then the strangest thing happened: out of its mandala-like body it created anatomies with which to relate to me. It crafted shapes in a pixelated, rainbow mandala pattern—little bodies.

I believe that the beings we see in DMT space exist on a kind of energetic continuum, almost like the colors of a rainbow. What people perceive energetically as clowns or jesters do so because they resonate with other properties aside from the visual. They exude joy, happiness, mischievousness, and playful prankster qualities. When I first saw them, it was their fractaline, pixelated visual motif that reminded me of the patchwork of a harlequin clown or acrobat.

Sara Phinn Huntley

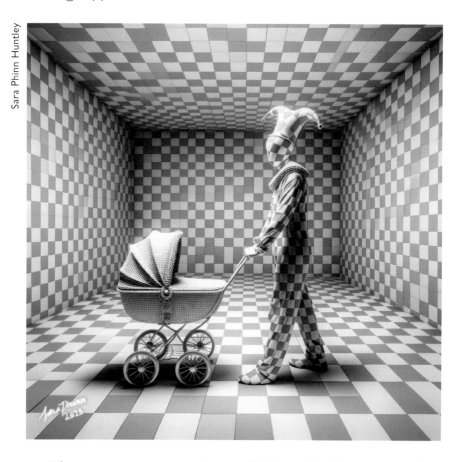

These patterns were reminiscent of Allyson Grey's paintings, where the glyphic language she creates is in a patterned contrast with the chaos of the background, which is composed of the same colors and pixels. It's merely the variance of their respective patterns that gives rise to one's ability to distinguish the foreground from the background. This type of patterning is how all dynamics and forms arise from the greater pools of energy and fractals of the cosmos.

Where one person sees a clown, another might see a jester or a machine elf. In some visions I have seen these small, machine elf tykes organize themselves as little hieroglyphic strips, imprinting themselves all over the surfaces of the room I am in, constructing reality in real time all around me. In later visions, I encountered angels and golden goddesses on bicycles. I've seen inky dark alien squids in Giger-esque spaceships.

Sara Phinn Huntley

One visionary experience in particular, which I find akin to those of Andrew Gallimore and Rick Strassman's extended-state DMT protocol, involved partaking in what is commonly referred to as "pharmahuasca," a reverse-engineered concoction inspired by ayahuasca that is composed of an MAO inhibitor and DMT. With this combination I had some of my most intense explorations.

The first time I did pharmahuasca, I initially ingested Syrian rue tea, along with a modest hit of acid. As the MAO inhibitor in the Syrian rue took effect, I felt a wave of nausea, which quickly developed into a mini purging. I am typically rather robotic about physical functions like vomiting; I just let them happen and steward myself to not have any particular emotional response to the process. However, this

purge was so deeply emotional that I found myself mourning the primate body that I have in this lifetime. I was forced to acknowledge my mortality in a visceral way.

I held my small, pathetic fleshy form and thanked it for all its hard work keeping me aloft in this world. I grieved that someday it would fail, die, and decay. It was like a beautiful poem, movie, or novel that would someday come to an end and be lost to the history of the universe. In this experience of gratitude, I let go of holding on to the pain of that grief and allowed myself to finish the purge with an acknowledgment of life's impermanence.

Then came time to smoke the DMT. As I watched the room dissolve into a shimmering, sugar-coated realm, I looked up to my right at the exquisite wood grain of the wall next to me. Out of the fractal wood grain, a giant crocodile goddess made herself apparent. She reached a clawed forefoot out toward me and rolled her digits, flexing the large, curved claws at me in a beckoning way. I saw the other panels of the wood grain as luxuriant furs, the petticoats of the goddess, both beautiful and terrifying in their splendor.

The crocodile goddess looked down on me from above, and I could hardly lift my gaze to her powerful reptilian eyes. In that moment I began to feel the presence of a dual nature within me—my own nature and the nature of this beast, this crocodile goddess, powerful but monstrous. I was terrified of this demon-like energy that was intrinsically part of the physical and genetic makeup of my evolution in this world, something I could not escape. I recoiled at this realization that I was intertwined with these beings; they were part of me, as I was part of them.

I reached out to the universe and said within my mind, "Yes, I already know the darkness. I am not here to focus on that, please have mercy on me." As soon as I beseeched the mercy of the cosmos, the outer darkness of these coiling, snakelike demons that were spiraling through my being, my spine, and my DNA peeled away like burning embers, and they revealed two serpents of bright white light. They

expanded around me in a crystalline matrix of the Sepiroth,* the Tree of Light.

I found myself rocketing up through multiple spheres of light, crashing through spheres of glowing crystal, almost like the elevator in *Willy Wonka and the Chocolate Factory.* As I ascended through the Tree of Life, I felt the resonance of multiple energies, each sphere's order of divinities. Once I emerged from what I presume must have been past the abyss of Da'at,† I found myself in a huge, cavernous space. It was like a colossal cathedral, but in the shape of a giant insect. I was inside the body of an insect goddess, as big as the cosmos itself.

Sara Phinn Huntley

*In the branch of Jewish mysticism known as Kabbalah, *Sepiroth* is a word for the ten divine emanations from Ain-Soph, the impersonal, universal principle or deity.

†In Kabbalah, Da'at is the mystical state in which all ten aspects in the Tree of Life are united as one.

Sara Phinn Huntley exhibiting the DMT entity costume that she designed, modeled after her encounter with the entity that inspired the drawing on p. 287 of herself in the costume.

Within this space, I could see a shimmering net of interconnected energy. It was Indra's net.* Each string was connected to each soul in the universe, arranged along the lines of evolution and karma. Each section of the net was related to the animal and plant kingdoms. As the wind of divine energy blew through the net, each string sang like music. I heard the songs of whales, calling out the names of ancient family ties.

*Indra's net of jewels is a metaphor of Mahayana Buddhism. It illustrates the interpenetration, intercausality, and interbeing of all things. In the realm of the god Indra is a vast net that stretches infinitely in all directions. In each "eye" of the net is a single brilliant, perfect jewel. Each jewel reflects every other jewel, infinite in number, and each of the reflected images of the jewels bears the image of all the other jewels—infinity to infinity. Whatever affects one jewel affects them all.

I reached out to the strings nearest to me; they glimmered like dew on spider webs. As my fingertips met the string, I literally felt the string under my nerves. I touched the net and felt it. It was the first truly tactile "hallucination" I'd ever felt, and it remains one of the most magical and soul moving moments I have ever had in my life.

I heard the whales singing multiple songs. Not only did they sing the songs of their families and karma, but I heard them sing something deeper, with a sense of dominion, that we belonged to that cosmic insect-like goddess. It was not a sense of foreboding, but a sense of power and belonging in a maternal way. From there, I found myself wading through what could only be described as a room full of analog tapes. Out of these compartments, reels and reels of tapes spewed forth, each one containing the history of a different species and their imprint on the cosmos. I was wading up to my waist in tapes, with my legs seemingly slogging against them, as they were tugging at me.

At one point I felt overwhelmed with data, information, and sensory overload, so I simply requested to be given a reprieve, a sort of defrag* or reset moment. My entire visual field went white. I was suddenly in a room that resembled the "Construct," the white room in *The Matrix*.† Looking around this white space with no walls and seemingly no floor that went on forever, I saw a small, silhouetted figure that resembled Kokopelli, the hunchbacked flute player of Southwest Native American mythology. This being was pointing at something, a small tear in the white room, almost like lifting up the corner of a page that was about to be turned. The being repeatedly pointed to this small, lifted corner, emphasizing the gesture that he was about to "turn the page."

I immediately recognized this gesture, this pointing and repeating. It was the same gesture I had been employing to show my beloved cat Luna that I wanted her to pay attention to something I was about to do.

Defrag means to rearrange data on a disk so that it is stored sequentially rather than randomly.

†In *The Matrix* film series, the "Construct" was a virtual workspace created to run simulations. It was also used as a loading program to launch or create virtual objects in preparation for whenever rebel operatives hacked into the Matrix.

It's quite tricky to teach a cat about symbolic body gestures that allude to a future event, but it was slowly working. I realized it must be similarly difficult to communicate certain things to an embodied being like me, in a noncorporeal and nonlinear space like this, so the entities were using a gesture that I myself had been using in a similar fashion. So, I focused my attention on the corner, and when I did, the being continued to lift it this time, and a large rainbow-embroidered, mathematical pattern, similar to Shipibo embroidery patterns, squiggled into the white room's space, stitching itself on the surface of the sentient, dome-like construct.

I had been studying complex geometry, in particular the 4-D cell sets from hyperdimensional geometry, just a few nights before. My study of those sets visually allowed me to realize in this unique moment that these "embroideries" were hyperdimensional shapes being stereoscopically projected into a lower-dimensional media where I, a being who inhabits a lower-dimension natively, could perceive them. It was a remarkable insight, because it gave me the impression that these visual perceptions really do operate on a level that relates to the natural sciences.

Sara Phinn Huntley

APPENDIX 2

■ ■ ■

PERFORMANCE ART INSPIRED BY DMT ENTITIES

THE WORK OF MAYA BRACKNELL WATSON

Maya Bracknell Watson is an interdisciplinary artist, poet, performer, and psychedelic and parapsychology researcher who has been involved in creating immersive and interactive performance art pieces inspired by her DMT entity encounters and the data from her research. Bracknell Watson worked as a research assistant for David Luke, the researcher involved in the extended-state DMT studies at Imperial College London referenced throughout this book.

Bracknell Watson was part of the team investigating DMT entities for a field study[1]—a precursor to the DMTx extended-infusion study—that investigated "the ontological status of anomalous and exceptional experiences under the influence of DMT, including encounters with the apparently sentient and other-than-themselves entities, precognition, shared visionary experiences with other users, creative problem solving and insight, and reportedly extra-dimensional visual precepts."[2]

Bracknell Watson has also helped create performance art in both

physical and virtual reality. In her "Deja Vu" performance at the 2019 Breaking Convention, Watson drew from her research and personal experience to create an immersive performance that "simulated the structure, content, tropes, experience, encounters [and effects] of a breakthrough DMT experience."[3]

Audience members were each "taken" at the beginning of the performance by a different "entity," and each was given a unique and private experience with that entity, while others watched them from a distance. The audience members were not briefed or expecting a performance. They were given coordinates of where to meet and walk—and then they came across an entity at the crossroads, who was played by David Luke. The entity guided them deeper into a forest, where they were left—and then pounced upon by the excited entities welcoming them home! At the end of the performance, the participants were turned into trees and left in the forest.

What makes Bracknell Watson's performance art especially interesting is the fact that there's a large social engagement around it. It pulls people into mythically reenacting DMT entity encounters, like ancient Greek theater, reminiscent of the Eleusinian mysteries. It's a most fascinating social phenomenon indeed. Below are some scenes from "Déjà Vu."

David Luke as one of the audience members who has been turned into a tree. According to Bracknell Watson, "One of the intentions of the work is that the audience are themselves turned into performers in the performance, mobilizing would-be passive observers of the art into both the art themselves and active co-creators and contributors to the happening."

Maya Bracknell Watson
as a DMT entity and
an audience member;
photo by Luis Solarat

Maya Bracknell
Watson as a DMT
entity; photo by
Alexander Irvine

DMT entities
surrounding an
audience member;
photo by Dan Harley

In a virtual environment, Watson has created "The Interdimensional Embassy," which is an art science collaboration and hub, an education and research platform, and an event space. It was designed to explore "the uncharted archipelagos of consciousness and proximal cosmic topographies at the intersections of life-death, virtual-unreal, hallucination-elucidation, indigenous-endogenous, shamanic-scientific, necro-techno, inner-other, and the human encounter with apparently discarnate sentient entities."[4]

Below are some image captures from events in "The Interdimensional Embassy."

A group photo of speakers at the Interdimensional Embassy "Fight Night: Mental Health and Madness; Psychiatry vs. Shamanism" public debate

The Interdimensional Embassy Headquarters reception and its receptionists

The Interdimensional Embassy HQ metaverse, hosted on frameVR

■ ■ ■

Maya Bracknell Watson's work can be found on
Instagram: @maya_themessiah

FURTHER READING ON DMT ENTITIES AND THE PSYCHEDELIC HYPERSPACE

WEBSITES

dmt-nexus.me

> This website is focused on the discussion, research, and exploration of DMT and related entheogens, providing information on their use, effects, and extraction methods.

psychonautwiki.org

> This website serves as a community-driven online encyclopedia designed to document psychonautics—the exploration of altered states of consciousness through practices such as meditation, lucid dreaming, and psychoactive substance use—in a comprehensive and scientifically-grounded manner.

dmtx.org

> This website details the Extended-State DMT program (DMTx) which was founded by Daniel McQueen and focuses on the

research and exploration of sustained DMT experiences to study consciousness, supported by a team including medical professionals and artists, and is integrated with the Medicinal Mindfulness community.

erowid.org/chemicals/dmt/dmt.shtml

This webpage on Erowid provides an extensive collection of resources on DMT, including user experiences, legal status, chemistry, dosages, and health effects, serving as a comprehensive guide for those interested in learning about this psychedelic compound.

deoxy.org

This website is a repository of varied content ranging from philosophical essays to psychedelic research, emphasizing alternative perspectives on consciousness, spirituality, and human potential.

shroomery.org

This website is a comprehensive resource for information on cultivating and identifying various types of psychoactive mushrooms, providing detailed guides, cultivation techniques, and community discussions related to psychedelic mushrooms and their effects.

alieninsect.substack.com

This Substack page by Andrew R. Gallimore focuses on the scientific exploration of psychoactive drugs, neuropharmacology, and consciousness, presenting insights and discussions on the culture surrounding psychedelics and other psychoactive substances.

youtube.com/@josikinz

This YouTube channel by Josie Kins is dedicated to exploring and documenting subjective effects of psychedelics through video content, targeting researchers, artists, and enthusiasts in the field.

youtube.com/@SymmetricVision

This YouTube channel focuses on recreating altered states of consciousness through audio and visual content, often experimenting with longer video formats since its inception in 2014.

Artwork by Ramin Nazer

CONTRIBUTING ARTISTS

Alex Grey: alexgrey.com

Allyson Grey: allysongrey.com

Andrew Android Jones: androidjones.com

Becca Tindol: alteredmoonart.com

Diana Heyne: dianaheyne.blogspot.com

DMT Vision: dmt-vision.net

Eliot Alexander: dmtx.org

Eloh: elohprojects.com

Erial Ali: Instagram @erialali

Ethan Nichols: Instagram @artofethan

Glass Crane: Instagram @glass_crane

Graham F. Ganson: facebook.com/profile.php?id=100084710652175

Harry Pack: harrypackart.com, Instagram @harrypackart

Jan Betts: janbettsart.com

Jason Louv: jasonlouv.com

Jason WA Tucker: actualcontact.com

Jeff Sullivan: jeffsullivanart.com

Jerry Cahill: jerrycahill.art

Jordan Fleshman: Instagram @elfmachinery

Juliana Garces: julianagarcesart.com

Luke Brown: lukebrownart.com

Marina Seren: marinaseren.com

Maya Bèllavi Ilizyon: Instagram @maya_themessiah

Michael Garfield: michaelgarfieldart.com

Ramin Nazer: raminnazer.com

Rebecca Ann Hill: Instagram @mollymoonwitchery

Salvia Droid: salviadroid.com

Shaun Noelte: Instagram @shaunnoeltesculptor

Shaynen Brewster: Instagram @pazoraarts

NOTES

EPIGRAPHS

Vallée, *Dimensions*, 5.

D. McKenna, *The Brotherhood of the Screaming Abyss*, 155.

T. McKenna, in the Shpongle song "A New Way to Say 'Hooray!,'" track 3 on *Tales of the Inexpressible* (2001).

Joe Rogan, "Mark Boal," episode #1911 of *The Joe Rogan Experience*, December 15, 2022.

A. M. Hubbard, "Report: D.M.T. Experience (1961)," excerpt from the Stolaroff Collection: Experience Report Collection, from Myron Stolaroff, and made available on the Erowid website.

I. ENTERING THE DMT REALM

1. Kärkkäinen, et al, "Potentially Hallucinogenic 5-hydroxytryptamine Receptor."
2. Dean, et al., "Biosynthesis and Extracellular Concentrations."
3. Timmermann, et al., "DMT Models the Near-Death Experience."
4. Strassman, *DMT: The Spirit Molecule*.
5. Jiménez, "Significance of Mammalian N,N-dimethyltryptamine (DMT)."
6. Shulgin, "DMT Is Everywhere," 249.
7. "Dennis McKenna—An Ethnopharmacologist on Hallucinogens, Sex-Crazed Cicadas, the Mushrooms of Language, BioGnosis, and Illuminating Obscure Corners (#592)," *The Tim Ferriss Show* podcast, May 4, 2022.

8. Servillo, et al., "N-methylated Tryptamine Derivatives in Citrus Genus Plants"; L. Servillo, et al., "Citrus Genus Plants Contain N-methylated Tryptamine."

9. "What Is DMT? What Makes it Dangerous?" CBS 17 YouTube channel, November, 5, 2019.

10. Lawrence, et al., "N,N-dimethyltryptamine (DMT)-Occasioned Familiarity."

11. Kins, "Autonomous Entity," Effect Index (online), accessed March 22, 2024.

12. Turetzky, "A Hermeneutic Phenomenology of the N,N-dimethyltryptamine (DMT) Experience," dissertation, Pacifica Graduate Institute, 2021, 85.

13. Kins, "The 6 Levels of DMT."

14. Personal message to the author, 2022.

15. Personal message to the author, 2022.

16. Personal message to the author, 2022.

17. Personal message to the author, 2022.

18. "Liber LXXI: The Voice of the Silence," supplement to *The Equinox* 3, no. 1 (1919).

19. Hancock, *Visionary*, 366.

20. "DMT Always Shows Shane Mauss the Same Purple Woman on the Trip."

21. Moore, "My Computer Just Became Self Aware."

22. Kent, "The Case against DMT Elves."

23. Kins, "Autonomous Entity."

24. Winkelman, "An Ontology of Psychedelic Entity Experiences."

25. Ball, *The Entheological Paradigm*, 272–73.

26. Lundborg, *Psychedelia*, 504.

27. Strassman, *DMT: The Spirit Molecule*, 147, 185.

2. SCIENTIFIC STUDIES ON DMT ENTITY CONTACT

1. David, et al., "Survey of Entity Encounter Experiences Occasioned by Inhaled N,N-dimethyltryptamine."

2. Michael, et al., "An Encounter with the Other."

3. Lutkajtis, "Entity Encounters and the Therapeutic Effect of the Psychedelic Mystical Experience."

4. Lawrence, et al., "Phenomenology and Content of the Inhaled N,N-dimethyltryptamine (N,N-DMT) Experience," 8562.

5. Leary, "The Experiential Typewriter."
6. Gallimore, "DMTx: The First Results."
7. Gallimore, and Strassman, "A Model for the Application of Target-Controlled Intravenous Infusion for a Prolonged Immersive DMT Psychedelic Experience."
8. Turner, *Salvinorin*, 38–40.
9. Luan, et al., "Psychological and Physiological Effects of Extended DMT."
10. Gallimore, "DMTx: The First Results."
11. "DMTx Breakthrough Panel Moderated by Graham Hancock, Dr. Andrew Gallimore and Dr. Rick Strassman."
12. From an interview conducted by the author with Daniel McQueen on July 5, 2023.
13. Strassman, *DMT: The Spirit Molecule*, 322–23.
14. Brown, *Conversations on the Edge of the Apocalypse*, 93–94.
15. "I'm beamed out of my body." "Asking people what's a trippy story you can tell us?" Uninauts Facebook page, posted August, 2023.
16. "Top 4 Insane Alien Encounters."
17. Shostak, "Space Aliens Are Breeding with Humans."
18. Jacobs, *Walking Among Us*, 18.
19. Drinkwater, et al., "Starseeds."
20. "Grant Morrison Interview by James Gunn," *Interview Magazine*, October 14, 2014.
21. Naser, *A Beautiful Mind*, 13.
22. Rodnight, et al., "Urinary Dimethyltryptamine."
23. Lazar, *Dreamland*.
24. Carey and Schmitt, *Witness to Roswell*.
25. Kean and Blumenthal, "Intelligence Officials Say U.S. Has Retrieved Craft of Non-Human Origin."
26. Gabbatt and Greve, "House of Representatives to Hold Hearing on Whistleblower UFO Claims;" "Live: Congress Holds UFO Hearing."
27. "100% They're Not Human."
28. Tonnies, *The Cryptoterrestrials*.

3. CATALOGING THE ENTITIES

1. Personal message to the author.
2. [z-action], commenting on "DMT Spirit Guides," Reddit, r/Psychonaut, October 25, 2011.

3. Interview with Alexander Beiner by the author, June 7, 2023.

4. "Hyperspace Lexicon," DMT-Nexus (online), accessed March 22, 2024.

5. Personal communication with Gabriel PropAnon Kennedy via Facebook, February 19, 2023.

6. Carlsberg, *The Art of Close Encounters* (Close Encounters Publishing, 2012), 230.

7. Lawrence, et al., "Phenomenology and Content of the Inhaled N,N-dimethyltryptamine (N,N-DMT) Experience": 8562.

8. Brown and Hill, *Women of Visionary Art.*

9. "Guide to Machine Elves and Other DMT Entities."

10. Blumenthal, *Soul Transcendence*, 149.

11. Jacobs, *Walking Among Us*, 19-20.

12. Lyke, "DMT and Entities."

13. Luke, et al., "Transpersonal Ecodelia."

14. Timmermann, et al., "Human Brain Effects of DMT."

15. Beiner, *The Bigger Picture*, 26–27.

16. Brown, "DMT Research and Nonhuman-Entity Contact," 148.

17. Brown, "Psychedelics, Psychic Phenomena, and Encounters with Non-Human Entities," 323–24.

18. Brown, "Extended State DMT and Alien Information Theory: An Interview with Andrew Gallimore," 346–47.

19. Interview with Alexander Beiner by the author, June 7, 2023.

20. Brown, "Delving into DMTx," 379–80.

21. Interview with Daniel McQueen by the author, July 5, 2023.

22. Joe Rogan, speaking with Michael Malice in "Michael Malice," episode #1608 of *The Joe Rogan Experience*, February 10, 2021.

23. Interview with Josie Kins by the author, May 28, 2023.

24. Friedler, "AI Can Now Generate DMT Visuals."

25. Kins, "AI Generated DMT Entities."

26. T. McKenna, "In Praise of Psychedelics," part 2, podcast 309, on the Psychedelic Salon, May 11, 2012.

27. Gallimore, "The Case for DMT Entities."

28. Kripal, *Secret Body*, 346.

29. Jaeger, "Alex Jones Says Secret Government Program Uses Psychedelics to Communicate with Aliens."

30. Joe Rogan, "Alex Jones Returns!," episode #1255 of *The Joe Rogan Experience*, February 27, 2019.

31. "It's All about the DMT (Alex Jones Remix)," NotPercy203 YouTube channel, May 8, 2016.

32. Luscombe, "Google Engineer Put on Leave after Saying AI Chatbot Has Become Sentient," *The Guardian*, June 12, 2022.

4. SELF-TRANSFORMING MACHINE ELVES, THE TYKES, AND CLOCKWORK ELVES

1. "Alien Dreamtime—Space Time Continuum with Terence McKenna."
2. Strassman, *DMT: The Spirit Molecule*, 193.
3. "Alien Dreamtime—Space Time Continuum with Terence McKenna."
4. "Guide to Machine Elves and Other DMT Entities."
5. Turner, *The DMT Chronicles*, 82–83.

5. MANTIS ENTITIES, MANTIDS, AND OTHER INSECTOID ALIENS

1. Pickover, "Why Do DMT Users See Insects from a Parallel Universe?."
2. Hall, "Fishes, Insects, Animals, Reptiles and Birds."
3. Luke, *DMT Dialogues*, 298.
4. Disembodied Eyes, "Preying Mantis Entity Reports."
5. Communication from someone in a Facebook group responding to my query.
6. Disembodied Eyes, "Preying Mantis Entity Reports."
7. Communication from someone in a Facebook group responding to my query.
8. Personal communication from Lori Weber via Facebook Messenger, May 4, 2023.
9. Communication from someone in a Facebook group responding to my query.
10. Arthur, *Salvia divinorum*, 72.
11. Aprile, "Mantis Aliens."
12. Jacobs, *Walking Among Us*, 26.
13. Masters, *The Extratempestrial Model*, 205–6.
14. Tonnies, *The Cryptoterrestrials*, 64.
15. "DMTx Breakthrough Panel Moderated by Graham Hancock, Dr. Andrew Gallimore and Dr. Rick Strassman."

6. REPTILIANS, REPTOIDS, AND LIZARD PEOPLE

1. Icke, *Children of the Matrix.*
2. Bump, "What It's Like to Believe You're Controlled by Reptilians."
3. "Reptilian God 'Capital of Friendship' Statue Erected by Peruvian Artist." UFOHOLIC, February 13, 2017.
4. "Police Officer Herbert Schirmer Abduction."
5. [Lemoine], "Alien Abduction: An Experience with DMT (exp89763)," Erowid (online), October 13, 2018.
6. [Ximot], "DMT - (Semi-experienced) Breakthrough Finally. Reptiles Galore," Bluelight (online), Trip Reports, November 12, 2006.
7. Strassman, *DMT: The Spirit Molecule*, 252–53.
8. Luke, "Discarnate Entities and Dimethyltryptamine (DMT)."
9. Huyghe, *The Field Guide to Extraterrestrials*, 15.
10. Hanna, "Aliens, Insectoids, and Elves! Oh, My!"
11. Communication from someone in a Facebook group responding to my query.
12. Mary Rodwell, as quoted in *Alien Reptilian Legacy*, documentary film directed by Chris Turner, 2015.
13. Rebecca Ann Hill, personal communication with the author, August 30, 2023.
14. Turner, *The DMT Chronicles*, 73–74.

7. GRAYS

1. Mack, *Abduction*, 23.
2. Report from Travis Walton, in 1975, as quoted in D. E. McDaniel, *The Illustrated Guide to Reported Alien Species* (CreateSpace Independent Publishing Platform, 2017), 7.
3. Strassman, *DMT: The Spirit Molecule*, 216–19.
4. [pozboy69], commenting on [eugenia_loli], "Have you met the archetypal Grey alien on your trips? What did occur?" Reddit, r/DMT, May 25, 2017.
5. Communication from someone in a Facebook group responding to my query.

8. BLUE- AND PURPLE-HUED BEINGS

1. "DMT Always Shows Shane Mauss the Same Purple Woman on the Trip."
2. Packwood, *Sativa Psychonaut*, 70.

3. [MethoxetamineLover], "LSD+DMT: First Breakthrough . . . So the Alien Stories Were Not a Joke . . ." Reddit, r/Drugs, October 28, 2013.

4. Communication from someone in a Facebook group responding to my query.

5. Communication from someone in a Facebook group responding to my query.

6. Communication from someone in a Facebook group responding to my query.

7. Communication from someone in a Facebook group responding to my query.

8. Communication from someone in a Facebook group responding to my query.

9. Communication from someone in a Facebook group responding to my query.

10. Communication from someone in a Facebook group responding to my query.

11. Personal communication from Roar Ladd via Facebook.

12. Communication from someone in a Facebook group responding to my query.

13. Communication from someone in a Facebook group responding to my query.

14. Strieber, and Kripal, 57–58.

15. Communication from someone in a Facebook group responding to my query.

16. Communication from someone in a Facebook group responding to my query.

17. Interview with Marina Seren by the author, June 12, 2022.

18. Communication from someone in a Facebook group responding to my query.

9. CLOWNS, JESTERS, TRICKSTERS, HARLEQUINS, IMPS, AND JACK-IN-THE-BOX ENTITIES

1. Ball, *The Entheological Paradigm*, 75.

2. Woolfe, "Why Do Jesters and Tricksters Appear in the DMT Experience?"

3. Strassman, *DMT: The Spirit Molecule*, 192.

4. Strassman, *DMT: The Spirit Molecule*, 169.

5. Woolfe, "Why Do Jesters and Tricksters Appear in the DMT Experience?"

6. Tonnies, *The Cryptoterrestrials*, 64.

7. Hollis, "Trickster."

8. Communication from someone in a Facebook group responding to my query.

9. Personal communication with a friend via email, August 18, 2023.

10. Communication from someone in a Facebook group responding to my query.

11. "Joe Rogan's DMT Experiences," JRE Clips YouTube channel (10:35), March 19, 2018.

12. [Akuma_Procopis], commenting on [voidmanbg], "Have You Guys Had Jesters Giving You the Finger and What Was the Message?" Reddit, r/DMT, July 23, 2021.

13. Interview with Alexander Beiner by the author, June 7, 2023.

14. Communication from someone in a Facebook group responding to my query.

15. Hancock, *Visionary*, 370.

10. GATEKEEPERS AND THRESHOLD GUARDIANS

1. Lundborg, *Psychedelia*, 461.

2. Carpenter, *A Psychonaut's Guide to the Invisible Landscape* (Park Street Press, 2006), 75, 82.

3. Lundborg, *Psychedelia: An Ancient Culture, a Modern Way of Life* (Lysergia, 2012), 461.

4. Communication from someone in a Facebook group responding to my query.

5. Communications with people in a Facebook group responding to my query.

6. Communication from someone in a Facebook group responding to my query.

7. [dmt_vision], "DMT space: The guardian of dimensions. . . . ," Reddit, r/DMT, June 16, 2020.

11. SPIRIT GUIDES

1. Snow, "Shamanic Journey."

2. Lilly, *The Scientist*.

3. Brown and Novick, "From Here to Alternity and Beyond with John C. Lilly," 266.

4. Communication from someone in a Facebook group responding to my query.
5. Interview with Alexander Beiner by the author, June 7, 2023.
6. [Oh_that_girl], commenting on "DMT Spirit Guides," Reddit, r/Psychonaut, October 25, 2011.
7. Barnett8, commenting on "DMT Spirit Guides," Reddit, r/Psychonaut, October 25, 2011.
8. Tiara, commenting on "DMT Spirit Guides," Reddit, r/Psychonaut, October 25, 2011.
9. [SurgeHard], commenting on "DMT Spirit Guides," Reddit, r/Psychonaut, October 25, 2011.

12. EASTERN, MIDDLE EASTERN, AND INDIGENOUS AMERICAN DEITIES AND DEMIGODS

1. Communication from someone in a Facebook group responding to my query.
2. Communication from someone in a Facebook group responding to my query.
3. Communication from someone in a Facebook group responding to my query.
4. Communication from someone in a Facebook group responding to my query.
5. Bobby Love, commenting on the question "Why Are Hindu Gods Often Seen during DMT Trips Despite Many Users Not Knowing What They Look Like Prior to the Trip?" Quora, July 31, 2022.
6. McIntosh, "An Interview with Jay Courtney Fikes."
7. Wilson, *Cosmic Trigger*, 24–25.
8. Communication from someone in a Facebook group responding to my query.
9. Communication from someone in a Facebook group responding to my query.

13. JESUS CHRIST

1. "What Is the Jesus Drug (Dimethyltryptamine)?" Got Questions (online), February 17, 2022.

2. Communication from someone in a Facebook group responding to my query.
3. David, et al., "Survey of Entity Encounter Experiences Occasioned by Inhaled N,N-dimethyltryptamine."
4. [Echthegr8], commenting on "Why do people that take drugs get cool encounters with Jesus," Reddit, r/Christian, August 4, 2022.
5. Strassman, *DMT and the Soul of Prophecy*.
6. Woolfe, "Israeli Scholar Benny Shannon Claims Judaism Was Influenced by DMT."

14. THE VIRGIN MARY

1. Personal communication with my friend Katara Lunarez via Facebook Messenger.
2. Personal communication with a friend via Facebook Messenger.
3. Communication from someone in a Facebook group responding to my query.
4. Communication from someone in a Facebook group responding to my query.

15. ANGELS

1. "Hyperspace Lexicon," DMT-Nexus (online), accessed March 20, 2024.
2. Communications from people in a Facebook group who responded to my query.
3. Strassman, *DMT and the Soul of Prophecy*, 196–202.
4. [PsyleXxl], commenting on [sunday311], "Anyone Encountered an Angel?" Reddit, r/Ayahuasca, June 21, 2019.
5. Communication from someone via Facebook Messenger responding to my query.
6. Communication from someone in a Facebook group responding to my query.
7. Communication from a friend via Facebook messenger.
8. Louv, *John Dee and the Empire of Angels*, 1.
9. Newman, *Angels in Vermilion*, 29.
10. Mallasz, *Talking with Angels*.
11. Taylor, *Messengers of Light*; quote from the back cover.

16. THE DEVIL AND DEMONS

1. Communication from someone in a Facebook group responding to my query.
2. Owen Cyclops, X (formerly Twitter), in a thread beginning on February 17, 2019.
3. [SAP111], "Has Anyone Seen Demons/the Devil?" post #5, DMT-Nexus (online), October 3, 2016.
4. Dreher, "Temptation of the Psychonauts."
5. Communication from someone in a Facebook group responding to my query.
6. Hancock, "Giving Up the Green Bitch."
7. [DmnStr8], "Has Anyone Seen Demons/the Devil?" post #2, DMT-Nexus (online), September 14, 2016.
8. Communication from someone in a Facebook group responding to my query.
9. Communication from someone in a Facebook group responding to my query.
10. Communication from someone in a Facebook group responding to my query.
11. Communication from someone in a Facebook group responding to my query.
12. Grof, *Spiritual Emergency*, 23.

17. THERIANTHROPES AND ANIMAL-HUMAN HYBRIDS

1. Harner, *The Way of the Shaman*, 74.
2. Hancock, *Visionary*, 57–62.
3. Hancock, *Visionary*, 66.
4. Nix, "The Imaginal Realm."
5. Rohrer, "In Relationship with the Numinous Encounters."
6. Personal communication with Kaleb via Facebook Messenger.
7. Communication from someone in a Facebook group responding to my query.
8. Communication from someone in a Facebook group responding to my query.
9. Personal communication with Alexa Baynton via Facebook Messenger, April 22, 2023.
10. Lledo, *The Law of One by Ra*; quote from the back cover.

18. ANCESTORS, DEAD RELATIVES, FRIENDS, AND STRANGERS

1. Timmermann, et al., "DMT Models the Near-Death Experience."
2. Communication from someone in a Facebook group responding to my query.

3. Communication from someone in a Facebook group responding to my query.
4. T. McKenna, "Terence McKenna—The DMT Experience."
5. Personal communication with Derrick S. via Facebook Messenger.
6. Strieber and J. Kripal, *The Super Natural*, 28.
7. Cutchin, *Ecology of Souls*, 12.
8. Ring, *The Omega Project.*
9. Garfield, *The Dream Messenger*, 33.

19. FAIRIES

1. For accounts of these fairy sightings, see *Seeing Fairies: From the Lost Archives of the Fairy Investigation Society, Authentic Reports of Fairies in Modern Times* by Marjorie T. Johnson; *The Secret Commonwealth of Elves, Fauns and Fairies* by Robert Kirk; and *The Fairy-Faith in Celtic Countries* by Walter Yeeling Evans-Wentz.
2. "The DMT Fairy," Reddit, r/Drugs, August 28, 2016.
3. "7 DMT Entities."
4. Rushton, "Faerie Entities and DMT."
5. "Man DIES in Crash."
6. Hurd, "Dreaming of Fairies."
7. Personal communication with AndRa Skye via Facebook Messenger, May 17, 2023.

20. GNOMES, KOBOLDS, AND GOBLINS

1. T. McKenna, "Terence McKenna—The DMT Experience (The Transcendental Object at the End of Time)."
2. [These_Meet2171], commenting on [High_On_Novacaine], "Have Any of You Seen Literal Elves/Gnomes on DMT? Machine Elves?" Reddit, r/DMT, March 4, 2022.
3. [These_Meet2171], commenting on [High_On_Novacaine], "Have Any of You Seen Literal Elves/Gnomes on DMT? Machine Elves?" Reddit, r/DMT, March 4, 2022.
4. [itsYaBoiMohammad], commenting on [High_On_Novacaine], "Have Any of You Seen Literal Elves/Gnomes on DMT? Machine Elves?" Reddit, r/DMT, March 3, 2022.

5. [Droman6787], "Seeing Gnomes and Fairies, Anyone Else?" Shroomery (online), March 11, 2018.
6. [High_On_Novacaine], "Have Any of You Seen Literal Elves/Gnomes on DMT? Machine Elves?" Reddit, r/DMT, March 2, 2022.
7. Communication from someone in a Facebook group responding to my query.

21. MOTHER AYAHUASCA, GRANDMOTHER AYAHUASCA, AND AYA

1. Orion, "When Ayahuasca Speaks," Reset.me.
2. Harris, *Listening to Ayahuasca*, 183.

22. NATURE, PLANT, AND FUNGI SPIRITS

1. Flores, "Niños Santos, Psilocybin Mushrooms and the Psychedelic Renaissance."
2. Heaven and Charing, *Plant Spirit Shamanism*, ix–x.
3. Brown and Novick, *Mavericks of the Mind*, 24.
4. Personal communication with Sara Phinn Huntley by email.
5. Personal communication with the writer via email.
6. Brown, *Frontiers of Psychedelic Consciousness*, 214.
7. Powell, *Magic Mushroom Explorer*, 28.
8. Maugh, "Swiss Chemist Discovered LSD."
9. Turetzky, "A Hermeneutic Phenomenology of the N,N-Dimethyltryptamine (DMT) Experience," 23.

23. SNAKES, JAGUARS, AND OTHER ANIMAL SPIRITS

1. Narby, *The Cosmic Serpent*.
2. Communication from someone in a Facebook group responding to my query.
3. Communication from someone in a Facebook group responding to my query.
4. Personal communication with Katara Lunarez via Facebook Messenger.
5. Stafford, *The Psychedelics Encyclopedia*, 349–50.
6. Sheldrake, *Ways to Go Beyond*, 135.
7. This is a quote from James Dearden Bush's forthcoming book.

8. Personal communication with Sigalit Sol Avigdory via Facebook Messenger.

9. Strieber, in the foreword to Clelland, *Stories from the Messengers*, xiii.

24. OCTOPUS AND OCTOPOID BEINGS

1. Rakowski, "DMT Entities at the Core of Belief Systems."

2. DMT Entities Wiki, "Octopus," accessed August 2023.

3. Personal communication with Sara Phinn Huntley by email, August, 2023.

4. Communication from someone in a Facebook group responding to my query.

5. Michael, et al., "An Encounter with the Other."

6. [blackclo], "The DMT Octopus," post #1, DMT-Nexus (online), November 2, 2006.

7. DMT Entities Wiki, "Octopus," accessed August, 2023.

8. [DrOpiumFiend], "Can We Talk about the DMT Octopus for a Second?" Reddit, r/Psychonaut, January 11, 2019.

9. [Namaste_gerro], commenting on [DrOpiumFiend], "Can We Talk about the DMT Octopus for a Second?" Reddit, r/Psychonaut, June 13, 2022.

10. [Name deleted], commenting on [Thatoneguy0311], "I Recently Met an Octopus Entity during a Mushroom Trip, Has Anyone Else?" Reddit, r/Psychonaut, December 15, 2018.

11. [Thatoneguy0311], "I Recently Met an Octopus Entity during a Mushroom Trip, Has Anyone Else?" Reddit, r/Psychonaut, December 15, 2018.

25. CHEMICAL SPIRITS

1. David, et al., "Survey of Entity Encounter Experiences Occasioned by Inhaled N,N-dimethyltryptamine."

2. Brown, "LSD, Science, Consciousness, and Mysticism: An Interview with Albert Hofmann," 12.

3. Brown and Novick, "Chemophilia: with Alexander and Ann Shulgin," 139–40.

4. [dragon-n], "2C-B as a sacrament," post #1, DMT-Nexus (online), June 29, 2010.

5. [lyserge], "2C-B as a sacrament," post #4, DMT-Nexus, June 29, 2010.

6. Communications from people in a Facebook group who responded to my query.

26. MOTHER GAIA

1. T. McKenna, "Reawakening Our Connection to the Gaian Mind."
2. Grey, *Sacred Mirrors*, 80.
3. Communication from someone in a Facebook group responding to my query.
4. Communication from someone in a Facebook group responding to my query.
5. Personal communication with someone who responded to my query via email.
6. Communication from someone in a Facebook group responding to my query.
7. Communication with Brian Christensen via Facebook.
8. Personal communication with Rob Bryanton via Facebook Messenger, April 20, 2021.

27. BEINGS OF LIGHT, PURE ENERGY, AND BODILESS BEINGS

1. Liester, "Near-Death Experiences and Ayahuasca-Induced Experiences."
2. Guttilla, *Contact with Beings of Light*, 12–13.
3. Brown, *The New Science of Psychedelics*, 53–56.
4. Communication from someone in a Facebook group responding to my query.
5. Communication from someone in a Facebook group responding to my query.
6. Personal communication with Katara Lunarez via Facebook Messenger.

28. GOD

1. Biro, *Hellucination*, 127.
2. Griffiths, W., et al, "Psilocybin Can Occasion Mystical-Type Experiences."
3. Biro, *Hellucination*, 4.
4. Personal communication with a friend via Facebook.
5. Personal communication with a friend via Facebook.
6. Rankin, *The Things I Wish They'd Told Me as I Was Growing Up*, 97.
7. Communication from someone in a Facebook group responding to my query.
8. Communication from someone in a Facebook group responding to my query.
9. Communication from someone in a Facebook group responding to my query.

APPENDIX 2: PERFORMANCE ART INSPIRED
BY DMT ENTITIES

1. Michael, et al., "An Encounter with the Other."
2. Quote from a personal communication from Maya Bracknell Watson with the author, August 7, 2023.
3. Quote from a personal communication from Maya Bracknell Watson with the author, August 7, 2023.
4. Quote from a personal communication from Maya Bracknell Watson with the author, August 7, 2023.

BIBLIOGRAPHY

"7 DMT Entities." Cryptic Chronicles (online), May 20, 2021.

"'100% They're Not Human,' Witness Details Alleged Alien Encounter in Las Vegas." 8 News Now, Las Vegas YouTube channel, June 8, 2023.

"Alien Dreamtime—Space Time Continuum with Terence McKenna." Recorded February 27, 1993; posted on the Metanoia YouTube channel, July 5, 2012.

Amaringo, P., L. Luna, *Ayahuasca Visions: The Religious Iconography of a Peruvian Shaman*. North Atlantic Books, 1993.

Aprile, C. "Mantis Aliens." Gaia (online), November 28, 2016.

Arthur, J. D. *Salvia divinorum: Doorway to Thought-Free Awareness*. Park Street Press, 2010.

Ball, M. W. *The Entheological Paradigm: Essays on the DMT & 5-MeO-DMT Experience and the Meaning of It All*. Kyandara Publishing, 2021.

Beiner, A. *The Bigger Picture: How Psychedelics Can Help Us Make Sense of the World*. Hay House, 2023.

Biro, S. *Hellucination: A Memoir*. Unearthed Books, 2011.

Blumenthal, S. *Soul Transcendence, Journeys to Other Dimensions: A DMT Volunteer Tells Her Story*. Independently published, 2022.

Brown, D. J. *Conversations on the Edge of the Apocalypse*. Palgrave MacMillan, 2005.

———. *Frontiers of Psychedelic Consciousness*. Park Street Press, 2015.

———. *The New Science of Psychedelics*. Park Street Press, 2013.

Brown, D. J., and R. A. Hill, *Women of Visionary Art*. Park Street Press, 2018.

Brown, D. J., and R. M. Novick, *Mavericks of the Mind*. MAPS, 2010.

———. *Voices from the Edge*. Crossing Press, 1995.

Bump, P. "What It's Like to Believe You're Controlled by Reptilians." *The Atlantic*, November 5, 2013.

Carey, T. J., and D. R. Schmitt. *Witness to Roswell.* New Page Books, 2022.

Carlsberg, K. *The Art of Close Encounters.* Close Encounters Publishing, 2012.

Carpenter, D. *A Psychonaut's Guide to the Invisible Landscape.* Park Street Press, 2006.

Charing, H. G., P. Cloudsley, and P. Amaringo. *The Ayahuasca Visions of Pablo Amaringo.* Inner Traditions, 2011.

Clelland, M. *Stories from the Messengers: Accounts of Owls, UFOs and a Deeper Reality.* Richard Dolan Press, 2020.

Cutchin, J. *Ecology of Souls.* Horse & Barrel Press, 2022.

David, A. K., J. M. Clifton, E. G. Weaver, E. S. Hurwitz, M. W. Johnson, and R. R. Griffiths. "Survey of Entity Encounter Experiences Occasioned by Inhaled N,N-dimethyltryptamine: Phenomenology, Interpretation, and Enduring Effects." *Journal of Psychopharmacology* 34, no. 9 (2020): 1008–20. doi:10.1177/0269881120916143.

Dean, Jon G., Tiecheng Liu, Sean Huff, Ben Sheler, Steven A. Barker, Rick J. Strassman, Michael M. Wang, and Jimo Borjigin. "Biosynthesis and Extracellular Concentrations of N,N-dimethyltryptamine (DMT) in Mammalian Brain." *Scientific Reports* 9, no. 1 (2019). doi:10.1038/s41598-019-45812-w.

Disembodied Eyes. "Preying Mantis Entity Reports." Posted September 27, 2009; accessed via the Wayback Machine of the Internet Archive, March 18, 2024.

"DMT Always Shows Shane Mauss the Same Purple Woman on the Trip." Tales from the Trip YouTube channel. Uploaded by Animated, July 15, 2020.

"DMTx Breakthrough Panel Moderated by Graham Hancock, Dr. Andrew Gallimore and Dr. Rick Strassman." Noonautics YouTube channel, May 23, 2023.

Dolan, R. *UFOs and the National Security State: The Coverup Exposed, 1941–1973.* Hampton Roads, 2002.

———. *UFOs and the National Security State: The Coverup Exposed, 1973–1991.* Keyhole Publishing, 2013.

Dreher, R. "Temptation of the Psychonauts: Exploring the Realm Opened Up by DMT Is to Put Your Soul and Your Sanity in Grave Peril." *The American Conservative*, January 10, 2023.

Drinkwater, K., A. Denovan, and N. Dagnall. "Starseeds: Psychologists on Why Some People Think They're Aliens Living on Earth." The Conversation (online), March 14, 2023.

Flores, García. "Niños Santos, Psilocybin Mushrooms and the Psychedelic Renaissance." Interview on the Chacruna website, November 12, 2020.

Friedler, D. "AI Can Now Generate DMT Visuals, Thanks to This Online Community." *Double Blind Magazine*, June 15, 2022.

Gabbatt, A., and J. E. Greve. "House of Representatives to Hold Hearing on Whistleblower UFO Claims." *The Guardian*, June 8, 2023.

Gallimore, A. R. "DMTx: The First Results . . ." *Alien Insect on Drugs*, April 17, 2023.

———. "The Case for DMT Entities." *Alien Insect on Drugs*, June 8, 2023.

Gallimore, A., and R. Strassman. "A Model for the Application of Target-Controlled Intravenous Infusion for a Prolonged Immersive DMT Psychedelic Experience." *Frontiers in Pharmacology* (2016). doi:2016.00211.

Garfield, P. *The Dream Messenger: How Dreams of the Departed Bring Healing Gifts*. Simon & Shuster, 1997.

"Grant Morrison Interview by James Gunn." *Interview Magazine*, October 14, 2014.

Grey, A. *Sacred Mirrors*. Inner Traditions International, 1990.

Griffiths, R. R., et al. "Psilocybin Can Occasion Mystical-Type Experiences Having Substantial and Sustained Personal Meaning and Spiritual Significance." *Psychopharmacology* 187, no. 3 (2006): 268–83.

Grof, S. *Spiritual Emergency: When Personal Transformation Becomes a Crisis*. TarcherPerigee, 1989.

"Guide to Machine Elves and Other DMT Entities." Reality Sandwich (online), May 6, 2020.

Guttilla, P. *Contact with Beings of Light*. Timeless Voyager Press, 2003.

Hall, M. "Fishes, Insects, Animals, Reptiles and Birds," in *The Secret Teachings of All Ages*. Dover Publications, 2010.

Hancock, G. "Giving Up the Green Bitch: Reflections on Cannabis, Ayahuasca and the Mystery of Plant Teachers." Graham Hancock personal website, January 21, 2013.

———. *Visionary: The Mysterious Origins of Human Consciousness*. Red Wheel/Weiser, 2022.

Hanna, J. "Aliens, Insectoids, and Elves! Oh, My!" *Erowid Extracts* 23 (November 2012).

Harner, M. *The Way of the Shaman*. HarperOne, 1990.

Harris, R. *Listening to Ayahuasca*. New World Library, 2017.

Heaven, R., and H. G. Charing. *Plant Spirit Shamanism: Traditional Techniques for Healing the Soul.* Destiny Books, 2006.

Hollis, J. "Trickster." Jung Society of Washington blog, October 15, 2017.

Hubbard, A. M. "Report: D.M.T. Experience (1961)." Excerpt from the Stolaroff Collection: Experience Report Collection, from Myron Stolaroff, and made available on the Erowid website.

Hurd, R. "Dreaming of Fairies and Connecting to the Ecological Self." Dream Studies (online). Accessed March 22, 2024.

Huyghe, P. *The Field Guide to Extraterrestrials.* Avon Books, 1996.

"Hyperspace Lexicon." DMT-Nexus (online). Accessed March 20, 2024.

Icke, D. *Children of the Matrix: How an Interdimensional Race Has Controlled the Planet for Thousands of Years—and Still Does.* David Icke Books, 2017.

"It's All about the DMT (Alex Jones Remix)." NotPercy203 YouTube channel, May 8, 2016.

Jacobs, D. M. *Walking Among Us: The Alien Plan to Control Humanity.* Disinformation Books, 2015.

Jaeger, K. "Alex Jones Says Secret Government Program Uses Psychedelics to Communicate with Aliens." Marijuana Moment (online), March 3, 2019.

Jiménez, Javier Hidalgo. "Significance of Mammalian N,N-dimethyltryptamine (DMT): A 60-Year-Old Debate." *Journal of Psychopharmacology* 36, no. 8 (2022). doi:02698811221104054.

Kärkkäinen, J., T. Forsström, J. Tornaeus, K. Wähälä, P. Kiuru, A. Honkanen, U.-H. Stenman, U. Turpeinen, and A. Hesso. "Potentially Hallucinogenic 5-hydroxytryptamine Receptor Ligands Bufotenine and Dimethyltryptamine in Blood and Tissues." *Scandinavian Journal of Clinical and Laboratory Investigation* 65, no. 3 (2005): 189–99. doi:10.1080/00365510510013604.

Kean, L., and R. Blumenthal. "Intelligence Officials Say U.S. Has Retrieved Craft of Non-Human Origin." The Debrief (online), June 5, 2023.

Kent, J. "The Case against DMT Elves." tripzine.com (online), May 4, 2004.

Kins, J. "The 6 Levels of DMT: Psychedelics Described." YouTube video, February 4, 2023.

———. "AI Generated DMT Entities." YouTube video, February 28, 2022.

———. "Autonomous Entity." Effect Index (online). Accessed March 22.

Kripal, J. *Secret Body: Erotic and Esoteric Currents in the History of Religions.* University of Chicago Press, 2017.

Lawrence, D. W., R. Carhart-Harris, R. Griffiths, and C. Timmermann. "Phenomenology and Content of the Inhaled N, N-dimethyltryptamine (N, N-DMT) Experience." *Scientific Reports* 12, no. 1 (2022): 8562.

Lawrence, D. W., A. P. DiBattista, and C. Timmermann. "N,N-dimethyltryptamine (DMT)-Occasioned Familiarity and the Sense of Familiarity Questionnaire (SOF-Q)." *Journal of Psychoactive Drugs* 10 (2023): 1–13. doi:10.1080/02791072.2023.2230568.

Lazar, B. *Dreamland: An Autobiography.* Interstellar, 2019.

Leary, T. *Exo-Psychology: A Manual on the Use of the Human Nervous System According to the Instruction of the Manufacturers.* StarSeed/Peace Press, 1977. Later revised and republished as *Info-Psychology* (New Falcon, 1994).

———. "The Experiential Typewriter." *Psychedelic Review* 7 (1965).

"Liber LXXI: The Voice of the Silence." Supplement to *The Equinox* 3, no. 1 (1919).

Liester, M. B. "Near-Death Experiences and Ayahuasca-Induced Experiences: Two Unique Pathways to a Phenomenologically Similar State of Consciousness." *Journal of Transpersonal Psychology* 45, no. 1 (2013).

Lilly, J. C. *The Scientist: A Metaphysical Autobiography.* Ronin Publishing, 1988.

"Live: Congress Holds UFO Hearing." Associated Press YouTube channel, July 26, 2023.

Lledo, O. *The Law of One by Ra: DMT Transmissions.* Independently published, 2020.

Louv, J. *John Dee and the Empire of Angels.* Inner Traditions, 2018.

Luan, Lisa X., Emma Eckernäs, Michael Ashton, Fernando Rosas, Malin Uthaug, Alexander Bartha, Samantha Jagger, et al. "Psychological and Physiological Effects of Extended DMT." PsyArXiv, April 13, 2023. doi:10.31234/osf.io/vg4dp.

Luke, D. "Discarnate Entities and Dimethyltryptamine (DMT): Psychopharmacology, Phenomenology and Ontology." *Journal of the American Society for Psychical Research* 75 (2011): 26–42.

———. *DMT Dialogues.* Park Street Press, 2018.

Luke D., A. Irvine, S. Yanakieva, et al. "Transpersonal Ecodelia: Surveying Psychedelically Induced Biophilia." Paper presented at the Interdisciplinary Conference on Psychedelic Research, Amsterdam, September 27, 2020.

Lundborg, P. *Psychedelia: An Ancient Culture, A Modern Way of Life.* Lysergia, 2012.

Luscombe, R. "Google Engineer Put on Leave after Saying AI Chatbot Has Become Sentient." *The Guardian,* June 12, 2022.

Lutkajtis, A. "Entity Encounters and the Therapeutic Effect of the Psychedelic Mystical Experience." *Journal of Psychedelic Studies* 4, no. 3 (2020): 171–78.

Lyke, J. A. "DMT and Entities: Not Everyone Gets Machine Elves: Jennifer A. Lyke." A 2016 presentation in Boulder, Colorado. Available on the Society for Scientific Exploration YouTube channel. Uploaded June 13, 2019.

Mack, J. *Abduction: Human Encounters with Aliens.* Simon & Schuster, 1994.

Mallasz, H. *Talking with Angels.* Am Klosterplatz, 2006.

"Man DIES in Crash, NDE Takes Him Into the INNER Quantum World of Nature: Tyler Deal." *Next Level Soul Podcast* YouTube channel, April 13, 2023.

Masters, M. P. *The Extratempestrial Model.* Full Circle Press, 2022.

Maugh, T.H. "Swiss Chemist Discovered LSD." *Los Angeles Times,* April 30, 2008.

McDaniel, D. E. *The Illustrated Guide to Reported Alien Species.* CreateSpace Independent Publishing Platform, 2017.

McIntosh, Sandy. "An Interview with Jay Courtney Fikes." Sustained Action (online). September 1999.

McKenna, D. *The Brotherhood of the Screaming Abyss: My Life with Terence McKenna.* Synergetic Press, 2023.

McKenna, Terence. "Reawakening Our Connection to the Gaian Mind." Presentation at the "The Bioneers," the fifth annual Seeds of Change conference, San Francisco, California, October 17, 1993.

———. "Terence McKenna—The DMT Experience." Intellectual Deep Web YouTube channel, July 27, 2018.

———. "Terence McKenna—The DMT Experience (The Transcendental Object at the End of Time)." We Plants Are Happy Plants YouTube channel, November 27, 2015.

Michael, P. D. Luke, and O. Robinson. "An Encounter with the Other: A Thematic and Content Analysis of DMT Experiences From a Naturalistic Field Study." *Frontiers in Psychology* 12 (2021): doi:2021.720717.

Moore, T. "Trevor Moore: The Story of Our Times—"My Computer Just Became Self Aware." Comedy Central YouTube channel, April 13, 2018.

Narby, J. *The Cosmic Serpent.* Jeremy P. Tarcher/Putnam, 1999.

Naser, S. *A Beautiful Mind.* Simon and Shuster, 2011.

Newman, P. D. *Angels in Vermilion: The Philosopher's Stone: From Dee to DMT.* Tria Prima Press, 2021.

Nix, D. C. "The Imaginal Realm." Medium (online), December 25, 2015.

Orion, D. "When Ayahuasca Speaks." Reset.me, May, 2021.

Packwood, R. K. *Sativa Psychonaut: Exploring the Deep Mind and Universe with Cannabis sativa.* Independently published, 2016.

Pickover, C. "Why Do DMT Users See Insects from a Parallel Universe?" Clifford Pickover's personal webpage hosted through Sprott's Gateway of the physics department on the University of Wisconsin at Madison website. Accessed March 18, 2024.

"Police Officer Herbert Schirmer Abduction." UFO Evidence (online), September 30, 2007.

Powell, S. *Magic Mushroom Explorer: Psilocybin and the Awakening Earth.* Park Street Press, 2015.

Rakowski, D. "DMT Entities at the Core of Belief Systems of Ancient South American Cultures Who Used Psychedelic Snuff." Graham Hancock personal website, June 22, 2023.

Rankin, D. *The Things I Wish They'd Told Me as I Was Growing Up.* Troubador Publishing, 2010.

Ring, K. *The Omega Project: Near-Death Experiences, UFO Encounters, and Mind at Large.* William Morrow & Co, 1992.

Rodnight, R., R. M. Murray, M. C. Oon, F. Brockington, P. Nicholls, and J. L. Birley. "Urinary Dimethyltryptamine and Psychiatric Symptomatology and Classification." *Psychology Medicine* 6, no. 4 (1976): 649–57. doi:10.1017/s0033291700018304.

Rodriguez McRobbie, L. "Why Alien Abductions Are Down Dramatically." *Boston Globe* (online), June 12, 2016.

Rogan, Joe. "Alex Jones Returns!" Episode #1255 of *The Joe Rogan Experience.* February 27, 2019.

———. "Joe Rogan's DMT Experiences." JRE Clips YouTube channel, March 19, 2018.

———. "Mark Boal." Episode #1911 of *The Joe Rogan Experience.* December 15, 2022.

———. "Michael Malice." Episode #1608 of *The Joe Rogan Experience.* February 10, 2021.

Rohrer, M. A. "In Relationship with the Numinous Encounters: Encounters with Animal Allies in the Imaginal Realm." Master's thesis (psychology), Sonoma State University, 2021.

Rushton, N. "Faerie Entities and DMT." deadbutdreaming (blog), July 5, 2020.

Servillo, L., A. Giovane, M. L. Balestrieri, R. Casale, D. Cautela, and D. Castaldo. "Citrus Genus Plants Contain N-methylated Tryptamine Derivatives and Their 5-hydroxylated Forms." *Journal of Agricultural and Food Chemistry* 61, no. 21 (2013): 5156–62.

Servillo, L., A. Giovane, M. L. Balestrieri, D. Cautela, and D. Castaldo. "N-methylated Tryptamine Derivatives in Citrus Genus Plants: Identification of N,N,N-trimethyltryptamine in Bergamot." *Journal of Agricultural and Food Chemistry* 60, no. 37 (2012): 9512–18.

Sheldrake, R. *Ways to Go Beyond and Why They Work.* Coronet: 2019.

Shostak S. "Space Aliens Are Breeding with Humans, University Instructor Says. Scientists Say Otherwise." NBC News (online), May 25, 2019.

Shulgin, A., and A. Shulgin. *TIHKAL: The Continuation.* Transform Press, 1997.

Slattery, D. *Xenolinguistics: Psychedelics, Language, and the Evolution of Consciousness.* North Atlantic Books, 2015.

Snow, A. "Shamanic Journey: Connecting with Spirit Guides and Our Highest Selves." Promotional copy for a guided meditation on InsightTimer (online). Accessed March 22, 2024.

Stafford, P. *The Psychedelics Encyclopedia.* Ronin Publishing, 1993.

Strassman, R. *DMT: The Spirit Molecule.* Park Street Press, 2001.

———. *DMT and the Soul of Prophecy: A New Science of Spiritual Revelation in the Hebrew Bible.* Park Street Press, 2014.

Strieber, W., and J. J. Kripal. *The Super Natural: Why the Unexplained Is Real.* TarcherPerigee, 2017.

Taylor, T. L. *Messengers of Light: The Angel's Guide to Spiritual Growth.* H. J. Kramer, 1989.

Timmermann, C., L. Roseman, S. Haridas, and R. L. Carhart-Harris. "Human Brain Effects of DMT Assessed via EEG-fMRI." *PNAS* 120, no. 13 (2023). doi:2218949120.

Timmermann, C., L. Roseman, D. Nutt, R. Carhart-Harris, et al. "DMT Models the Near-Death Experience." *Frontiers in Psychology* 9 (2018). doi:2018.01424.

Tonnies, M. *The Cryptoterrestrials.* Anomalist Books, 2010.

"Top 4 Insane Alien Encounters." From *The Proof Is Out There* television series, posted on the History Channel YouTube channel, August 20, 2022.

Turetzky, R. "A Hermeneutic Phenomenology of the N,N-Dimethyltryptamine (DMT) Experience." Dissertation, Pacifica Graduate Institute, 2021.

Turner, Chris, director. *Alien Reptilian Legacy.* Documentary film, 2015.

Turner, D. M. *Salvinorin: The Psychedelic Essence of Salvia divinorum.* Panther Press, 1996.

Turner, T. *The DMT Chronicles: Parmenides, Plato, and the Psychedelic.* TransLinguistic Press, 2010.

Vallée, J. *Dimensions: A Casebook of Alien Contact.* Anomalist Books, 2014.

———. *Passport to Magonia: from Folklore to Flying Saucers.* Contemporary Books, 1993.

"What Is the Jesus Drug (Dimethyltryptamine)?" Got Questions (online), February 17, 2022.

Wilson, R. A. *Cosmic Trigger: The Final Secret of the Illuminati.* And/Or Press, 1977.

Winkelman, M. J. "An Ontology of Psychedelic Entity Experiences in Evolutionary Psychology and Neurophenomenology." *Journal of Psychedelic Studies* (2018). doi:10.1556/2054.2018.002.

Woolfe, S. "Israeli Scholar Benny Shannon Claims Judaism Was Influenced by DMT." Sam Woolfe personal website, July 1, 2013.

———. "Why Do Jesters and Tricksters Appear in the DMT Experience?" Sam Woolfe personal website, February 4, 2019.

Zell, O. *GaeaGenesis: Conception and Birth of the Living Earth.* BlackMoon Publishing, 2022.

INDEX

AUTHOR'S AND ARTIST'S BIOGRAPHIES

David Jay Brown is the author of *Dreaming Wide Awake: Lucid Dreaming, Shamanic Healing, and Psychedelics* and *The New Science of Psychedelics: At the Nexus of Culture, Consciousness, and Spirituality.* He is also the coauthor of seven bestselling volumes of interviews with leading-edge thinkers: *Mavericks of the Mind, Voices from the Edge, Conversations on the Edge of the Apocalypse, Mavericks of Medicine, Frontiers of Psychedelic Consciousness, Women of Visionary Art,* and *Psychedelics and the Coming Singularity.* Additionally, Brown is the author of two science fiction novels, *Brainchild* and *Virus,* and he is the coauthor of the health science book *Detox with Oral Chelation.* Brown holds a master's degree in psychobiology from New York University and was responsible for the California-based research in two of British biologist Rupert Sheldrake's books on unexplained phenomena in science: *Dogs That Know When Their Owners Are Coming Home* and *The Sense of Being Stared At.*

His work has appeared in numerous magazines, including *Wired*, *Discover*, and *Scientific American*, and he was the senior editor of the special-edition themed *MAPS* (Multidisciplinary Association for Psychedelic Studies) *Bulletins* from 2007 to 2012. In 2011, 2012, and 2013, Brown was voted "Best Writer" in the annual *Good Times* and *Santa Cruz Weekly*'s "Best of Santa Cruz" polls, and his news stories have been picked up by *The Huffington Post* and *CBS News*. To find out more about his work, see www.davidjaybrown.com.

■ ■ ■

Sara Phinn Huntley is an artist, writer, and performer working in the visionary art genre using emerging technologies such as VR and AI to explore the imagination. She is multidisciplinary in her approach, and hyperdimensional realms and mythical culture are her closest inspirations. Blending the archaic and futurism is at the heart of her work and arts mission. You can find her work at www.saraphinn.com and her YouTube channel: Dreamseed_VR.